# Praise for Kath
## *Face Down Be: SACRA...*

"Set in Buxton, Derbyshire, in Elizabethan historical series sm political intrigue, period customs, and crime."
—*Publishers Weekly*

"*St. Anne's Well* is among Emerson's best because she puts the emphasis on her core characters who have aged, changed, and grown since they first appeared in *Marrow-Bone Pie*, set in 1559. Her great strength as a writer is her portrayal of women, no matter their station in the stratified 16th century.... It's the relationships among the women who visit the hot springs in Buxton that make *St. Anne's Well* seem comfortable and familiar in the 21st century."
—*Bangor Daily News*

"Susanna, herbalist, housewife and detective (a real Renaissance woman, since she lives in the reign of Queen Elizabeth I) discovers intrigue everywhere...."
—*Kirkus Reviews*

"Emerson offers a remarkable range of vivid and telling details, whether domestic, scientific, political, social, legal, or religious. She also manages to create dialogue that achieves a period sound without being stilted or unnatural."
—*Mystery Scene*

"Lady Appleton unravels a tangled web of passion, deceit, and possible treason. As usual, the twisted affairs of state provide a colorful backdrop for Susanna's machinations, as Tudors and Stuarts vie for both political and religious power and control.... Emerson steeps her period whodunits thoroughly in Elizabethan-era manners, language, and historical detail."
—*Booklist*

# FACE DOWN
## O'ER THE BORDER

# Face Down O'er the Border

*A MYSTERY FEATURING*

## Susanna, Lady Appleton

*Gentlewoman, Herbalist, and Sleuth*

## Kathy Lynn Emerson

M M V I I
PALO ALTO / McKINLEYVILLE
PERSEVERANCE PRESS / JOHN DANIEL & COMPANY

A PERSEVERANCE PRESS BOOK
Published by John Daniel & Company
A division of Daniel & Daniel, Publishers, Inc.
Post Office Box 2790
McKinleyville, California 95519
www.danielpublishing.com/perseverance

Book design: Studio E Books, Santa Barbara, www.studio-e-books.com
Set in Perpetua

Cover painting by Linda Weatherly S.

10 9 8 7 6 5 4 3 2 1

LIBRARY OF CONGRESS CATALOGING-IN-PUBLICATION DATA
Emerson, Kathy Lynn.
  Face down o'er the border : a Lady Appleton mystery / by Kathy Lynn Emerson.
    p. cm.
  ISBN-13: 978-1-880284-91-9 (pbk. : alk. paper)
  ISBN-10: 1-880284-91-fl (pbk. : alk. paper)
  1. Appleton, Susanna, Lady (Fictitious character)—Fiction. 2. Great Britain—History—Elizabeth, 1558-1603—Fiction. 3. Scotland—History—16th century—Fiction. 4. Women detectives—England—Fiction. 5. Herbalists—Fiction. I. Title.
  PS3555.M414F313 2007
  813'.54—dc22
        2006101552

# ❧Cast of Characters❧

*† indicates a real person*

SUSANNA, LADY APPLETON  gentlewoman, herbalist, and sleuth; of Leigh Abbey in Kent; widow of Sir Robert Appleton

CATHERINE RUSSELL, LADY GLENELG  half sister of the late Sir Robert Appleton; widow of Gilbert Russell, ninth baron Glenelg

JEAN FERGUSON, LADY RUSSELL  Catherine's widowed mother-in-law; daughter of the seventh baron Glenelg

GAVIN RUSSELL, LORD GLENELG  tenth baron Glenelg; Catherine's eight-year-old son

CORDELL RUSSELL  Catherine's seven-year-old daughter

ANNABEL MACREYNOLDS  retired intelligence gatherer

AVISE HAMON  Catherine's maidservant and Cordell's nurse

† JAMES VI  eleven-year-old king of Scotland

† JAMES DOUGLAS  fourth earl of Morton and regent of Scotland

SIR LACHLANN DUNBAR  Gavin Russell's guardian

UNA  Jean Ferguson's maidservant

DUGALD  Jean's manservant

MALCOLM LOGAN  Jean's nephew, the Glenelg heir

NICK BALDWIN  Lady Appleton's neighbor and dear friend; merchant

SUSANNA JOHNSON  one of Lady Appleton's goddaughters, aged five

ROSAMOND APPLETON  Sir Robert Appleton's fourteen-year-old illegitimate daughter; fostered by Lady Appleton

JENNET JAFFREY  Lady Appleton's housekeeper and friend; at Leigh Abbey

SIR ROGER ALLINGTON  Cordell Russell's godfather; courtier

TOBY WHARTON  Nick's manservant

FULKE ROWLEY  horsemaster at Leigh Abbey; widower

JAMIE ROWLEY  Fulke's five-year-old son

MARK JAFFREY  Jennet's husband; steward at Leigh Abbey

† ANNABELLA MURRAY, COUNTESS OF MAR  governess of the
    king's household

AILIS AND MARTA  Glenelg House maidservants

† ANDREW BORTHWICK  bailie for the Burgh of the Canongate

ALASDAIR ACHESON  merchant of Edinburgh

JOHN DANIELSTONE  another merchant

NORA MACCRIMMON  Annabel MacReynolds's cousin

ELSPETH DOUGLAS, LADY TENNANT  cousin of James Douglas

SIR WILLIAM TENNANT  her husband

SIM URWEN  baker

† GEORGE BUCHANAN  one of King James's tutors

† PETER YOUNG  another tutor

SIBEAL DUNBAR  Sir Lachlann's twelve-year-old daughter

CATRIONA DUNBAR  Sir Lachlann's sixteen-year-old daughter

FIONNGHUALA DUNBAR  Sir Lachlann's twenty-year-old
    daughter

## ✎ *Other Real People Mentioned in the Story*

ELIZABETH TUDOR  queen of England

MARY STEWART  queen of Scots until her abdication; now a
    prisoner in England

MARY TUDOR  now deceased; Elizabeth's older sister and queen
    of England 1553–1558

CATHERINE DE' MEDICI  queen mother of France; reputed to
    use young women as spies

JOHN KNOX  now deceased; leader of the Reformation in
    Scotland; opposed to the concept of women rulers

JOCKY O' THE SCLAITISS  John Erskine, earl of Mar; Lady Mar's son

# ❆Glossary❆

(Also please see Glossaries in
*Face Down Below the Banqueting House* and
*Face Down Beside St. Anne's Well*)

*aqua vitae*  whisky or other strong liquor ("water of life")

*bailie*  Scots magistrate who performed some of the duties of
English constables, coroners, and justices of the peace

*besom*  derogatory term for a woman

*biliments*  borders of silk, satin, or velvet trimmed with gold or
jewels that decorated women's bonnets

*body-stitchet*  corset made of heavy canvas or boiled leather and
stiffened with busks made of wood, steel, or cane

*booth-maill*  a shop

*burgh*  town organized for commerce and/or defense

*Canongate, the*  a separate town in the sixteenth century that in-
cluded the "king's street" between Holyrood Palace and the city
wall of Edinburgh

*close*  narrow street; often a cul-de-sac

*demesne*  lands surrounding a manor house

*demi-cannon*  oversized sleeves, later called "leg-o-mutton"

*doom of forfeiture*  criminal penalty of forfeiting all lands and
property to the Crown

*ell*  37 inches in Scotland; 45 inches in England

*escheat*  confiscation of all moveable goods

*factor*  one who acted for a merchant, often in another country

*firth*  river estuary (e.g., Firth of Forth)

*fish day*  days on which no meat was to be eaten: Wednesday, Fri-

day, and Saturday

*forebooth*  shop at the front of the ground floor of a building

*footpad*  robber

*frieze*  coarse wool fabric

**Gachtlet**  the language of the Highland Scots; Gaelic

**Geneva**  center of the Protestant Reformation

*harquebus*  early type of portable firearm used by soldiers

**Holland cloth**  any fine linen

**Inglis**  the language of the lowland Scots; similar to the English spoken in Northern England

*laigh floor*  cellar

*lappets*  attached or hanging part of a hood or bonnet

*leman*  lover; mistress

**Master**  heir to a Scots title (e.g., Master of Mar)

*merk*  a unit of accounting (not a coin) valued at forty placks

*merling*  a kind of fish (European whiting)

*netherstocks*  men's hose

*outlawed*  declared a fugitive from the law

*pentice*  hinged wooden shop front on which goods are offered for sale

*plack*  Scots coin worth twopence in 1577

*placket*  opening in a skirt to allow the wearer to reach items beneath that hang from the waist, including "pockets"

*ploddan*  checkerwork cloth used in cloaks

*pocket-dag*  pistol; hand gun

**Port**  city gate

**Reform, the**  the establishment of the Church of Scotland

**Scottis**  another name for Inglis

*screens passage*  area between the entrance to a house and a floor-to-ceiling screen separating it from the Hall

*sink*  a hole in the ground outside the house used to dump waste water; usually lined with rocks

*stifled by the damp*  asphyxiated

*stock fish*  salted and dried cod

*tangle*  seaweed; a popular food in Scotland, eaten both raw and cooked

*Tolbooth*  combination courthouse, jail, and town hall

*turnpike stair*  spiral staircase

*Venetians*  any breeches fastened at the knee and separate from the netherstocks

*wynd*  narrow side street or passage

# FACE DOWN
## O'ER THE BORDER

## 🕸1🕸

CATHERINE HEARD someone shout her name. The noise made her head throb. Other pains stabbed at her from a dozen directions. One hip hurt abominably. So did her right elbow.

"Catherine! Get up! Do you hear me, Lady Glenelg? Arise at once."

The meaning of the sharp-voiced words took time to penetrate layers of confusion. Even after she understood the commands, Catherine could not seem to make her limbs respond. Only with a great deal of effort did she manage to open her eyes.

A woman hovered above her, visible in silhouette. For one disoriented moment, Catherine thought she might be an angel.

The steel busks in Catherine's body-stitchet soon disabused her of the notion that she was dead. They pressed painfully against her quilted underbodice. Heavy folds of fabric twisted around her lower limbs, and the padded roll known as a French farthingale, designed to hold out the skirt under which it was worn, had been shoved out of position to make an awkward lump beneath her buttocks.

Puzzled, Catherine let her eyes drift closed again. Something was not right. If she had fallen—she must have fallen, she decided, for she could feel the smooth marble of the staircase landing

beneath one hand—and her farthingale was out of place, then shift and underskirt and skirt should be in a welter around the middle of her body, not wrapped around her ankles.

"Catherine!" This time the voice seemed familiar, but Catherine could not put a name to it. Before she was able to respond, blackness engulfed her.

A shoe prodded Catherine's shoulder, bringing her back to consciousness. She blinked and her surroundings came into focus. This time the period of disorientation was shorter. She realized almost at once that she was lying on her back on one of the landings of the new staircase. It turned in broad flights around a square stone newel. Because the back of her head ached so much, she decided she must have struck it against the wall or the steps as she fell.

She could not *remember* doing so.

The woman came into Catherine's line of vision. She was a very large woman, and her face matched her girth, replete with double chins and deep pouches under the eyes. Catherine stared into their green depths without recognition until the musky perfume the woman wore stirred a memory. It slipped away again before she could grasp it.

"Up with you," the woman said, sliding her hands under Catherine's shoulders and lifting until Catherine achieved a sitting position. "Give me a moment and I'll move her off your feet."

*Her?* Another wave of confusion engulfed Catherine, but it ebbed the instant the other woman shifted her bulk. The cloth twisted around Catherine's legs was not her own brown velvet skirt. It was black, trimmed with golden crowsfeet.

"Jean," Catherine whispered in horror as her gaze traveled along the distinctive fabric to the back of her mother-in-law's head. A thin line of blood stained snowy white hair. An unpleasant odor emanated from the ominously motionless body.

Abruptly, Catherine found the strength to move. Scrambling to her knees, she scuttled backward, trying to put as much

distance as possible between herself and the corpse. She came up hard against a wall.

The big woman knelt with some difficulty, since she wore a Spanish farthingale to hold out her cinnamon-colored skirts, and turned Jean's body over to reveal eyes that were wide open and seemed to stare accusingly at Catherine. Using the wall for balance, Catherine attempted to get to her feet, but a wave of dizziness defeated her. She landed on her rump with a startled cry.

"What happened here, Catherine?"

"I do not know. I cannot remember."

The woman gave Catherine a puzzled look but did not pursue the matter. She closed Jean's eyes and laid her gently on her back and then, with considerable effort, regained her feet. Advancing on Catherine, she hauled her upright. "Where are the servants?"

Catherine struggled to recall. "An errand. Jean sent them away."

"When?"

The relief Catherine felt at being able to remember *something* faded as she once more had to acknowledge that she did not know. There were gaps in her memory and the more she tried to fill them, the more elusive her recollection of recent events became.

"What *do* you remember?"

Assisted by the other woman's arm around her waist, Catherine climbed the staircase with slow, unsteady steps. The woman already seemed to know the way to Catherine's chamber.

"Who are you?" Catherine asked when she was seated in the room's single chair and had removed her silk-lined caul, already dislodged by the fall, to feel gingerly at the lump at the back of her head.

The woman looked surprised by the question. "You do not remember me, either?"

"You seem familiar, but no, I do not know your name."

"I am Annabel MacReynolds."

Shocked, Catherine stared at her. The Annabel she had known had been a beautiful young woman at the court of Mary, queen of Scots, slender and vivacious, clever and amusing. A dozen years ago, they'd been good friends. Catherine had helped Annabel learn to speak English without an accent and Annabel had taught Catherine to dance.

Annabel poured water into a basin and dipped one corner of her handkerchief into it. "I have changed, yes. But this is not the first time you've seen me since returning to Scotland. Think, Catherine."

As she leaned closer, dabbing at Catherine's cheek and making it sting, Catherine once more inhaled Annabel's musky perfume. A fragment of memory surfaced. Annabel—this older, larger Annabel—here in Glenelg House. She'd come at Catherine's request, agreed to help find a way to remove Catherine's eight-year-old son, Gavin, from danger.

Alarm had Catherine on her feet and this time she fought back a wave of dizziness. "Cordell," she whispered. She knew where Gavin was, but what had happened to her seven-year-old daughter?

This time an answer surfaced without effort and she sagged onto the purple velvet cushions, weak with relief.

"She is safe?" Annabel inquired.

"Yes. With her nurse. Avise took her to Greenside to hear a concert by the town waits."

But how long ago had that been? A glance at the window told Catherine no more than that it was still day. Anything from an hour to an entire afternoon might have passed since Avise and Cordell left Glenelg House, and Catherine could not remember any of it.

## 2

ANNABEL REGARDED her old friend with a mixture of concern and irritation. Her goal, upon returning to her native land two years earlier, had been to live quietly and do nothing to bring herself to the attention of the regent or his rivals. She had a feeling that was about to change. Oddly, the idea was not entirely without appeal.

"I was late for our meeting." Annabel examined the bump on Catherine's head, then pressed a cold, wet cloth against it. "Hold that in place. You are fortunate. You do not seem to have broken any bones."

"I remember that we planned to meet," Catherine murmured. "I remember that I asked for your help."

"You wanted me to find a reason to remove Gavin from Stirling Castle." Having finished her ministrations, Annabel dumped the pink-tinged water into the slop bucket.

Gavin had been Lord Glenelg ever since his father's death when he was two years old. The previous April, at eight, he had been summoned to attend upon his liege lord, the king of Scotland. King James was eleven. It was a great honor to become one of his schoolmates, but Catherine had not wanted her son to go. She was English by birth, and in England she had wished to remain, with *both* her children.

Unfortunately, the queen of England had sided with the earl of Morton, the current regent of Scotland. In short order, Gavin's wardship had been granted to Sir Lachlann Dunbar, a stranger, and Catherine, to be closer to her little boy, had moved to Scotland, into the house her mother-in-law already occupied just outside of Edinburgh. That Jean Ferguson, Lady Russell, had been instrumental in obtaining a place for Gavin at the royal court had not endeared her to Catherine. That Stirling Castle, where King James resided, was a two-day journey from Glenelg House, had only made matters worse.

"The information you uncovered—"

"That must wait," Annabel interrupted. "We have more pressing matters to concern us. Where are the servants?"

It was the second time she'd asked, and as she'd hoped, Catherine now remembered more. "Jean sent Una, her maid, and Dugald, her manservant, to Master Uddart's shop in Edinburgh. She'd ordered carpets, and a ship from Antwerp arrived with them on Saturday. She sent Una to make certain the quality was acceptable and Dugald to drive the cart to transport them here."

Annabel heard the underlying edge in Catherine's voice and understood its cause. In the three years Lady Russell had been in Edinburgh, she had spent freely of Glenelg money and rarely asked anyone's permission first. Most of it had gone into renovating Glenelg House. Lady Russell had lived in England for decades and had grown accustomed to the luxuries found in wealthy English homes. She'd been determined to recreate that same level of comfort in Scotland.

"Where are the other servants?" Annabel asked. There were, she recalled, a cook and a scullion and several more maids.

Catherine frowned. "Jean sent the cook to Leith for fish. She said she was tired of being served platters of porridge and little pieces of sodden meat. The maids went to reclaim laundry the washerwoman has not yet brought back."

"I doubt any of them would have dared investigate, even if they had been in the house to overhear the quarrel," Annabel said.

"What quarrel? I do not remember arguing with Jean."

"You clashed with alarming frequency," Annabel reminded her. "I have no doubt but that you fought again today."

Catherine went very still. "You think we were quarreling when we fell down the stairs? That I *pushed* Jean? No! That's impossible! The fall must have been an accident." She dismissed the idea out of hand, and removing the damp cloth from her head, folded it small.

Annabel did not press the issue. It mattered little to her how

Lady Russell had died. A simple lie would remedy the situation. She would claim she had arrived an hour earlier, that she had been with Catherine in the Hall when they had heard a tremendous crash from the stairs. Catherine's bumps and bruises were hidden by her clothing. It only remained to find an explanation for the damage to her face.

"Where is Sir Lachlann Dunbar?" Annabel asked. "I was late. He should have arrived here ere now."

"Perhaps he was delayed in Stirling, though it is strange he did not send a message." Catherine gave a choked laugh. "Mayhap he did and I do not remember."

"And Malcolm Logan?" Annabel asked. "Where is he?"

"I have given up keeping track of that one," Catherine said, a hint of asperity in her voice. "I was not the one who invited him to stay here."

Malcolm Logan was next in line to inherit the Glenelg title, should something happen to young Gavin. He was the son of one of Lady Russell's sisters, by all accounts an untidy, uneducated lout with no manners to speak of and a surly attitude. Annabel had caught a glimpse of him once and that had been more than sufficient. She had no desire to meet him.

"There did not seem to be anyone about when I arrived," she said thoughtfully. "I believed the house empty until I found the two of you on the landing."

Catherine started and cried out in dismay. "How could I have left Jean lying there?"

This time Catherine did not sway when she stood. A wince told Annabel that Catherine's head still hurt, but the worst of the dizziness appeared to have passed.

"We will have to wait until the servants return to move her," Annabel said, plucking up Catherine's discarded caul as she followed her out of the room.

"She should not be left alone."

They had scarce reached the landing when the sound of a

cart in the street outside announced the return of Una and Dugald.

"Go down and tell them there has been an accident," Catherine ordered. "Bring them here to help us carry her to her bed."

Annabel's eyebrows lifted at the peremptory command, but she took it for proof that Catherine's recovery continued apace. After a moment's consideration, she paused long enough to arrange Catherine's headdress for her, then obeyed.

<div align="center">❈3❈</div>

THE BODY OF Jean Ferguson—who had called herself Lady Russell when she lived in England, in spite of the fact that her husband had never been made a knight—lay atop her own bed, ready to be stripped, washed with perfumed water, and wrapped in a winding sheet.

"It is my right to serve as Lady Russell's tiring woman one last time," Una insisted. The tears streaming down her lined face attested to the strength of her devotion to her mistress.

Una was well into her sixties and had been in Jean Ferguson's service since both of them were girls. They'd gone together to England and had stayed so long that neither had retained more than a trace of a Scots accent.

Catherine felt a stab of guilt as she watched the simple act of a maid removing her mistress's shoes. Una truly mourned Jean's passing, as Catherine herself could not.

Although her recollection of events just prior to her fall remained hazy, Catherine suddenly remembered, with vivid clarity, a day some eight years earlier. She'd hidden in the stables of her London home to get away from Jean's nagging. Nothing had pleased her mother-in-law. She'd found fault with everything

Catherine did. Catherine had consoled herself by imagining that Jean had been abducted by pirates and carried off to be sold into slavery on the Barbary Coast.

"I did not mean it," she whispered to the corpse, although in her heart she knew she had. She'd seen no harm in picturing such a fate for the old besom. Nor had she ever learned to control her temper when Jean was at her most irritating. They'd quarreled a hundred times, a thousand, over the years.

A gasp from the maid brought Catherine back to the present. She looked at Jean again, and saw that Una had removed her mistress's ruff. For a moment, Catherine could not grasp the significance of what lay revealed. Then she had to fight not to cry out in horror.

A pattern of bruises showed livid on Jean's white throat, the marks of fingers. A glance at Annabel told Catherine that she had seen and understood them, too.

Catherine's gaze dropped to her own hands. Had she been responsible? Had her last quarrel with Jean been so fierce that she'd strangled her mother-in-law? Was that how they'd fallen, locked in mortal combat?

Una made no attempt to disguise what she thought. "You did not mean it!" she repeated, her expression rife with suspicion and disgust.

Before Catherine could explain away the damning words, Una lifted one of Jean's hands and examined the dead woman's fingers. Catherine was close enough to the body to see what the maid did—there was blood beneath Jean's nails. She'd clawed at someone, defending herself.

Nausea roiled in her stomach as Catherine reached up to touch her own cheek, feeling the wound Annabel had cleaned. It was not a cut caused by the fall, as Catherine had supposed. With her fingertips she traced the paths of three long scratches.

Confronted by this proof that she had strangled Jean, unable to remember for herself anything that had happened after she saw

Avise and Cordell off for Greenside, Catherine abruptly fled
Jean's chamber. She ignored Annabel when the other woman
spoke her name.

Averting her gaze as she passed the blood still visible on the
landing, she descended to the floor below. Blindly, she sought the
*aqua vitae* Jean kept in a cupboard in the Hall. She doubted any-
thing less potent than the fiery drink the Scots called *uisque-beatha*
would calm her.

She had downed only one swallow before Sir Lachlann Dunbar
strode into the room, newly arrived from Stirling. The dust of the
road covered his dark brown cloak and his knee-high riding boots.

He stopped in his tracks when he caught sight of her, his criti-
cal gaze raking over her from head to toe, taking in her disheveled
appearance and the damning scratches that marred her cheek.

Catherine burst into tears.

To her surprise, Sir Lachlann responded by offering comfort.
He was tall. He was solid. He'd never been anything but courte-
ous to her, even though they disagreed about how and where
Gavin should be raised. The moment he pulled her close, uttering
sympathetic murmurs and giving her an awkward little pat on the
back, the whole story tumbled out—how she and Jean had always
been at odds, how they must have been quarreling yet again when
they'd tumbled down the stairs.

She spoke in French, for they were both more fluent in that
language than in the other's native tongue. "I came to my senses to
find her dead beside me and I cannot remember anything of the
events just before we fell."

In the nick of time, Catherine stopped herself from suggest-
ing that Jean's death had been anything other than an accident.
Perhaps she was wrong about that. Perhaps there was another
explanation for those bruises.

"Nothing?" She heard the astonishment in Dunbar's voice and
wondered how long it would be before bewilderment turned into
suspicion.

"I have tried and tried." Catherine dashed her tears away with the back of one hand. "But I can recall nothing of the last three hours." It was only thanks to Una that she now knew how long the servants had been gone.

"A pity I did not arrive sooner," Sir Lachlann lamented. "I was delayed when my horse went lame. I was obliged to borrow my man's mount to complete the journey."

He'd come from Stirling. The distance was not great—a mere twenty-four miles—but more than an ordinary day's ride to Edinburgh.

"I was not in time to prevent this tragedy, but mayhap I can be of some assistance to you now," Sir Lachlann said after a moment. "I have buried my share of kin."

"I have no idea how the law works in Scotland," Catherine admitted, "except that it differs from the way things are done in England."

She felt him stiffen. "The law?"

"Her death was sudden, and since I have no memory of being witness to it, must be deemed 'unattended.' Surely a coroner should be called in? Or the local justice of the peace?" If she were still living at Leigh Abbey in rural Kent, that would be Nick Baldwin, their nearest neighbor. Would Nick have arrested her for Jean's murder? Catherine rather thought he would have and had to suppress another sob. Still, there was no help for it. The matter must be investigated. If those bruises on Jean's throat could not be explained away, then she must accept her guilt.

"Do not trouble yourself about such matters, Lady Glenelg." Sir Lachlann's voice smoothed out but his grip on her did not relax. "I will take care of everything."

*Will you arrange to have me imprisoned and put on trial when you see those bruises?* She did not ask the question aloud.

After further reassurances, still in French, Sir Lachlann added an admonition in the local dialect: "*Ye maunna fash yersel, lass.*"

Do not worry? Easier to bring Jean back to life! Catherine

watched him depart to fetch the proper authorities with a curious blend of relief and trepidation.

As soon as he was gone, Annabel stepped into the Hall from a place of concealment in the screens passage. "Do you mean to wait calmly to be charged with this crime?" she inquired. "Whether she died from strangulation or from injuries sustained in the fall, you will surely be blamed for her death."

An image of herself with her hands around Jean's neck flashed through Catherine's mind. Memory or imagination? She shook her head. "I know it looks as if I killed her, but why would I do such a thing? Why *now?*"

"What does your reason matter? The marks on her throat and the scratches on your cheek are enough to condemn you. They will say that you fell together, while you were pummeling her. You will be prosecuted and found guilty...if you are here to be taken into custody."

Catherine began to tremble. With her emotions in turmoil, she could not think clearly.

"Catherine!" Annabel spoke sharply and seized her arm. "Come with me now. You must not stay here."

*I will be arrested if I do not flee.* Catherine swallowed bile. She was a stranger in Scotland—a foreigner, a *sasunnach* woman. But when Annabel tugged at her sleeve, Catherine pulled free. "I need something from my bedchamber."

On unsteady limbs, once more needing Annabel's assistance, she made her way upstairs. It did not take long to retrieve the two pouches of coins she kept hidden in the false side of a clothes chest.

While she collected them, Annabel snatched up a cloak and a pair of sturdy boots. "You'll need these later. Now hurry. We must away."

Catherine followed her out of Glenelg House and did not balk again until Annabel tried to lead her into one of the narrow closes that wound between the densely packed houses and walled gardens and emerged in the South Back.

"No," she objected. "We must go by way of the North Back of the Canongate." Both Backs allowed access to the common wells and grazings of the burgh, but only by going north could they reach the path that circled the lower reaches of Craigingalt and led to Greenside, where Avise had gone with Cordell.

"South," Annabel insisted. "'Twill be safest if we enter Edinburgh by Cowgate Port."

"I cannot abandon my daughter." Leaving Annabel to follow or not, Catherine threaded her way through one narrow wynd and into another until she came out at the foot of the hill.

Annabel pursued her. "You must leave Cordell in Avise's care. She'll be safe enough at Glenelg House with the servants. A child will only slow us down. You will be caught."

"I—"

Annabel's exasperation inscribed even deeper lines into the furrows of her face. "You'll be no good to her in gaol…or hanged."

"I will not go without my baby." Limping painfully, Catherine forced herself to climb the steep flight of steps cut into the hillside. When they ended she stumbled across the grassy, gorse-strewn slope. She felt the effects of her fall in head and limbs and the thin leather of her indoor shoes provided little protection from the rough ground underfoot. Every sharp stone felt as if it cut straight through to the skin, but she never wavered in her determination to reach Cordell. A mother could not simply disappear, leaving her precious child behind.

"Do you *want* to be tried for murder?" Annabel came alongside Catherine and kept pace. Her girth did not seem to slow her down.

Catherine ignored the harangue. The dull ache at the back of her head had increased into a steady throb, and shards of pain stabbed at her from a dozen directions with each step she took. Her breath came in short gasps.

"You have no friends at court to support you. Your own ac-

tions have cost you any hope of allies there. If you value your life, Catherine—"

"Hssst! No more."

For the first time that day, the Fates were kind. Up ahead she caught sight of the familiar forms of Avise and Cordell, returning from the afternoon concert. Propelled by a new burst of energy, Catherine dashed toward them.

Annabel, moving with unexpected agility, darted ahead of her to reach Avise first. "There has been an accident," she said to the maidservant. "You must not return to Glenelg House. Hire men and horses and take the child to Lady Appleton."

Catherine started to protest, then realized Annabel's suggestion made sense. Cordell would be safe in Kent, no matter what happened here. Susanna Appleton was one of Cordell's godmothers. Moreover, Catherine, Gavin, and Cordell had lived with her for the last few years. Leigh Abbey was the place Cordell still thought of as home.

"It is best you go at once," she said to Avise, handing over half the money she'd taken from Glenelg House. Then she hugged and kissed her daughter. "Be a good girl and mind Avise."

With the directness typical of seven-year-old children, Cordell pulled away and challenged the decision. "You come too, Mama." Her lips compressed in a thin, trembling line and her eyes reflected both hurt and a sense of betrayal, piercing Catherine's heart.

"I cannot leave Scotland without your brother." Catherine's voice broke.

"You love him more than you do me."

"I love you both equally. And I shall miss you terribly. It will not be a long separation. I promise you that, my little love." She bore the pain without complaint when Cordell launched herself into a farewell embrace. The child was small for her age and thin, but she clung with frantic strength, pressing herself against Catherine's bruises until Avise pried those little fingers loose and

lifted Cordell into her own arms. The girl promptly buried her face against her nursemaid's shoulder and refused to look at her mother again.

"I'll keep 'er safe, madam," Avise promised. Her plain face was pale as new-fallen snow but Catherine did not doubt the sincerity of her words, not even when she added, "I cut bene whids."

"I know you speak truly, Avise," Catherine assured her, translating the phrase for Annabel's benefit. Avise had a tendency to betray her origins by falling into thieves' cant when she was nervous or upset, but she was fiercely loyal to Catherine. "I would trust you with my life, and I do trust you with my daughter's."

"Best get out of 'ere, then." Avise's gaze had shifted downhill.

Alarmed, Catherine turned, startled to see how high they had climbed. From this vantage point she had a panoramic view that extended all the way from Edinburgh Castle on her right to the palace of Holyrood on her left. Along the mile in between were the houses of the Canongate, her own among them. Sir Lachlann Dunbar had just reached the gate of Glenelg House. Malcolm Logan was with him, easy to recognize in the Highland dress he affected, together with a man she did not know.

"The bailie," Annabel said. "We must away."

Carrying Cordell, Avise set off at a trot, heading back the way she'd come. "Get out of 'ere, madam," she called over her shoulder. "Never let the poxy cuffins take you."

Overcome by exhaustion, tormented by the growing fear that she might have murdered her mother-in-law, Catherine still hesitated. "Annabel—what if I *did* strangle Jean?"

"All the more reason to avoid being caught." Seizing Catherine's arm, Annabel hauled her down the hill in a direction that would bring them out on the road to Leith.

# 🎔4🎔

THE UPPER parlor of Nick Baldwin's country estate in North-amptonshire was an open, comfortably furnished room made bright at this hour of the morning by large, east-facing windows. Susanna Appleton occupied her favorite perch on the cushioned window seat, one hand holding a book and the other idly stroking Greymalkin, the housekeeper's elderly cat.

She glanced toward the door at the sound of running foot-steps. There was no cause for alarm. She recognized the patter of her young namesake's feet.

Susanna Johnson, aged five years and seven months, who lived in a cottage on the Candlethorpe estate with her mother, was also Susanna Appleton's goddaughter. Susanna had taken a lively interest in the child's upbringing from the day of her birth and willingly put aside the weighty tome she'd been studying when the parlor door burst open.

Young Susanna clasped a packet of letters in one chubby, grubby hand, waving it as she approached at a dead run. "From Kent!" she piped, face alight at having been entrusted with the delivery.

Nick Baldwin appeared in the doorway behind her, filling it with his broad shoulders. The grin on his face told Susanna that he'd been the one to send the child on her errand. He doted on her, just as Susanna did.

"Let me see, sweeting."

The slightly sticky packet changed hands and Susanna made short work of the oilskin wrappings. Inside, as she'd expected, was a letter from Jennet Jaffrey, Susanna's housekeeper at Leigh Abbey and her friend. Another came from Rosamond, who was both stepdaughter and foster daughter, and Susanna's heir. The third was in a hand Susanna did not recognize, so she left it for last.

She frowned when she'd finished reading Jennet's account of everyday life at Leigh Abbey. "I must leave here soon," she said to Nick. "I fear Jennet is not well."

"Does she say so?"

"She says just the opposite, but I know how hard the last two years have been on her. It was all very well to set up a school for Rosamond and the other girls, but their tutors cannot oversee everything and I have been too often away."

She'd journeyed to Devonshire to attend her cousin's wedding and this was her second visit to Candlethorpe in as many years. She'd been here with Nick since June this time. Her excuse for staying on through the heat of August had been flimsy at best. True, there had been a virulent outbreak of the plague in London in late summer, adequate reason to avoid traveling through that city to reach Leigh Abbey and risk carrying the disease home with her, but they could have taken a more roundabout route. They could even, in spite of her dislike of travel by water, have made the trip by sea. Now that it was nearly the middle of September, she knew she must no longer put off leaving.

The real reason she had delayed her departure was her reluctance to lose the contentment she'd found at Candlethorpe in Nick's company. He was her nearest neighbor in Kent, but that was not the same as sharing a house, and a bed, with him. They could not spend as much time together once she returned to Leigh Abbey, no matter how much they might want to. They would also have to be circumspect, to avoid gossip...and worse. More and more of late, the church took an undue interest in the private business of individuals. Several years ago, thanks to her parish clergyman, Susanna had found herself facing accusations of immoral behavior. She had no wish to repeat the experience.

Preoccupied with such thoughts, which perforce led her to the subject of Nick's repeated proposals of marriage and her refusal to consider them, Susanna unfolded the third letter in the

packet. A note in Jennet's hand informed her it had arrived at Leigh Abbey from London on the eighth of September.

A frown creased Susanna's brow and the furrow deepened as she read. At first, the words made no more sense than the identity of her correspondent.

She had met Sir Roger Allington only once, at the christening of Catherine Glenelg's daughter, Cordell. Susanna, Sir Roger, and Lady Allington were the girl's three godparents. Cordell had been named after Sir Roger's wife.

"Is something wrong?" Nick asked. When she did not answer, he shooed Young Susanna out and closed the door. "Tell me."

"Catherine is in trouble." Sir Roger did not give many details, saying only that an acquaintance in Scotland had sent word to him in London that Gilbert's mother was dead and the whereabouts of Catherine and her daughter unknown. He asked Susanna if she had heard from Catherine and requested that she send word to him at once if she did. Susanna passed the letter to Nick.

"Who is Roger Allington?" Nick asked when he'd read it.

Susanna explained the connection, adding, "He and Catherine's late husband became friends shortly after Gilbert and Catherine were married. Gilbert spent several years in Scotland at that time, at Queen Mary's court. Allington was one of the courtiers Queen Elizabeth regularly sent as emissaries to her royal cousin."

Nick nodded. He had never met the late Lord Glenelg, but he knew Catherine's history almost as well as Susanna did. After Mary Stewart's abdication in favor of her infant son, Scotland had been ruled by a series of regents. One of them had sent Gilbert to London as his representative to the English court. When Gilbert had died during an outbreak of the plague, Catherine had remained in England. She'd returned to Scotland only because her son, as the heir to the barony of Glenelg, had been ordered to join the king's household at Stirling Castle. Although she could not be with him, she had wanted to be close at hand.

"Can you trust Allington's report?" Nick asked.

"I've no doubt his information is accurate. It is what he does not say that troubles me." Absently, she resumed stroking the cat.

The death of Catherine's despised mother-in-law alone was not cause for alarm. She'd seen more than seventy summers. Any number of things might have proved fatal. But if she had died of natural causes, Catherine would have written to Susanna with the news. That left two equally alarming possibilities. Either someone had murdered Jean and kidnapped Catherine, or Catherine was suspected of killing the old woman herself and had fled with Cordell to avoid arrest.

"Sir Roger would have said so if he thought she'd been abducted." Susanna was dismayed to hear her voice shake. She cleared her throat. "He would want us to be prepared for a ransom demand."

"He does not say how Lady Russell died." Nick sat beside Susanna on the window seat, displacing Greymalkin, and took her hands in his. "Would he not be more specific if her death was linked with Lady Glenelg's disappearance?"

"He is a courtier," Susanna reminded him. "They are almost as devious as intelligence gatherers." She should know. Her late husband had been both.

But Nick's thoughts had obviously run along the same lines as Susanna's. "Murder? Would Catherine—?"

"I hope not, but Catherine and her mother-in-law were at odds from the moment they met. If Lady Russell's death was in any way suspicious, Catherine is likely to have been blamed."

"So you think that is why she is missing—she fled to avoid being charged with a crime?"

"That is what I fear," Susanna admitted.

"Is there someone in Edinburgh you can write to?" Nick asked. "Someone who can provide more information?"

"No. No one. Besides, in the time it will take to send a letter and receive a reply, I can travel to Edinburgh and discover the

truth for myself." Driven by the need to do something to help
Catherine, a woman she'd loved like a younger sister from the
time Catherine was a slip of a girl of fourteen, Susanna sprang to
her feet. "A day to prepare. Two on the road. I must make haste."

Nick followed her from the parlor to her bedchamber and
watched in silence as she hauled garments out of the clothes press
and piled them on the bed. Combs and jewelry came next, tossed
into her capcase with no regard for order.

"A too-precipitous trip to Edinburgh will avail you nothing."

The calm tone of Nick's voice penetrated the haze of chaotic
emotions fueling Susanna's flurry of activity. She stopped her
frenzied packing. What was she doing? It was not like her to panic
this way, to rush blindly into action. If there had been time
enough for the news to reach Allington in London, then a week or
two, perhaps more, had already passed since Lady Russell's death.
Perhaps Catherine had already returned to Glenelg House. Per-
haps this was all a mistake.

And mayhap Catherine had already been arrested, tried, and
executed.

Susanna squeezed her eyes shut against that terrifying
thought.

Nick's arms came around her and she leaned into his
strength. "If Catherine sought to avoid arrest, would she not make
her way to the Border with all speed? Even now, she may be half-
way to Leigh Abbey."

But Susanna shook her head. "As long as her son is in Scot-
land, Catherine will not leave. And if I am to help her, I must go
to Edinburgh."

"*We* must go," Nick corrected her. "Very well, I will secure
horses and outriders. We will leave tomorrow at dawn, but we
will be three days on the road." When Susanna started to object,
Nick put one finger to her lips to silence her protests. "There is
no advantage in riding hard and arriving exhausted. We are nei-
ther of us as young as we once were."

"How unkind you are to remind me!" Next St. Crispin's Day, she would celebrate the forty-third anniversary of her birth.

His smile was both wry and tender. "You have two years yet before you reach my present advanced age. Now that I am forty-five, people have begun to refer to me as 'aged'!"

"At least they cannot add the word 'crone' to that description." In spite of Susanna's fears for Catherine and Cordell, bantering with Nick lifted her spirits. "Make your preparations, old man. I will be ready to ride when you are."

## 5

*September 16, 1577*
*Glenelg House, Burgh of the Canongate, Scotland*

GLENELG HOUSE was not difficult to find. It was situated near the Laplee Stane in the Canongate, along the half mile of wide, paved highway that connected the Flodden Wall surrounding Edinburgh to Holyrood Palace. Nick and Susanna arrived at late morning on their fourth day of travel.

A narrow passage led to a small garden and a stable at the back. There Nick helped Susanna dismount and handed the reins of both their horses to Toby, his manservant. Nick paid and dismissed the men he'd hired to guide and guard them on the journey north and gave the packhorse into Toby's keeping as well.

No servants appeared to greet them. Indeed, the only sign that Glenelg House was occupied was a tentative whinny from inside the stable.

"There does not seem to be anyone about," Susanna remarked as they made their way toward the main entrance. She sounded nervous, as well she should be.

It had occurred to Nick more than once during the last few

days that they'd scarce be welcome here if Catherine *had* killed the old woman. He watched with admiration as Susanna squared her shoulders and strode boldly up to the door. Only after repeated knocking did an elderly maidservant open the portal.

"I am Lady Appleton." Susanna did not wait to be asked in. "I have come at Lady Glenelg's invitation."

That was even true. Before she'd left England, Catherine had generously said that both Nick and Susanna were welcome to visit her in Scotland at any time they chose.

"Lady Glenelg is not here," the maid said as she scurried after Susanna. Her voice was a nasal whine but she spoke excellent English.

Nick followed, pausing only long enough to close the door behind him.

"Where has she gone?"

"No one knows where she is." Although the woman kept her tone carefully neutral, some strong emotion flared in her pale blue eyes before she averted her gaze.

"And her daughter? What has become of her?"

"She's gone, too, madam, together with Lady Glenelg's servant."

Avise Hamon, Nick recalled, and remembered also that Catherine had rescued Avise from the streets of London. She'd likely be a help if Catherine *were* in hiding.

"Show me to Lady Glenelg's bedchamber, if you please," Susanna ordered in a voice that brooked no disobedience. "I will take it for my own in her absence. Master Baldwin will require separate accommodations."

The maidservant did not argue, although she looked as if she'd like to. She led the way up the impressive, curving stairs, scuttling a little faster when they reached the landing. She was nervous, Nick realized, and wondered why.

It seemed odd, too, that the house was not decked out in mourning. Everything should have been swathed in black cloth.

True, Catherine had not been here to give the order, but Nick would have expected a steward or a housekeeper to do so.

They emerged from the stairwell into a generously proportioned gallery. Several doors appeared to lead to adjoining chambers and the maid had started toward one of them when Susanna stopped her. "Who is that?" she asked.

A solitary figure sat hunched over a small table at the far end of the room. Quill in hand, what looked like an account book open before him, he glanced up at Susanna's question. Annoyance momentarily turned otherwise pleasant features almost ugly.

"Who are these people, Una?" In contrast to the maid's fluency in English, his use of that language seemed hesitant.

"Lady Appleton, come from England, sir."

"Lady Glenelg is a kinswoman of mine," Susanna said.

"Yes, I know of you." He rose and offered her his chair. "I am Sir Lachlann Dunbar, Lord Glenelg's guardian."

Nick watched through narrowed eyes as Susanna took the proffered seat. Dunbar was in his late thirties and in good physical condition. He dressed in a fashion that had gone out of style many years ago in England, but there was nothing to sneer at in the sword he wore at his belt. He carried it in an unadorned hanger of simple construction, indicating it was meant for use rather than show.

To Susanna, now that he knew who she was, he showed every courtesy. He asked politely if they might converse in French rather than English, as he spoke it more fluently.

"Allow me to serve as interpreter, then," Nick offered, "interjecting translations as needed." Although Susanna could read several languages, he knew she had difficulty pronouncing foreign words.

His expression somber, Dunbar confirmed in French what both Susanna and Nick had been afraid they would hear: "I am sorry to tell you, Lady Appleton, that your friend has been accused of murdering Jean Ferguson."

Susanna blinked at him. "Do you mean Lady Russell?"

"I beg your pardon," Dunbar said, bestowing a slightly conde-
scending smile on Susanna. "I had forgot you English do things
differently. Most Scotswomen keep their own surnames after
marriage."

Since this information was of little importance compared to
Catherine's plight, Susanna did not comment upon it. "Was there
a witness to this crime?"

"Alas, no, but there is evidence aplenty of Lady Glenelg's
guilt, and her disappearance confirms it, for why else run away?"

"What evidence?"

Nick could tell she did not want to believe Catherine guilty
of murder, but they both had reason to know that anyone could be
driven to kill, given the right circumstances. He listened intently
as Dunbar described what he had found upon arriving at Glenelg
House on the twenty-seventh day of August. Catherine had told
him that she and her mother-in-law had fallen down the stairs.
She'd claimed she did not know how the accident happened. She'd
said that she'd struck her head during the fall and could not
remember what had preceded it. She'd said that Jean Ferguson
had been dead by the time she'd regained consciousness.

"An accident—"

"No, Lady Appleton. For when the body was examined,
bruises were found about Lady Russell's throat. Finger marks. I
saw them myself. She had been strangled. And there was blood
beneath her fingernails. She had tried to defend herself against
attack. The scratches she made were plainly visible on Lady
Glenelg's face."

Dunbar's voice conveyed both sincerity and sympathy. If Nick
had been in Kent and acting in his accustomed capacity as a justice
of the peace, he'd have issued a warrant for Catherine's arrest
himself after hearing Dunbar's account. "Has she been outlawed?"
he inquired.

"Aye. She failed to answer a summons to the Tolbooth."

"Tolbooth?" Susanna asked. Along with given names and a sprinkling of English words, Dunbar had not translated this term into French.

"The Tolbooth is a building. It houses both gaol and courts. Since a criminal prosecution has been brought against Lady Glenelg, she was required to appear there to answer the charge. She did not."

Her expression grim, Susanna continued to ask questions, but Dunbar was unable to tell her what Catherine had taken with her or whether Catherine and her mother-in-law had quarreled prior to Lady Russell's death.

"What of *your* relationship with Lady Glenelg?" Nick interjected. "How did you happen to be here that day?"

Dunbar's agreeable expression did not falter. "We did not always think alike when it came to her son's future, but we got along well enough. I arrived shortly after Una discovered the bruises on her mistress's neck. I had come to stay for a few days to discuss certain business matters. This property belongs to young Lord Glenelg, although Lady Glenelg has a life interest, and as such is administered by me."

"And you've remained here ever since?" Susanna asked.

"Someone had to arrange the funeral for Lord Glenelg's grandmother. I'd not trust her nephew to handle the burial." He went on to explain that Malcolm Logan, Master of Glenelg, was also in residence at Glenelg House.

"I know neither the name nor the title," Susanna said.

"He is the son of Lady Russell's youngest sister and next in line to become Lord Glenelg if young Gavin fails to marry and produce heirs."

"He lives here?" Nick asked.

Dunbar could not quite mask a grimace. "He invited himself to stay some months ago and shows no inclination to leave."

"A disagreeable sort?" Susanna guessed.

"Uncouth." Dunbar looked abashed at his own frankness to

strangers, then shrugged. "Most Highlanders are barbarians until they've been civilized."

"Where was *he* when his aunt died?" Susanna asked. Nick wondered if she was envisioning the same thing he was—a bare-legged savage in a saffron shirt, beard untrimmed and armed to the teeth.

"Out," Dunbar answered, "as was everyone else in the house-hold save Lady Russell and Lady Glenelg."

"I wish to question the servants," Susanna said. "I trust you have no objection to my doing so or to my staying here during my sojourn in Scotland?"

"My dear Lady Appleton, nothing would please me more than to have someone discover another explanation for this tragic event, but I fear you will learn nothing of any use."

So, Nick thought, Catherine had never regaled Dunbar with tales of Susanna's successes. Her ability to ferret out the truth of a given situation had brought more than one murderer to justice.

Still, Nick did not like what he heard. The evidence against Catherine sounded damning indeed. If it turned out that she *had* killed her mother-in-law, Susanna would be devastated. She believed all life was sacred. She believed in righting wrongs. She would be placed in a terrible quandary if she had to decide be-tween obeying the law and saving a loved one from execution.

"You must make yourself at home here," Dunbar said, "and we will talk again anon, but I fear I have an appointment in Edinburgh and must abandon you for the nonce."

For the benefit of Una, who had lingered all this while in the doorway, he repeated this sentiment in Inglis, the language of the lowland Scots, making it into an order to take good care of his guests. That accomplished, he turned back to Susanna and bent over her fingertips to kiss them in farewell.

The French had left their mark on Scotland, Nick thought in annoyance.

As Dunbar started for the stairs, Nick straightened away from

the wall and went after him. "If you have no objection, I will accompany you into Edinburgh. I have several acquaintances among the merchants of the city." They were engaged, as Nick was, in the outland trade, sharing a circle of international contacts. He hoped that would make them willing to exchange information.

Displeasure flashed in Dunbar's eyes, even as he agreed with outward graciousness. Nick could not resist. He darted to the side of his lady's chair, aped Dunbar's courtly bow, and planted his lips on the back of Susanna's hand with a resounding smack.

## 6

SHAKING HER head at Nick's outrageous behavior, which she interpreted as an attempt to lift her spirits, Susanna turned to Una and once again asked the maidservant to show her Catherine's bedchamber. "I vow," she remarked, "my head is spinning from the effort it takes to remember how to pronounce all those French words. I am most grateful, Una, that you speak English."

"I lived longer in England than I ever did in Scotland." Una's manner was as stiff as it had been earlier, but she unbent a trifle when Susanna offered condolences on the loss of her mistress.

"You were with her for many years," Susanna added, thinking of her own close relationship with Jennet Jaffrey, who had been both friend and servant since early in Susanna's marriage to Sir Robert Appleton.

"Over forty-five years," Una agreed. "I went with her when she left Dunfallandy to visit friends in England. She met Master Russell the first day and nothing would do for either of them but that they marry. Old Lord Glenelg, her father, objected because Master Russell was English, but Mistress Jean married him anyway."

Susanna tried to imagine Jean Ferguson young and in love and

could not. "Did you have a choice about staying with her? Surely you must have missed the village where you were born?"

"Terrible backward place," Una declared. "If I never return there, it will be too soon."

"I gather Lady Russell shared your view?"

While she questioned Una, Susanna explored Catherine's bedchamber. She recognized the furnishings. Catherine had brought them to Leigh Abbey from London and taken them with her again when she moved to Scotland. The walnut bedstead had a canopy of purple velvet, and a double valence and curtains of fine purple silk decorated with gold lace and fringed with purple and gold. The chair had purple velvet cushions to match. Surrounding these two pieces were several wardrobe chests and on the wall hung the familiar portrait of Gilbert, ninth lord Glenelg, Catherine's late husband.

"She'd not have come to Scotland if it had not been for the boy," Una said.

"Do you speak of Lady Russell or Lady Glenelg?" Susanna asked, momentarily confused.

Una bristled. "Who else but Lady Russell? She believed young Lord Glenelg deserved to take his proper place at court. She worked hard to make sure that he was invited. Why else should she have left London? We were comfortable there. Settled."

Susanna considered this as she made a closer inspection of the room's contents. She could see no evidence that anything was missing. The wardrobe chests were full to bursting with clothing. When Susanna inhaled, she caught a whiff of violets, the scent Catherine favored. It even lingered on the man's garments she wore for long journeys on horseback.

Catherine's comb and brush and tooth picks likewise seemed untouched, but most telling of all was that portrait of Gilbert. It had been hung on the wall facing the bed so that it would be the first thing Catherine saw when she thrust aside her bed curtains every morning. The portrait was not so large that she could not

have carried it away with her. Only one conclusion was possible—Catherine had left in a hurry, in too much of a rush to collect the thing she valued most.

Susanna stepped closer to the painting. She had seen it many times when Catherine lived with her at Leigh Abbey. It was not a particularly good likeness, though it did capture the red-brown of Gilbert's neat, close-cropped hair and the blue of his eyes. He had been the image of the perfect courtier—tall, broad-shouldered, elegant in his manner—and this was all Catherine had left to remember him by, save for their children.

"Lady Russell's son never seemed anxious to take up his duties as Lord Glenelg," Susanna said. Gilbert had preferred to live in London, where he'd been born. He'd never expected to inherit the Scots title and had been raised an Englishman.

"And a great pity that was, too," Una said. If she'd had any qualms about speaking her mind, they'd been overcome. "He was the only child to survive," she added, "and his parents always let him go his own way."

Susanna opened the coffer that contained Catherine's jewelry. Again, nothing seemed to be missing. "Was Lady Russell a good mistress?" Susanna asked.

"She was to me." Una swiped at the first hint of moisture leaking from her eyes and managed to stem the tide. "She said she'd provided for me. In her will. That I could live wherever I chose when she was gone."

For a moment Susanna considered the maid as a potential murderer, then dismissed the notion. Of all those who had known Lady Russell, she seemed to be the only one who had genuinely liked the dead woman.

"It may be some time before legal matters are settled. Would you be willing to serve as my tiring maid in the interim? I will pay you whatever Lady Russell did."

A sly look came into the woman's face. "She valued me. Paid me twenty shillings per annum."

Susanna lifted one eyebrow, since ordinarily only a cook or a head gardener earned that much, but she nodded her assent. "Done."

Catherine's bedchamber adjoined a smaller room used as a nursery, but there were no more answers among Cordell's possessions than there had been in her mother's. Avise's belongings seemed to consist of a single change of clothing. Susanna examined a plain bodice with close-fitted sleeves that could be rolled up out of the way when the maid's work required it. Beneath, neatly folded, was a matching skirt. A rectangular piece of linen was next, meant to be wrapped around Avise's head to keep her hair clean. Finally there was an apron, oblong in shape with the waistband attached to the narrow end for only a short distance, so that the corners hung down at the sides. Una, Susanna realized, was wearing an almost identical ensemble.

She'd started to replace the garments in the box where she'd found them when she noticed that the inside seemed more shallow than the outside would indicate. It took only a moment to locate the mechanism that opened the false bottom. Susanna stared at the contents in consternation.

Avise, it seemed, had been given even less time than Catherine to escape the house. She had left behind her meager collection of valuables, including a small money pouch. Given what Susanna knew of the woman's history, she concluded that Avise would never willingly abandon the coins. With a sinking sensation in the pit of her stomach, Susanna put everything back as it had been.

Una awaited her in the outer room, where she'd busied herself by starting to unpack the bags and boxes Susanna had brought with her from Northamptonshire. Susanna realized she'd heard someone bring them in while she'd been inspecting the nursery. Toby, she supposed. Nick's man was both loyal and efficient.

"I know this will be difficult for you, Una," Susanna said, "but it is necessary that I hear from your own lips all that happened here on the day Lady Russell died."

The story the maid told was the same as Sir Lachlann's version, but she was able to provide a few more details.

"You say it was your mistress, Lady Russell, who sent you and Dugald away?" Susanna asked, wanting to be certain. If Catherine had given the order, it might seem proof she'd *planned* to kill Jean.

"Yes, madam."

"It does not appear that either Lady Glenelg or her maid took any clothing with them. Do you recall what Lady Glenelg was wearing that day?"

The question seemed to surprise Una, but she wrinkled her brow and applied herself to the task of recalling. "She'd left off mourning. Said her husband would not have wanted her to wear nothing but black."

That sounded like Catherine, Susanna thought. Independent of spirit. If she'd had time to pack a capcase, she'd doubtless have taken the breeches, hose, shirt, and jerkin Susanna had found, rather than skirts and petticoats.

"Brown velvet," Una decided after more thought. "The partlet and sleeves were made of lighter brown silk covered with trellis-work of narrow brown velvet, and the shoulder pieces and skirt were braided with grey, open over a black satin underskirt with black velvet bows and roses."

"Excellent, Una. Do you recall what kind of sleeves?"

"Demi-cannon."

"And the farthingale?"

"She'd wear nothing but French farthingales, madam. Said the Spanish farthingale made it too difficult to sit down. And her headdress was a simple net caul lined with silk."

Her tongue loosened, Una launched into a description of what Lady Russell had been wearing when she died, but Susanna had no interest in hearing about black velvet and gold chains or the style of the bodice.

"Lady Glenelg's servant, Avise—was she here when Lady Russell died?"

Una shook her head. "She took Mistress Cordell to hear the town waits. I'll wager she met a man there. She was the type."

Susanna's pulse quickened at this news. Catherine would have trusted her maidservant to help her escape. "Do you know this man's name?"

But Una had to admit that she did not. In fact, she did not know for certain there was a man at all. "Took her off the streets, did Lady Glenelg," Una muttered. "She was no better than she should be. That sort *always* has a man."

In fact, Susanna recalled, Avise *had* been a whore before Catherine rescued her from that life. But, if anything, her experiences had soured her on men. She'd always kept to herself at Leigh Abbey, avoiding both men and women whenever she could. Besides, she was no longer a young, wild girl, being well past her thirtieth year.

"How was Avise dressed when you last saw her?"

"Dark blue homespun with a bodice that laced up the back, worn over a linen smock gathered into neck- and wristbands."

"Was there anything distinctive about her clothing?" Susanna persisted. What the maid described was typical of the garb of servants.

"She wears square-toed shoes of thick black leather. Wasteful, I call it. Most maidservants have but one pair of hose and one of shoes and go barefoot to spare them for the Sabbath."

Susanna glanced at Una's well-shod feet but did not comment. "When Avise lived at Leigh Abbey," she said instead, "she liked to wear striped petticoats. Does she still?" It had been the woman's only touch of frivolity.

Una could neither confirm nor deny that detail, but she did recall the sort of cap Avise had been wearing—horseshoe-shaped at the back, with the front folding away from the face. That was no help at all. There was nothing unusual about the style, nothing to make Avise stand out in a crowd.

"Do you want to know what the other woman wore?" Una

asked. Without waiting for Susanna's reply, she rushed into a description of a cinnamon-brown silk banded at several angles with velvet of a deeper shade. "And there were wider bands of velvet crisscrossed with gold on her overskirt."

"This woman—what did she look like?"

"A very large woman, madam. Not so very old, I do not think, but there are silver streaks in her red hair. And she wore a heavy perfume. Musk."

"Annabel," Susanna whispered, and fumbled behind her for the chair. She sank into it, feeling as if she'd just been struck in the chest.

"Madam?"

"A name, Una—did you hear a name?"

"Oh, yes, madam. Lady Glenelg called her Mistress MacReynolds. She was here once before and they seemed to be great friends."

"Una, heed me well. You must remember the order of things. Was Mistress MacReynolds in the house when you and Dugald returned to find your mistress dead?"

Una nodded, eyes round as saucers as she began to follow Susanna's reasoning.

"And then Master Dunbar came?"

"Yes, madam."

"Did he speak to Mistress MacReynolds."

"No, madam. I do not think he knew she was here."

How like Annabel, Susanna thought.

"He spoke to Lady Glenelg, but he said she could tell him very little."

"Why is that, Una?"

"He said she told him that she could not remember. He said she had a great lump on her head, from where she'd fallen down the stairs."

"They both fell? Lady Glenelg *and* your mistress? You are certain of that?" It seemed to Susanna that this was the most

important piece of the puzzle and she wanted to be sure of her facts.

"That is what Lady Glenelg *said* happened, madam."

Pushing herself out of the chair, Susanna strode toward the door. "Come, Una. Show me where this occurred."

A few minutes later, she stood on the landing, a reluctant Una at her side. There was nothing left to see. The stairs and landing had been scrubbed clean. Only Una's nervousness testified to there having been a body.

"It *must* have been an accident," Susanna murmured.

Catherine had been fortunate to survive the fall down these stairs, and she had been in good physical condition. A frail, elderly woman would not have stood a chance. Bruises on her throat? Why she'd broken her neck, that was all. She'd broken a few bones, too, no doubt, and every part of her body that had struck stone on the way down must have blossomed with bruises.

"But the scratches, madam," Una protested when Susanna advanced this theory. "Lady Glenelg had scratches on her cheek. Fingernail scratches."

"Mark my words, Una, there will be an explanation for those marks. Tell me, when did Mistress MacReynolds leave here that day?"

Una's frown answered her before the woman spoke. She had no idea what had become of Annabel.

Once she'd dismissed Una, Susanna pondered what she had learned. One conclusion was obvious to her. The presence of Annabel MacReynolds, retired intelligence gatherer and sometime assassin, altered everything. Even more important, it gave Susanna a place to start looking for Catherine.

## ✦7✦

*September 16, 1577*
*Leigh Abbey, Kent, England*

AS LADY APPLETON'S horsemaster, Fulke Rowley had his own cottage near the stable. Officially he shared it only with his son, Jamie. In practice, the place was always full to bursting with females. From maidservants to schoolgirls, they all seemed drawn to the motherless five-year-old.

There were some who said Fulke himself was the attraction, but he discounted this as foolish talk. He'd had too hard a time winning the affections of his late wife, Hester, to believe such nonsense, and even she had complained that he was more at ease with the horses than he was with her. He was big and clumsy, except around sick animals. His skin was perpetually rough and reddened, in consequence of working in the stable and out of doors, and he'd once been told by a lady of his acquaintance that his face put her in mind of a mournful hound—long and plain and jowly.

Approaching the cottage, Fulke paused on the doorstep. Woodbine twined around the sill, its sweet-smelling flowers and small red berries nearly gone. Hester had planted the climbing shrub and he'd kept it in her memory, but to himself he could admit that he missed Hester less than he'd supposed he would when she'd died giving birth to Jamie. The little lad was the center of his world now. And since Jamie reveled in the fussing of the distaff side of the household at Leigh Abbey, then Fulke, though he had always been more fond of solitude than company, was prepared to endure the chatter of whatever visitors had descended upon them today. He pushed open the door and went in.

He was not surprised to find Mistress Rosamond Appleton sitting tailor-fashion on the floor, plum-colored skirt tucked beneath her as she helped Jamie build towers of wooden blocks. She did not stand on her fourteen-year-old dignity with him.

She'd be fifteen in December, he realized, finding it difficult to believe so many years had passed. Once, long ago, he'd been man-servant to Rosamond's father, traveling with Sir Robert to such far-off places as Scotland and Spain.

Mistress Rosamond had the look of her sire, from the gently waving dark brown hair and brown eyes, set in a narrow face with a high forehead, to the charming smile. Just now, however, as she did more and more of late, Rosamond put Fulke in mind of her aunt, Catherine, Lady Glenelg, who also shared those character-istic features.

Lady Glenelg had been plain Catherine Denholm when she'd first come to Leigh Abbey. At Rosamond's age, Catherine had been—and still was—devoted to horses. She'd spent hours in their company and perforce with Fulke, who had at that time been one of Leigh Abbey's two grooms. He was only a year Catherine's senior and she'd treated him as an equal and a friend rather than as a servant. Fulke felt his lips twist into a wry smile when he realized he'd spent more time these last few months missing Catherine than he had thinking about his late wife.

Catching sight of his father, Jamie flung himself into Fulke's arms and planted a smacking kiss on his cheek.

"Have you eluded your tutors again, Mistress Rosamond?" Fulke asked, setting the boy on his feet and then joining him to kneel on the floor. Rosamond had shoved rushes out of the way to clear a bare, level area on which to construct what Jamie now in-formed him was a castle.

"They were glad to see me go," Rosamond said, beginning work on the curtain wall. "I have no talent for lute playing and no desire to develop one. I do not know why Mama thinks I should learn such a useless skill. I am very rich. If I want to hear music, I will hire musicians."

"Mama" was Lady Appleton, widow of Rosamond's father. The girl had been born to another woman on the wrong side of the blanket, but Susanna Appleton was not the sort to punish a

child for the sins of the father. She'd provided for Rosamond and her mother for the first few years of Rosamond's life, sending them to live at Appleton Manor in Lancashire. Then she'd brought Rosamond to Leigh Abbey to be fostered. It was no secret that Rosamond much preferred life with "Mama" to spending time with "Mother"—Eleanor, Lady Pendennis, the woman who'd given birth to her.

"Just as well, mayhap," Fulke said, a teasing note in his tone. "If you are not obliged to waste hours strumming your lute, you will have more time to perfect the other skills every gentlewoman is expected to possess. Embroidery comes to mind."

"Mama does not do embroidery." Rosamond sounded sulky. "She cannot even sew a straight seam. I do not see why I should have to learn such a—"

"—useless skill?" Fulke finished for her. "Be truthful, Mistress Rosamond. If you cannot at once excel at some task, you refuse even to attempt it again. You are afraid of making a poor showing."

"I am afraid of nothing," she sputtered, much offended. "I dislike wasting my time. That is all. I have better things to do than sit and stitch."

Sprawled on the floor beside his son, Fulke grinned at the girl. "What things?"

"Look after Jamie," Rosamond said. "And exercise Courtier."

"A nursemaid could do the first and a groom the second."

Courtier was Rosamond's horse and she was as devoted to the animal's care and feeding as Catherine had been to looking after Vanguard, the great black courser she had inherited from Sir Robert. Vanguard was gone now, after a long and eventful life, but no more forgotten in Leigh Abbey's stables than his mistress.

Fulke jerked his thoughts back to the present. If he hoped to cajole Mistress Rosamond into returning to her lessons, he could not be distracted by...horses. "I believe women learn embroidery, at least in part, so that they have an excuse to gather together while they labor and engage in conversation."

"Gossip, you mean. I have no interest in who is going to have a baby or what maidservant is trying to——" She broke off suddenly and color rose into her cheeks.

Fulke sighed and handed Jamie the last of the blocks to add to the top of the tallest tower. "Not you, as well, Mistress Rosamond? Bad enough that Jennet thinks all the maids are trying to lure me into matrimony."

The idea that she and Jennet Jaffrey, Leigh Abbey's housekeeper and the bane of Rosamond's existence, should have any opinion in common, seemed to strike Rosamond dumb.

Into the silence came the sound of hoofbeats. Rosamond sprang to her feet and rushed to the door, flinging it open wide. Amused, Fulke stayed where he was, watching Jamie knock down all the walls they had just built.

"Do you expect company, lass? Or a letter?" Rosamond corresponded regularly with Jennet's son Rob, who resided five miles away at the King's School in Canterbury. Jennet did not approve of their friendship. She thought Rosamond was a bad influence on the lad.

Rosamond craned her neck to see into the stableyard. "It is a post rider."

Fulke was not given to premonitions, but at Rosamond's announcement a chill ran through him. He stood, lifting Jamie to his feet at the same time. "Let us see what he has brought."

Rosamond looked surprised by his suggestion, but was too curious to argue. "One of the grooms will take it straight to Master Jaffrey."

"Then let us go to the steward's office." Fulke swung Jamie onto his shoulders and led the way.

The door stood open. Mark Jaffrey, Jennet's husband and steward of Leigh Abbey, responsible for keeping the estate running smoothly whether Lady Appleton was in residence or not, did not like to be cut off from the activity of the manor house. When Fulke rapped, he looked up from the letter he had just opened.

"News?" Fulke inquired, stepping inside.

"Lady Appleton is on her way to Scotland." Mark glanced at the date and corrected himself. "Likely she is already there."

Catherine is in trouble, Fulke thought.

As Mark read the rest of the letter, his expression grew ever more somber. He paused once to finger a second missive lying on the writing table.

"Well?" Fulke prompted. At his side, Rosamond was as skittish as any filly. That the letter contained bad news must be as obvious to her as it was to Fulke.

"There has been a death. Lady Glenelg's mother-in-law. And Lady Glenelg is…missing. Lady Appleton wrote this when she was about to leave for Edinburgh to sort things out."

Jamie's squeal of protest made Fulke realize he was holding the boy too tightly. He handed his son to Rosamond and braced both hands on Mark's writing table. "A death?" he asked. "Or a murder?" To his sorrow, he knew how often Lady Appleton seemed to attract the latter.

"She does not say. Mayhap when she wrote this she did not know. But another letter arrived just now, along with Lady Appleton's. This one has your name on it."

Fulke accepted the thrice-folded parchment sealed with plain red wax. *Fulke Rowley, Leigh Abbey, Kent* was written on the outside in Catherine's flowing script. Fulke's hand shook as he broke the seal and he read the message with a growing sense of alarm. "She's sent her daughter away!" He thrust the page at Mark.

Too impatient to wait her turn, Rosamond set Jamie down and seized the letter before the steward could peruse it. Her eyes widened as she read. "She says she sent Avise here, with Cordell. She writes as if she thinks they'll already have arrived."

Mark twitched the paper out of Rosamond's fingers and read it for himself. "There is no date, but if someone sent word to Lady Appleton and she wrote this—" he tapped the first letter "—when she was about to leave Candlethorpe, then it

must have been at least a week earlier that Lady Glenelg disap-
peared."

"And Catherine's letter seems to imply she sent Avise and
Mistress Cordell south at once," Fulke finished for him. He
exchanged a worried look with Mark. Travel was dangerous even
with an armed escort. A woman and a child alone, perhaps
attempting to elude pursuit, did not bear thinking about.

"Is there nothing we can do?" Rosamond asked. "Can we send
out search parties?"

"Avise is a...resourceful woman," Fulke said, choosing his
words carefully. "Mayhap the delay means no more than that she
has been cautious."

"And perhaps we are too quick to assume there was murder
done or that Lady Glenelg is in hiding," Mark said.

Fulke just looked at him. Every instinct he possessed urged
him to take action. Catherine had written to him because she
trusted him to protect her child. "There is no point in delay," he
said, "I will set out at once along the most likely route she would
have followed from Scotland."

"I will come, too," Rosamond declared.

"You most certainly will not," said a voice from behind them.
In the open doorway stood Jennet Jaffrey, hands on wide hips. She
directed a ferocious glower at her young charge. That she'd over-
heard everything was abundantly clear.

"Neither will you," said Jennet's husband. He held up one
hand to stop her protest. "Do you think I cannot tell what you are
thinking? You believe Lady Appleton needs you and want to rush
to her side, but she is not alone in Scotland. For once, let her
manage without your help."

Fulke paid little attention as husband and wife debated the is-
sue. He knew who would win. Jennet had been in ill health for
some time. And she had responsibilities here. She oversaw the
school Lady Appleton had set up for Rosamond two years earlier.
The other pupils were Jennet and Mark's daughters, Kate and

Susan, and Rosamond's friends, Diony and Lina. Rosamond alone was a handful. Aided and abetted by those four, containing her required all Jennet's energy.

Rosamond slipped her hand into Fulke's. "Catherine would not send Cordell away unless the need were pressing," she whispered.

"That is why I must make an attempt to find them. And I must go alone, that I may travel quickly and sleep rough."

"What if Cordell arrives after you leave?" Jennet demanded, breaking off her debate with Mark.

"Then you will care for her until I return, just as you will care for Jamie in my absence."

Jamie, who had been clinging to Rosamond's skirt, gazed up at his father with reproachful eyes. He did not speak. He rarely did.

Fulke knelt beside the boy and placed both hands on Jamie's thin shoulders. "You must be a good lad while I am gone, Jamie. I will come back as soon as I am able."

"Promise him gifts," Rosamond suggested.

"I hope to bring Cordell," Fulke said.

As Fulke released Jamie and stood, the boy switched his hold to Jennet's skirts. "Do you mean to go all the way to Edinburgh?" she asked, laying one hand on the lad's tousled locks.

"If I must. And it is possible I can be of some help to Catherine if I go to Scotland. I have been there before, with Sir Robert." He knew a bit about the darker side of the city.

"Godspeed, then," Jennet said.

With a nod, Fulke left the steward's office and headed toward the stables. There was light enough left to make a start on the journey. He could reach Canterbury before nightfall, perhaps even Faversham.

The piping voice of his son followed him into the kitchen yard. "Bring Cordell," Jamie called. "Bring Cordell's mama, too."

## ❧ 8 ❧

*September 16, 1577*
*a house in the Netherbow, Edinburgh, Scotland*

"COME AWAY from the window, Catherine." Annabel did not bother to hide her exasperation. Her old friend seemed determined to bring trouble down upon them. "Do you *want* to be caught?"

With obvious reluctance, Catherine stepped back a pace. She no longer limped. In the twenty days she had been in hiding, she'd had time to recover from all the injuries incurred in her fall down the stairs. She had assured Annabel that her hip had stopped hurting, that her right elbow functioned again, that a multitude of bruises had faded, and that the bump on her head had subsided. Even the scratches on her face had healed and faded. The only thing not back to normal was her memory. Catherine still could not recall a single detail of what had happened between the time Una and Dugald had left Glenelg House and the moment she awoke on the landing, lying next to her dead mother-in-law.

"Any sensible fugitive would have fled the country by now," Catherine murmured. "I doubt anyone is looking for me in Edinburgh."

Annabel's lodgings were on an upper floor of a tall house just inside the Netherbow Port, the city gate that led directly into the Burgh of the Canongate. They were less than a quarter of a mile from Glenelg House.

"Why take chances?" Annabel replaced Catherine at the window. It looked out along the High Street and she had a clear view as far as the Mercat Cross, the High Kirk of St. Giles, and Edinburgh's Tolbooth.

"They are all intent upon their own business," Catherine said, prompting Annabel to peer down at the steady flow of traffic below the window, where pedestrians jostled for space with

horsemen and carts. Although the street was wide, it was also crowded.

The High Street gave visitors the impression that Edinburgh was flat and spacious, but in truth the land dropped sharply downhill on either side, dissolving into dozens of narrow wynds and closes where two people could scarce walk abreast without rubbing shoulders. Buildings were crowded together, their balconies, booths, and forestairs further reducing the width of the passages.

"I am weary of confinement," Catherine complained.

"But it is such a pretty prison." Annabel ran one hand over the broad oak boards with which the walls were paneled. Adjacent to the Hall, the chamber had been built on timber jetties projecting out over the street.

"You have been most generous to let me stay with you, Annabel, but I have spent nearly three weeks indoors and done naught but talk of ways to rescue my son. It is time to act."

"What profit in leaving here only to end locked up in Canongate Tolbooth?"

"Surely enough time has passed to risk coming out of hiding."

"You must not go out until I am certain it is safe. No one seems to be searching for you, but that does not mean you can travel with impunity." Catherine could ruin everything with one impetuous action.

Annabel herself made daily forays into the world outside her lodgings. When she'd visited the shops to procure food, she had also gathered information. She had heard no mention of Lady Russell's death being murder, or of Catherine being outlawed. Annabel found this most encouraging but had not shared the information with Catherine. Why raise false hopes before she knew the truth of the situation?

Besides, fugitive or not, there remained Catherine's determination to attempt the kidnapping of her own son. Young Glenelg was at court, living so close to the king that it would be well nigh

impossible to reach him without attracting the attention of the royal guards. Annabel felt a tingle of anticipation just thinking of it. The challenge of doing exactly that appealed to her. Life in retirement had become increasingly boring. Devising a variety of plots while hiding Catherine had served to enliven an otherwise dull existence.

Two years earlier, when Annabel first returned to Scotland after more than a decade abroad, she'd have laughed if someone had tried to tell her that she'd miss the intrigue and danger of life as an intelligence gatherer. Now the old juices were stirring again. Could she rescue Gavin and spirit him out of the country with his mother, and avoid being forced into exile herself? The very thought that she could filled her with exuberant good humor. Outwardly, her countenance gave no indication of these jubilant feelings, but inside she was dancing a cinquepace.

"Think of the danger to you if I remain here much longer," Catherine wheedled. "Surely your neighbors will become suspicious that I am never seen abroad."

Annabel snorted. "If they happened to notice your arrival, they no doubt thought you were a friend come home to sup with me. If any saw a strange face at a window, they likely assumed I had at last acquired a servant."

In truth, she did not think her neighbors paid any attention to her goings and comings. She never saw the occupants of the laigh floor, which had three cellar apartments. The ground floor was taken up, for the most part, by a Hall and two chambers leased to a bonnet maker. He also had the forebooth on the south side and the pentice below the outside stairs. A tailor occupied the main merchant's booth on that level and the Hall and two chambers on the first floor just above. The stane shop on the west side of the ground floor was in possession of a cobbler. Just below Annabel's lodgings was the principal dwelling space, again a Hall and two chambers, which currently stood empty while Lady Dalrymple visited her daughter in Perth.

"I'd never be mistaken for a tiring maid in these clothes," Catherine reminded her, running one hand over the soft velvet of her skirt.

"I can remedy that."

"Well, then, if I am to don a disguise, why not leave here and travel to Stirling Castle?"

"Worry about yourself first, Catherine. Your son is not in mortal danger."

"How can you be certain of that? If what Lady Mar told you is true—"

"Lady Mar's presence at Stirling Castle is among the things that argue in favor of caution."

At Catherine's request, Annabel had approached the widowed countess of Mar, who had charge of the royal household at Stirling. The countess had been at Queen Mary's court years ago, when Annabel was one of that unfortunate queen's lesser ladies in waiting. Lady Mar had remembered Annabel, and she'd recalled Catherine, too, since Catherine had frequently visited Holyrood Palace in company with her husband. It had been curiosity, Annabel thought, that had led Lady Mar to answer Annabel's questions—that and a "gift" of jewelry to loosen her tongue.

For a time, Annabel and Catherine stood silent, side by side, regarding the ever-changing street scene below the window. Then Catherine heaved a heavy sigh. "Do you think Avise will have reached Leigh Abbey by now?"

"No doubt she has." And that, Annabel thought, was an outright lie. Unless Avise had been wise in her selection of outriders, she was just as likely to have been robbed and left to fend for herself and the child in some remote part of northern England. If she and the girl had not been murdered for their few possessions. Still, there was no sense in reminding Catherine of the dangers of travel. She had enough to worry about.

Annabel studied her companion with objective eyes. Catherine had not been sleeping well. She had lost weight. She was

nervous and irritable. Annabel thought it likely Catherine had killed Jean Ferguson. That she could not remember doing so only increased the probability that she had.

"It cannot be," Catherine murmured.

For a moment, Annabel thought the other woman had read her thoughts. Then she saw that Catherine had her nose pressed to the window.

"What is it?"

"That man? Do you see? In the Bristol red doublet and the hat with the high crown that bulges at the top? Is that not Nick Baldwin?"

Annabel did not recognize the name, but she had no difficulty picking out the individual Catherine described. The doublet was very fine, slightly padded with small, goffered cuffs and ruffs, full sleeves, and braided shoulder rolls. His Venetians formed folds around his thighs, showing off well-shaped legs in netherstocks and ankle-high boots. Attached to his leathern belt was a pouch— heavy with coins by the look of it.

As they watched, he passed directly beneath the window, heading for the Netherbow Port and Canongate. He did not look up.

"Who is Nick Baldwin?" Annabel asked. English, by his name, but that meant little. These days there were many Englishmen in Edinburgh.

Catherine sank down onto the bench against the inner wall, clasping her hands in her lap. "Nick Baldwin is Susanna's... friend."

Annabel felt her eyes widen. "Lover, do you mean? I'd have thought marriage to Robert Appleton would have soured her on men."

"Only on marriage. They are neighbors in Kent. He asks her repeatedly to marry him but every time she refuses, though I think she loves him. A few years ago, the local clergyman made a fuss and they have been careful since never to *appear* to behave with impropriety."

"Has Baldwin a reason to be in Edinburgh?"

"He is a merchant. He could be here on business, but I do not think so."

"There has scarce been time for Avise and Cordell to reach Kent, let alone for anyone to return. You cannot believe he is here to search for you?"

If ever a woman looked guilty, Catherine did. Annabel loomed over her, glaring.

"What have you done?"

"I sent a letter to Leigh Abbey."

"When?"

"It was early in my stay here, one day when you were out. I gave a penny to a street urchin to take it to the carrier."

"Did you tell Lady Appleton where you were lodged?"

Catherine would not meet Annabel's eyes. "I did not write to Susanna. I sent word to another...friend."

Her careful intonation had Annabel lifting a brow in speculation. "Are your friend and Susanna's likely to have come here together to look for you?"

Catherine sighed, head still bowed. "Not just the two of them, no."

Annabel had no trouble following Catherine's logic and had to stifle a groan at the obvious conclusion: Susanna Appleton was in Scotland.

## 9

*September 16, 1577*
*Glenelg House, Burgh of the Canongate, Scotland*

"WHAT NEWS, NICK?" Susanna rose from the bench in front of the hearth in a small room off the Hall. She appeared to have been contemplating the design on the tiles, since there was no fire. A cup brimming with liquid sat on the small table beside her.

"No news. No one I talked to knows what has become of Lady Glenelg. Nor is the death of Lady Russell widely known, not in Edinburgh at any rate." There had been no hue and cry raised there for her killer.

"Did you visit the English ambassador?" She crossed the comfortably furnished room to fetch a pitcher and pour out a second cup. Her steps made little sound on the rush mats that covered the floor.

"There is none at present," Nick said, accepting the drink. Walking into Edinburgh and back had worked up a thirst. "Englishmen in Scotland needs must deal with a secretary."

"When will a new ambassador arrive?" Susanna resumed her seat, while Nick moved to stand by the curtained window that overlooked the tiny stableyard at the back of the house. Imported hangings decorated the walls and the furniture was solid oak, elaborately carved. For Scotland, this was very grand.

"Not until January at the earliest." Nick took a sip of his drink and grimaced—not ale, but barley water. He left the window to drop onto the bench beside Susanna. "Have you learned anything new in my absence?" He had more to tell her, but was curious what the servants had said.

"Una, Lady Russell's maidservant, confirmed the bruises on her mistress's neck, and the scratches on Catherine's face, too. Una clearly believes Catherine killed her, and given the evidence, I can understand her conviction."

"Never tell me you believe Catherine guilty?"

"Anyone can kill, given provocation enough."

Nick went rigid, even though he was certain Susanna had not meant the comment to remind him of just how well he knew that fact. Fortunately, she did not notice his reaction. She was toying with her cup, running one finger around the rim.

"Lady Russell was a most provoking woman. Catherine *could* have been responsible for her mother-in-law's death. But I do not *want* to believe it, and I think it more likely that if Catherine *did* kill her, it was either an accident or in self-defense. The latter explanation would account for the scratches on Catherine's cheek. Lady Russell must have attacked her. And if Catherine later struck her head and was confused, what more likely than that she'd flee in panic, fearing arrest?"

The eager look in Susanna's eyes as she sought Nick's agreement with her theory tore at his heart. He hated to dash her hopes, but he would not lie to her. "It has been almost three weeks, Susanna. Her panic has had time to fade. If she is innocent, why hasn't she sent word to someone?"

"I believe a third party has convinced her to stay in hiding." She placed one hand on his sleeve. "Annabel MacReynolds was here that day."

For a moment Nick could not think who she meant. He had never met anyone by that name. Then the memory snapped into place. "The spy?"

Susanna nodded.

Annabel MacReynolds had been more than an intelligence gatherer, Nick recalled. She'd also been one of the late Sir Robert Appleton's mistresses. Nick felt his features harden into a scowl and hid his face in his goblet.

Would he never be free of the fellow? Appleton had been dead for twelve years! Nick could not fault Susanna for loving Rosamond, her husband's bastard, as if the girl were her own daughter. Susanna had never conceived a child. But he could and

did resent that so many other people who had known Appleton seemed determined to intrude into Susanna's life.

Moreover, these ghosts from the past always seemed to want something. To her credit, Susanna strove to right wrongs her late husband had done, but every reminder of what her marriage had been like strengthened her resolve never to wed again.

"I parted with Annabel on good terms," Susanna mused, "and she swore she wanted nothing more than to return to her native land and live quietly, but she has lied to me before. And, unlike Catherine, she is capable of murder."

"You believe *she* killed Catherine's mother-in-law?" Nick did not want Catherine to be guilty, but Susanna grasped at straws to suspect Annabel MacReynolds of the crime. The woman had no reason to want Lady Russell dead.

Susanna took another sip of her barley water, looking pensive. "No, in truth I do not, but I should very much like to find her. Catherine went away with Annabel. I am certain of that much."

"Did someone see them leave together?"

"No, worse luck. With Una's help as translator, I spoke to all the servants. The cook and the scullion are both the sort determined to mind their own business and had naught to offer. Lady Russell's man Dugald is a big, quiet fellow who reminded me a bit of Fulke Rowley. Unlike Fulke, however, he pays little attention to what is happening around him. He noticed nothing out of the ordinary on the day his mistress died. He could not even recall seeing scratches on Catherine's face."

"Mayhap my man Toby can learn more. He makes friends easily. I will ask him to see if he can extract any further information from Dugald, and from the kitchen staff, too."

"He may meet with even greater success with the maid-servants."

Nick chuckled. "Are they comely? I cannot demand too great a sacrifice from him."

As he'd hoped, the comment was rewarded with a faint smile.

"There are two girls, Ailis and Marta, neither of them any great beauty, but they are young and full of life. They stayed to gossip with the washerwoman and did not arrive back at Glenelg House until after the bailie arrived. By then Catherine was gone."

"I should doubtless speak to the bailie. Did they know his name?"

"One Andrew Borthwick. But, Nick, what is a bailie? Constable? Coroner? Justice of the peace?"

Nick set his cup aside and leaned forward, resting his elbows on his knees and staring into the hearth. "All three in one, if I understand aright. This Scottish system of justice is not like ours. The ambassador's secretary did not seem well-versed in the subject, but he did say that most criminal prosecutions are brought by the near kin of the victim rather than in the king's name. If no private person makes an accusation of murder, the matter is likely to be dropped. That Catherine was charged with this crime, that she was called to appear at the Tolbooth as Dunbar said, and was outlawed when she failed to do so, all that could only have happened if someone related to Jean Ferguson accused Catherine of killing her. Jean's grandson is her closest living relative."

He looked up in time to see Susanna's face lose every trace of color. "Gavin?" she whispered. "He's a child. He's Catherine's son."

"But Sir Lachlann Dunbar is his guardian. It seems to me that he must have brought charges on young Gavin's behalf."

## ❧10❧

PROPERLY ATTENTIVE, with livery badges of the Glenelg bee and thistle worked in silk on their sleeves, Catherine's servants put the evening meal on the table. Then they sat down with Sir Lachlann, Nick, and Susanna to share the food. Already uncomfortable with the prospect of supping with the man she held responsible for Catherine's status as a fugitive, Susanna was further disconcerted by eating at one table with the entire household. Her own servants at Leigh Abbey were allowed considerable freedom and encouraged to better themselves, but these Scottish retainers struck her as uncommon independent. Clearly, though, their behavior was normal. Sir Lachlann took no notice of it.

The fare set before them was unadorned in the extreme. Along with a pottage was a bit of meat—ox flesh by the taste of it—a kale soup, tangle boiled with butter, and a bannock of barley meal. As Susanna remembered from her last visit to this country, Scottish ale was more potent than the English version. She sipped cautiously from one of the horn drinking vessels, which she had been told were called *cuaches*, before turning with careful courtesy to Sir Lachlann Dunbar, who sat on her right.

"I have uncovered a puzzle, Sir Lachlann," she said in labored French. "Mayhap you can help me solve it."

"I will do all I can to serve you, dear lady."

"The charges made against Lady Glenelg came from a private individual, or so I believe."

"That is correct."

"From you?" Convinced of the logic of this assumption, Susanna was surprised by his answer.

"No, Lady Appleton. I might have accused her, on Gavin's behalf, but in the time I have known her I have developed a deep and abiding affection for Lady Glenelg. Indeed, I was on the verge of declaring myself when this tragedy occurred."

"You meant to *court* her!" The words came out much too

loudly. Toby, seated at the far end of the table—he had overcome the language barrier sufficient to flirt with Marta—jumped. Nick, seated on Susanna's left, went ominously still.

"I do not know why you should be so surprised," Dunbar admonished her. "Catherine Glenelg is an attractive woman. Thirty-two years of age, it is true, but still capable of bearing children."

And wealthy in her own right, Susanna added silently. She took another sip of the ale to give herself time to think. She had always been protective of Catherine. She had not thought the late Gilbert Russell good enough for her either.

"I am a widower," Dunbar continued. "I have three daughters in need of a mother."

"In Stirling?"

"I have a house near Stirling Castle, but the family seat is a small island off the west coast of Scotland."

"Did Catherine know of your interest in her?"

Dunbar toyed with a particularly large piece of kale in his soup. "I never told her and now I fear I will never have the opportunity. To be safe, she should leave Scotland, if she has not already done so. If you can find her, I would advise you to spirit her out of the country with all speed."

"I would if I could, Sir Lachlann, but I do not know where she is."

"I've tried my best, but he will not listen to reason."

"Who will not?"

"Jean Ferguson's nephew, young Malcolm. He is the one who purchased the so-called 'criminal letter' calling Lady Glenelg to appear before the court. He's a hot-blooded young fool. He cannot get it through his thick head that it would be better for everyone, especially Catherine, if he dropped the criminal suit and pursued civil charges instead."

"I do not understand you, Sir Lachlann." Susanna gave up all pretense of eating.

Nick interrupted, in English. "Will you allow me?"

At Susanna's nod of assent, a rapid exchange followed. Her French was not good enough to follow it but she trusted Nick to provide her with all the details when he'd finished his interrogation.

Lady Russell's nephew? Who was he? Susanna realized she knew little of the Ferguson family here in Scotland. She vaguely recalled that there had been other heirs who had not been pleased when English-born Gilbert had succeeded to the title. For all she knew, there were dozens of cousins, all jealous of young Gavin's inheritance. But why prosecute his mother? Susanna could not imagine that Lady Russell, so long a resident of London, had close ties with her Scots kin.

"Well?" she demanded when Sir Lachlann resumed eating and Nick sat back in his chair.

"Lady Russell had a nephew staying with her at Glenelg House, one Malcolm Logan, a younger sister's son. When she died, he brought charges against Catherine. Criminal charges that will result in execution if she's caught and tried."

Susanna's hands clenched in her lap. She had to swallow twice before she could speak calmly. "Sir Lachlann mentioned civil charges."

"It seems that here in Scotland there are two different paths private prosecutions may take. There was no need to bring criminal charges at all. Master Logan could instead have sought what is called assythment. Compensation."

"Money."

"Aye. In that case, once Catherine paid him what he demanded, he'd have granted her a 'letter of slains.' In other words, he'd have promised no further prosecution. Then she'd be able to purchase a 'letter of remission' from the king—a pardon. This seems to be the preferred way of dealing with murders. Sometimes a prosecution in criminal court is begun solely to force the accused to agree to assythment."

"But not in this case?"

"No. Young Logan seems determined upon vengeance. Dunbar has argued with him but to no avail. On the other hand, the search for Catherine was never extended beyond the Burgh of the Canongate, not even into Edinburgh. I am not certain what that oversight means. I hope it indicates the possibility that we can reason with the fellow."

Susanna, pondering these revelations, fanned a flicker of hope into a flame. She was mentally composing more questions to ask Sir Lachlann when her ruminations were rudely interrupted by the sound of a door slamming. A moment later a very large, very inebriated young man staggered into the Hall. He was altogether a remarkable sight, for he wore his hair long, with no hat, and neither hose nor shoes. His attire consisted of a full, pleated linen shirt that hung to his knees with a short jacket on top and a long, rectangular piece of wool over both, fastened at his shoulder with a large brooch. The shirt was bright yellow, the jacket red, and the woolen garment striped with blue and purple.

He stopped short when he realized there were strangers at table, frowning at Susanna and Nick in confusion. Into the sudden silence, he let loose a loud belch.

"Lady Appleton," Sir Lachlann said, "allow me to present Malcolm Logan, Master of Glenelg."

# ❧11❧

*September 17, 1577*
*the shop of Alasdair Acheson, Edinburgh, Scotland*

"INGLIS MAY bear a strong resemblance to the speech of Northumberland," Susanna complained, "but I was born and raised in Kent. I can scarce understand one word in ten."

"Then it is as well you have me with you to translate," Nick told her.

In spite of her difficulty with the dialect, Susanna had picked up the rudiments of casual conversation. She knew *hout* was an exclamation used when one was impatient, that *och* expressed sorrow or longing, and that *atweel* had the same meaning as "certes."

Their plan in visiting Edinburgh's shops was to buy as well as to ask questions. In the normal way of things, Alasdair Acheson sold only to tailors and members of the nobility, but it would please him to show off his stock to an English gentlewoman and delight him if she purchased some of what he had to offer.

Susanna admired a collar made of lawn embroidered with silver. "Twenty-eight shillings each?" she inquired.

"A bargain," Nick informed her. "Remember that the English pound has four times the value of the Scots pound."

Acheson himself joined the discussion to point out that as much as an ell of material had been used in the construction of each collar. "An ell is less in Scotland, too," Nick said, *sotto voce*.

Acheson, a barrel-shaped individual with bright blue eyes and a merry smile, carried fine cloth and trimmings, as well as accessories of dress for men, women, and children. In addition to taffeta, satin, velvet in many colors, and Holland cloth, he stocked sackcloth, frieze, and serge for sturdy outergarments. He was also more than happy to exchange news with his old friend Nick. Both had engaged in successful overseas trade deals with Jean Builduik, a factor in France.

They talked of trade in the Low Countries as Susanna examined a belt that came complete with bag and whinger—a short sword. She abandoned this find for another belt of velvet edged with leather that had a bag and an inkhorn on its hangers. A gift for young Lord Glenelg, Nick supposed. At one of the shops they had already visited, she had purchased a stand of three coifs for

children in lawn and silk embroidery for thirty shillings, gifts for her goddaughters.

She went on to examine the wide selection of items Acheson carried, from papers of pins to psalm books. Acheson brought the conversation closer to home, complaining that it was less expensive to rent a house in Edinburgh than a booth-maill. The former could be had at four pounds per annum, but the latter ran upwards of six.

"I wonder if you know the whereabouts of an old acquaintance of Lady Appleton's?" Nick said, coming at last to the real point of this shopping expedition. "Mayhap she is even a customer. Annabel MacReynolds is her name."

Acheson did not know her, but he thought John Danielstone might have dealt with her.

"Do you know aught of a Malcolm Logan?" Nick asked next.

That young man had made but a brief appearance the previous evening. Already deep in his cups, he'd seized one of the *cuaches* of ale and downed it, taken his place at table to devour what was put before him, and bolted for his own chamber when Susanna attempted to question him. Only with difficulty had Nick persuaded her to allow Logan to sleep off his debauch. When they returned to Glenelg House this afternoon, she fully intended to confront him.

Acheson asked for a description of Logan and Nick duly provided it. Aside from his manner of dress, the young man's massive shoulders and bulging arm muscles made him stand out in a crowd. The size and strength of his upper body, and his head and hands for that matter, were in direct contrast to the appearance of his lower limbs. He was slightly bow-legged, as if he'd spent a great deal of time on horseback. Nick wondered now if Logan's rolling gait *had* been entirely attributable to the drink.

"Aye. A *pawky clootie*." Acheson's clenched jaw deterred Nick from asking why he thought Logan was a sly devil.

"Have you had dealings with him yourself?"

Acheson denied it but was quick to change the subject by giving Nick directions to the shop of John Danielstone.

Nick took the hint. As soon as Susanna had paid for her purchase, they set out on foot. Nothing was very far away from anything else in Edinburgh. Tall houses—some as high as seven stories—built of unpolished stone but faced with wooden galleries, were packed tightly together. Some said as many as 10,000 people lived within the 140 acres enclosed by the Flodden Wall.

John Danielstone's shop was in Fowler's Close, on the north side of the High Street. An entrance from the street gave access to the backhouse he leased from another merchant, one who was obviously in the midst of renovations to his property. Freshly inscribed on the lintel were the words BLISSET-BE-GOD-OF-AL-HIS-GIFTIS, and two men were hard at work installing a lead gutter to carry off water from the eaves. They gave Nick and Susanna curious looks but did not pause in their labor.

Danielstone, a tall, gaunt individual with a dour expression, was another of Nick's old acquaintances. He'd spent several years in England and spoke the language of the court with as fine an accent as any of Queen Elizabeth's subjects. He greeted Nick warmly, and bade Susanna enter and examine his stock. She busied herself with Florence ribbons, cases of bone combs, crystal mirrors, pen knives, and tooth picks, but Nick knew she was listening intently to every word Danielstone spoke.

"You're rebuilding, I see," Nick remarked, following the pattern he'd established of leading up to mentioning Annabel by degrees.

"Not I. My landlord. He claims he's already spent nearly a thousand merks on his properties, but money's not worth what it once was, not since the earl of Morton took over as regent."

"I had heard Morton was not popular with merchants."

"How could he be, after he reduced the value of the plack from fourpence to twopence and that of the hardhead from one and a half pence to a penny?"

A hardhead, Nick recalled was a French coin made of copper. They were also called lions.

"There has been a flood of counterfeit money ever since."

"Still, Scotland seems peaceful these days. Most men obey the laws."

"Such as they are." Danielstone snorted. "The regent has ordered a review of municipal laws. Morton is very keen on enforcing laws and in their codification."

"Has he reason to be?" Nick asked.

"He has reason to fear what will happen if he does not maintain the law." Danielstone lowered his voice. "There was a plot earlier this year to kill him with a harquebus as he went down the street toward his apartment at Holyrood Palace. A treasonable conspiracy to slaughter my Lord Regent's Grace."

Regents did not fare well in Scotland, Nick thought. The earls of Moray and Lennox had been assassinated. The earl of Mar had died after only a short time in office. Now James Douglas, fourth earl of Morton, had acquired both the privileges and burdens of the post.

"The conspirators were arrested and confessed under torture. The doom of forfeiture was pronounced against the leaders."

"You do not execute traitors in Scotland?" Susanna asked.

"Loss of all property is a worse fate."

Nick and Susanna exchanged a look, and she entered into the questioning. "I wonder, good sir, if you have had dealings with one Annabel MacReynolds."

"A wealthy woman," Danielstone recalled. "Most respectable. And she paid cash."

"No hint of scandal about her?" Nick inquired.

"Not in the least."

"Do you know where she lodges?"

But there Susanna and Nick were doomed to disappointment. The best Danielstone could provide was the name of another merchant Annabel had dealt with.

By the end of the day, they had talked to several more people who'd sold goods to Mistress MacReynolds but were no closer to locating her. Nick felt Susanna's discouragement more deeply than his own.

"We will find her," he promised as they approached Nether-bow Port en route to Glenelg House.

The way narrowed, then opened out again. Several newly built houses lined the street, replacements for those pulled down to improve town defenses during the siege of Edinburgh that had ended only four years earlier. Edinburgh Castle was still being repaired.

"We will visit more shops on the morrow," Nick added when Susanna made no reply.

A few more minutes of walking brought them back to Glenelg House, but when Susanna inquired after Malcolm Logan's where-abouts, she was told he had gone out. She went straight to the chamber he had occupied, to assure herself that he'd not taken his belongings with him.

"Why would he leave?" Nick asked, following her into the room.

"Mayhap because he killed his aunt and he fears we will dis-cover it."

"What reason would he have?"

"Perhaps he is her heir. We must discover the full contents of Lady Russell's will."

Wrinkling her nose, Susanna threw open the window, for the place was badly in need of airing. The late afternoon sun revealed a space littered with discarded clothing and abandoned scraps of food. Conspicuous by their absence were any books or papers.

"He will be back," Nick predicted. "You can talk to him then."

"If he is not too far gone into drink to make sense."

"We've time. In truth, it may be better to wait. If he's the stubborn sort, he may refuse out of habit. Better to bring him

gradually around to the idea of asking for money rather than execution."

Kicking an abandoned boot out of her way, Susanna began to pace in the confines of the cluttered chamber. "There would be no *need* to convince him if we could prove someone else killed Lady Russell. If he did it himself he might seek to put the blame on Catherine."

"He could not know she'd lose her memory and run off."

Exasperated, she stopped, hands on hips, to glare at him. "Must you always be so sensible?"

He did not bother to answer. She had a logical mind herself and knew he was right.

Catching sight of the discarded boot's mate beneath the bed, Susanna frowned. As Nick had, she'd learned a bit about Highland dress since the previous night. The Highlanders were sometimes called "redshanks" because they went about bare-legged, but it appeared Malcolm Logan did not always follow that tradition. Did he also own more civilized clothing than the yellow *léine,* the red *ionar,* and what Sir Lachlann had called a *breacán brat*—that striped piece of rectangular cloth Logan had worn like a cloak?

Dismissing any qualms she might ordinarily have about invading another's privacy, Susanna opened the nearest storage chest. Inside she found doublet and hose, a good cloak, and a pair of shoes. "I wonder why he does not wear these when he is in the lowlands?"

"Pride in his heritage," Nick suggested.

"It can scarce have been a ploy to win favor with Lady Russell. She despised everything about Dunfallandy."

Nick crossed to her side to finger the material of the doublet. "This is well made but much worn. If Lady Russell refused to provide him with money to buy new clothes, Logan may have worn the saffron shirt to spite her."

"In that case, he may have accused Catherine of murder solely as a means of getting the authorities to help him locate her. After

all, he cannot expect restitution for Lady Russell's death so long
as Catherine remains in hiding." Susanna seemed to find this logic
reassuring. It did not answer the question of who had really killed
Lady Russell, but it offered the possibility that Logan could be
talked into dropping the criminal case against Catherine.

## ﷽12﷽

*September 18, 1577*
*a house in the Netherbow, Edinburgh, Scotland*

CATHERINE WAS watching from the padded bench by the
open casement, letting the sounds and smells of Edinburgh wash
over her, when Annabel appeared in the street below. She was in
disguise, but Catherine had seen her before she went out. She rec-
ognized Annabel's cloak of three colors of checkerwork, vulgarly
called ploddan, and the ponderous gait the other woman assumed
in her role as a humble servant.

Suddenly as nervous as a hen spotting a boy with an ax,
Catherine smoothed out her skirt, then seized a cushion, clutch-
ing it in front of her like a shield. "What news?" she demanded as
soon as Annabel entered the room.

"Someone has been asking questions about me!" Annabel
sounded furious but there was also an air of suppressed excite-
ment about her as she stalked across the Turkey carpet toward
Catherine. It was spread on the floor—a great extravagance.
Most people used them only to decorate the tops of tables.

The embroidery on the cushion pressed into Catherine's
palms as she tightened her grip. "Susanna knows, then. Someone
has told her that you came to Glenelg House on the day Gilbert's
mother died."

Catherine did not know whether to laugh or cry. She had not

wanted anyone else to become involved in her problems, especially since she meant to commit a crime. *Another* crime, she reminded herself, since it seemed likely she had been the one who'd strangled her mother-in-law. That she could not remember did not mean it had not happened.

"I purchased almost everything I own since my return to Scotland and had some of those items delivered here. Eventually, Susanna will stumble upon a merchant who can tell her where to find me." Annabel gave Catherine a hard look. "Do you wish to avoid Susanna Appleton or ask her help?"

"I neither wanted nor expected anyone to come to Scotland from England. She will be better off if I can keep her out of this coil."

"You wish to protect her, then?"

Catherine nodded. "I only wrote to Fulke because I wanted him to look after Cordell for me."

Annabel gave her a speculative look. "Fulke? The same Fulke who was with Sir Robert Appleton in Scotland years ago? *He* is your lover?"

Catherine felt her face flame. "I've had but one lover and that was my husband. I will never love anyone as I did Gilbert." She did not think she could make Annabel understand the special bond she shared with Fulke Rowley. She was not certain she understood it herself.

Annabel shook her head and lifted her eyes to the tempera-painted beamed ceiling with its decorations of flowers, animals, and grotesque figures. Catherine supposed she was asking Heaven for patience. She was surprised when Annabel waxed philosophical.

"I remember how you were with Gilbert Russell. Your love for him was the wild passion of youth. It is possible, so I am told, to enjoy a quieter and gentler sort of love when one is older." Annabel frowned. "In its own way, that could be just as exciting, and might even prove more satisfying."

Catherine did not dare let herself think of love. If all went as she hoped, she would never see any of her friends again—not Annabel, not Susanna, and most certainly not Fulke Rowley.

"Fulke is my friend," she said in a firm voice. "I chose to write to him because I remembered, after sending Avise on her way, that Susanna would still be at Candlethorpe, Nick Baldwin's home in Northamptonshire."

"I'd have thought you'd write to Jennet Jaffrey, if you meant to deal with servants. A woman—"

"Fulke has a young son, Jamie. Cordell is most fond of the boy. I thought—" What *had* she been thinking? Annabel had the right of it. The sensible thing would have been to ask Jennet to care for Cordell, but that solution had never crossed Catherine's mind. After Susanna, she had considered only Fulke.

To Catherine's relief, Annabel dropped the subject. "If you do not want Susanna to find us here, then we'd best leave today. The time has come to set in motion your plan to rescue Gavin."

*       *       *

CATHERINE and Annabel left the house in the Netherbow a few hours later, both of them wearing clothing selected by Annabel to make the casual observer assume they were servants. Catherine hesitated as she was about to step into the street.

"Are you certain no one is searching for me?"

"Only in Canongate, as far as I could determine, and not even there after all this time. If you do not call attention to yourself, all will be well. Come along. There is no time to waste."

Annabel set a brisk pace, leading Catherine by a circuitous route through Edinburgh's narrow streets. Both women carried large bundles. Catherine could only hope that did not look suspicious, since there was no help for it. Annabel planned to change their appearance at least once more before they reached Stirling.

They had almost reached the stable where Annabel intended to hire horses when Catherine recognized the familiar figure of

Malcolm Logan. He was walking toward them, his arm slung around the shoulders of a pretty young woman. All his attention seemed to be on his companion, but Catherine dared not count on luck to keep him from looking up and catching sight of her. She grasped Annabel by the sleeve and tugged her into the nearest shop.

Annabel obeyed the silent plea and went still, standing just inside the door and shielding Catherine from view with her own body.

"Malcolm Logan," Catherine whispered.

Then she could do nothing but wait, praying Gavin's kinsman had not seen her. If she had been outlawed by the authorities in Canongate, then it was certain he knew of it. He'd been with Sir Lachlann when he'd returned to Glenelg House with the bailie. She had no doubt that Logan would call for her arrest if he'd recognized her. He must surely believe, as everyone at Glenelg House likely did, that she had killed his aunt.

A merchant's voice, speaking in Inglis, startled Catherine. She spun around, suddenly terrified that she had blundered into even worse trouble. Anyone could have been in this shop. She had not taken the time to look.

The genial smile on the shopkeeper's face reassured her and a quick glance at his wares told her he was a bonnetmaker. He only wanted to know if he could be of assistance. Catherine was searching her jumbled thoughts for a reply when Annabel saved her the trouble.

Speaking too quickly for Catherine to translate, Annabel made some excuse to the shopkeeper and steered Catherine back out into the street. Malcolm Logan was nowhere in sight, but Annabel was muttering curses under her breath.

"What is it? What is wrong? Did Malcolm see me?"

"He took no notice of either of us, but I fear that bonnet-maker may have recognized me in spite of my disguise. I was in his shop only a few weeks ago. If he thinks long enough, he may

even remember my name. Christ aid! We are leaving this city not a moment too soon."

Trailing along in Annabel's wake, Catherine kept a wary eye out for other familiar faces, but they reached their immediate destination without further incident. By the time they had hired horses for their journey, Annabel's irritation had vanished. Once again she had that devil-may-care look in her eyes, as if she relished charging headlong into danger.

## 13

*September 19, 1577*
*a house in the Netherbow, Edinburgh, Scotland*

AFTER THREE days of searching, Susanna and Nick had located a merchant who'd delivered a tapestry with a pastoral scene to Annabel MacReynolds's lodgings. They were located in a house in the Netherbow, one of the older ones that had been subdivided. The rooms she'd leased were reached by a turnpike stair but no one answered their hails.

"Shall I break down the door?" Nick asked.

"Better to find the building's owner," Susanna said, albeit reluctantly. "We could have the wrong place."

More likely, she thought, they were too late. Annabel was not the sort to cower behind a locked door. And Catherine, were she within, would surely recognize Susanna's voice. Just to be certain, she called out again.

"Catherine? It is I, Susanna Appleton. Will you not let us in?"

There was no answer from the other side of the door, but heavy footsteps behind them on the stair heralded the arrival of the landlady. Nick tried an appeal to her sympathy first, explaining that they feared for Mistress MacReynolds's health. When that

ploy failed, he offered a generous gratuity. More money changed hands before Susanna and Nick were left alone to search the premises at leisure.

In the Hall, Susanna recognized the hanging with the pastoral scene. A full description of the piece had accompanied the seller's directions to this place.

Nick gave a low whistle. "Annabel and Lady Russell shared expensive taste in furnishings."

"They both liked their comforts," Susanna agreed. Apparently Annabel had been able to indulge herself. Long years of service to important personages of various nationalities had allowed her to accumulate considerable wealth and she'd had no one to spend it on but herself.

"You scarch," Nick suggested. "I will question the neighbors."

Susanna made quick work of the Hall, which was very fine, with a painted ceiling and a tiled fireplace, and moved on to Annabel's bedchamber. At once she saw signs, in the chests and coffers that held clothing and jewelry, of hurried packing. Much had been left behind, however, and it was impossible to tell what was missing. Susanna went through everything, looking in particular for garments made of cinnamon brown silk. It appeared that Annabel had worn or taken with her the clothes Una had described. Susanna hoped that would make her easier to locate.

The chamber was small, no more than eight feet by ten. It did not take long to examine every inch of the room, including the space under the mattress of Annabel's comfortable bedstead. Susanna sought in vain for any clue to her whereabouts. Annabel had been trained by the best. She'd left nothing behind to help her pursuers in their quest.

The second chamber contained naught but another hearth, a desk, and an ornately carved, cushioned bench. Discouraged, Susanna made her way up narrow, winding stairs to the loft room above the turnpike and there, at last, found evidence of Catherine's occupancy. The clothes Una had said Catherine was wearing

when Jean died had been flung carelessly across the foot of a nar-
row camp bed.

Susanna sank down onto the bed, one of Catherine's sleeves
clasped to her bosom. The scent of violets made her want to
weep. Where would they go? Why would they hide from *her*?
Catherine might at least have left her a note.

None of this made sense...unless Catherine was hiding from
someone else—some unknown person who had slain her moth-
er-in-law and tried to murder her. What if *both* women had been
pushed down those stairs?

Susanna rubbed her forehead. Disjointed thoughts went
round and round in her brain and took her nowhere. Glenelg
House had not been robbed and she could think of no one who
profited by Lady Russell's death, let alone Catherine's. According
to Sir Lachlann, Lady Russell had not left a will. That was hardly
surprising, in spite of Una's expectations. Most people did not
bother with one until they thought they were on their deathbeds.

Which made Malcolm Logan's actions all the more incom-
prehensible. There was financial gain to be had from bringing civil
rather than criminal charges against Catherine. Susanna still had
no inkling why he had insisted upon pursuing the latter. He had
not been seen at Glenelg House since Tuesday morning. No one
knew where he had gone.

Nick returned to Annabel's lodgings a short time later. From
his bleak expression, he'd had no more success than she had.

"The neighbors report that Annabel has been in and out as
usual during the weeks since Catherine's disappearance. No one
remembers seeing another woman in her rooms of late, nor a
child and a maidservant."

"Cordell," Susanna whispered, stricken. In her concern for
the mother, she had forgotten the daughter. "I saw no evidence of
a child living here, Nick."

"Mayhap Avise and Cordell have been hiding elsewhere."

"Catherine would not want to be separated. You know how

she feels about both her children. Oh, Nick—what if something has happened to Cordell? What if she has been kidnapped? That would explain Catherine's behavior. She'd do anything to protect her child. Even strangle Lady Russell, if she thought her mother-in-law had something to do with the disappearance of her daughter."

Nick caught her by the shoulders, not easing his grip until she met his gaze. "We'll find explanations for everything," he vowed, "and we will find both Catherine and Cordell."

"How?" She felt perilous close to giving in to despair and despised herself for the weakness.

"I will go back to the merchants. There is one question I did not pursue. I never asked if Annabel was in anyone else's company when she made her purchases. She must have made some friends in Edinburgh. She has lived here for more than two years. I will find them for you, Susanna, and they will lead us to Annabel, and to Catherine."

## 14

*September 19, 1577*
*Linlithgow, Scotland*

EDINBURGH PAST Queen's Ferry to Kirkliston was six miles. Kirkliston to Linlithgow was another six. "Halfway there," Catherine murmured. It had taken almost twenty-four hours to journey this far, thanks to Annabel's overly cautious pace.

Linlithgow to Falkirk-over-Forth would be another six miles and then six more miles would bring them into Stirling-upon-Forth. *Stirling Castle.* That was all Catherine could think about, and she spared barely a glance for the royal palace at Linlithgow,

flanked on one side by a loch and on the other by the ancient par-
ish church of St. Michael.

The town itself, like Edinburgh, was bustling, and crowded.
Two women—even two women riding astride and without an
escort—had blended with ease into the crush of travelers. They
were garbed in nondescript clothing. Catherine wore the ploddan
cloak over a simple bodice and kirtle, quilted for warmth but un-
decorated. Annabel's garments were similar but she covered them
with Catherine's good hooded cloak of brown wool.

"Your husband's old master, the earl of Moray, was gunned
down in the street just there," Annabel said, pointing.

Catherine felt a pang of remorse, along with a twinge of self-
pity. "How I wish he were still alive, and still regent. Gilbert was
his representative in London. Moray would help me now if he
could."

"Only if it served his own ends," Annabel said bluntly, "and the
same is true of all his successors."

Lennox, Mar, and now, Morton. As always, Scotland abound-
ed with political turmoil. One faction currently wanted Morton
replaced by a different nobleman. Another urged that Mary Stew-
art be freed from captivity in England and restored to the throne.
Still a third suggested that King James, at eleven, was old enough
to rule the country on his own.

"We must press on to Falkirk," Catherine said aloud. "If we
hurry we can arrive before dark."

"You forget yourself, Catherine. Today you are naught but my
humble servant. You must follow my lead in everything." Annabel
turned the scruffy little broom-tail she rode down a narrow wynd
and Catherine followed.

Her own mount was even less impressive. No wonder Robert
Appleton's Vanguard had been the envy of so many Scots horse-
men—and women, too. Catherine had inherited the big black
courser from her half brother and had been heartbroken when
the horse finally died of old age.

With a twinge of guilt, Catherine admitted to herself that she'd felt the loss of Vanguard more than she'd regretted the passing of his former owner. Similarly, she'd grieved for her husband, but could not mourn his mother. She knew she *should* feel Jean's loss more deeply, but any lingering sense of remorse was not because Jean had died but because she, Catherine, might be hanged for killing her. If she were caught. She did not intend to be.

Annabel stopped in front of a plain stone house. "We will stay here for the night."

"What place is this?" It did not look like an inn. Indeed, in contrast to England, Scotland boasted few public accommodations for travelers.

"I have kin here. A MacCrimmon of Skye, as my mother was. I'll tell you that family's history one day, if you care to hear it. 'Tis a fine tale, and one that helped endear me to the Italian woman who is queen mother of France."

Catherine de' Medici, Catherine Glenelg recalled, had recruited Annabel as an intelligence gatherer, using her to spy on her own queen, Mary of Scotland, and to seduce secrets out of over-confident Englishmen like Sir Robert Appleton.

Annabel's cousin, Nora by name, was half Annabel's girth and dressed three times as fine. She was at work in the wine shop that took up the ground floor of the building when they arrived. Her eyes widened in surprise and she mouthed Annabel's name, but she did not abandon her customer to greet them.

For rich merchants and the gentry, vintners suppled wine in kegs and butts, but the small-scale needs of others were filled by offering a variety of vintages kept in a purpose-built cupboard. This one was as tall as Nora herself. It stood open, revealing several large storage pitchers called jacks, each of which could contain as much as five gallons of wine. The heady mixture of aromas hit Catherine as soon as she and Annabel entered the shop.

The customer made his selection and Nora MacCrimmon

filled the pitcher he had brought with him from one of the jacks. She replaced it and closed the cabinet door carefully when she was done, but Catherine could still smell the wine. The door of the cabinet was pierced with open-work carvings to allow the wine to breathe and to entice customers to buy.

The wine paid for and the man who'd bought it on his way home to supper, Nora welcomed her cousin with open arms. She offered them the hospitality of her home without question.

Nervous at first, Catherine slowly relaxed. Nora's husband the vintner, one Ogilvie by name, was in Burgundy, and not likely to object to his wife's generosity. The household consisted of a scattering of servants, three small children, and a bevy of cats. The talk at table was all of other MacCrimmon kin, most of them still living on Skye and nearby islands. Many of them, it appeared, were proficient at playing the bagpipe.

Catherine had never developed much tolerance for the screeching that passed for music on that instrument, but her daughter adored the sound. It had been to hear the bagpipers play that she'd gone to Greenside on the fateful day when Jean Russell died.

With a start, Catherine realized that someone had asked her a question. "My mind wandered," she apologized.

"I asked if you have ever been to Italy," Nora said. "Cremona is said to be a fine place to live."

"Italy?" Catherine repeated in confusion.

"You will need to go somewhere new to live," Annabel said, *sotto voce.* "After."

*After* she rescued Gavin.

Catherine had not thought that far ahead. "I must return to England for Cordell before I go anywhere else."

"And then?"

"Does it matter?" She glanced along the board but none of the servants were paying any attention to their mistress or her guests. "Anywhere that is safe."

She would think about that part of things later. First she must be reunited with her son. If she made the attempt to free him and failed, she would have no future to worry about.

## ⚜15⚜

*September 20, 1577*
*Glenelg House, Burgh of the Canongate, Scotland*

LATE ON Thursday night, Malcolm Logan, Master of Glenelg, had returned from what Susanna presumed to have been a three-day-long debauch. Dawn had scarce broken on Friday morning before she made the decision to invade his bedchamber, Una in tow to translate. "We will roust that sorry young man from sleep and ask him a few pointed questions," she told her maidservant.

"Are you certain that is wise, madam? He has a temper, that one does."

"How do you know that, Una? Did he threaten Lady Russell?"

"Not in so many words, but they were at odds. He all but invited himself to lodge here and ignored her hints that he was no longer welcome." Una helped Susanna into her kirtle and began to tie the many laces needed to keep it in place and attach the sleeves and ruff.

"What did he want from her? Money?"

"He wanted to be lord of Dunfallandy in young Gavin's place."

Dunfallandy, Susanna knew, was in the first range of the Highlands, north and west of the Firth of Tay. The lands controlled by the Fergusons included a wide stretch of the banks of the Tummel in Strathardle and Glenshee.

"Do they speak Inglis in Dunfallandy?" she asked Una.

"Their first language is Gachtlet, the Highland tongue. Some

refuse to speak anything else and still cling to the old ways." Una adjusted the lappets that fell from the back of Susanna's headdress and tucked an escaping strand of hair back up under the brim. "Under the Highland system, Gavin would not have control of those lands. When the heir is under the age of fourteen, the nearest adult male relative succeeds instead."

"Malcolm?"

"Aye. That was the old way. But the Fergusons changed all that a long time ago, when they first accepted the title of Baron Glenelg from the king."

"Has Malcolm always lived in Dunfallandy?" Susanna asked, thinking of the worn doublet and hose in his wardrobe chest.

"Why, I suppose he has. I only met him once before. Just after Gilbert succeeded to the title my mistress went back to Dunfallandy and took me with her. The place had not changed a bit. A rude, crude backwater with naught to offer anyone. When Lady Russell decided to return to London, Malcolm begged to be allowed to go with her, but his mother, Lady Russell's sister, would not hear of it."

"How old was he?" Susanna made a few rapid calculations. Gilbert and Catherine had been married in 1562 and shortly thereafter had paid their one and only visit to Gilbert's lands in Scotland. Fifteen years ago.

"Six or seven, I suppose." Una looked uncertain. "He was a surly little brute then and he has not improved with age. He reminds me of his uncle, Lady Russell's brother, and *that* Lord Glenelg I remember well—he was a vicious, deceitful, thoroughly unpleasant man."

Susanna had never met the eighth Lord Glenelg, but she had heard enough about him to know Una did not exaggerate. If Malcolm had inherited his temperament, this was going to be a difficult interview.

"Does Malcolm understand English?"

"He must ken a bit, but he refuses to converse in it. It made

Lady Russell quite wroth with him, for she had forgot much of her Gachtlet."

"But you speak it?" They had left Catherine's chamber and had almost reached the room assigned to Malcolm.

"Well enough." Una opened the door.

Malcolm Logan opened bleary eyes and stared at them without recognition.

Susanna entered and made herself comfortable in the room's only chair. "Tell him I am prepared to wait as long as necessary to hear his account of the day Lady Russell died." So far, she'd had no luck finding out where Annabel and Catherine had gone. It was time to focus on her other goal—discovering if someone else might have killed Lady Russell and persuading Malcolm to exchange a criminal suit for civil charges.

The young man's attitude remained surly and uncooperative. Doubtless he still felt the after-effects of too much drink. But he rose from his bed, revealing that he wore the voluminous, long-sleeved, saffron-colored, pleated shirt to sleep in, and found a supply of ale in a cupboard. When he'd quaffed a healthy quantity of the stuff, he deigned to address Susanna.

"Let me hear your questions," Una translated. "Only then will I tell you if I am willing to answer them."

"Ask him where he was the afternoon his aunt died."

The answer came back without hesitation: he did not intend to tell her, or anyone else, where he had been. It was no one's business but his own. After a moment he said something else.

"Well?" Susanna prompted when Una hesitated.

"He says whoever strangled Lady Russell made a great mistake. They should have murdered her grandson instead."

"After which his title would go to Malcolm. I am sure he would have been pleased if someone had removed such an obstacle from his path." She did not take the comment seriously. "Ask Master Logan when he first heard of his aunt's death."

"He arrived at the same time Sir Lachlann brought the bailie,"

Una told her, without bothering to translate the question and wait for a reply. "The three men came in together. That is when we discovered Lady Glenelg had disappeared."

"Ask *him*," Susanna repeated, nodding toward Malcolm Logan.

The reply that came back was the same one Una had given, coupled with a few more words the maidservant did not translate. Susanna had a feeling they were not complimentary.

"Let us move on," she said. "Listen carefully, Una, and tell him precisely what I say." She cleared her throat, thought a moment, and began. "You have brought criminal charges against Lady Glenelg, claiming she did foully murder your kinswoman. The punishment for this crime is execution and escheat, the confiscation of all moveable goods." Nick had gleaned a few more details of the vagaries of Scottish law from his friends and passed them on to Susanna. "Lady Glenelg has vanished. If she cannot be found, you will have no satisfaction from your charges, and no profit. Her properties lie in England and cannot be confiscated. All this—" she waved a hand to indicate Glenelg House and its contents "—belongs to Lord Glenelg, not his mother."

She waited while Una spoke, watching Malcolm's face. He had a sly look about him, but she did not make the mistake of confusing that with intelligence. He struck her as cunning rather than clever. She hoped to convince him that there would be no advantage to him in Catherine's execution. Indeed, she suspected he already agreed with her that monetary gain would be preferable to exacting "an eye for an eye" in revenge.

The explanation of how this would work took some time and was made more difficult by Una's frequent protests. She had loved her mistress and did prefer vengeance.

"He means to go on with the criminal suit," Una reported after a long, incomprehensible exchange Susanna could only hope conveyed what she'd really said.

"Tell him I am wealthy in my own right and will double what-

ever assythment the civil court would award him from Catherine's holdings."

"You are both English, and your estates are in England," Una objected. "How can he be certain any money will reach him?"

"I will provide a bill of exchange, as merchants do, and convey funds to Scotland." As for transferring Catherine's money, that might prove more difficult. Until Catherine was found, she could not authorize the disbursement. Susanna prudently did not remind Malcolm of this fact. Besides, she still hoped to prove someone else had murdered Jean Russell, which would render this entire discussion of compensation moot.

This time it took Una only a few moments to convey Susanna's newest suggestions. Malcolm, who had grown increasingly more restive as the interrogation went on, glowered at Susanna. "No," he said, quite clearly.

"You're certain he understands what he's giving up?" Susanna asked Una.

"If you doubt me, madam, find someone else to translate."

Perhaps she would, Susanna thought, but for the moment she accepted Una's word. Bidding a strained farewell to Malcolm Logan, she retreated.

"Reminds me of his uncle, just as I said," Una muttered as she followed Susanna back into Catherine's chamber. "Rather stir up trouble than breathe. Lived to make mischief, that one did."

Some character traits ran in families, Susanna mused. Lady Russell had not been easy to live with, either. Gilbert, presumably, had taken after his English father. Fortunate for Catherine, and for her children, too.

Next time she spoke to Malcolm Logan, she decided, she would find another interpreter. Una was convinced Catherine had killed her mistress and wanted her punished for it. Who knew what she had really said to the Master of Glenelg?

For the nonce, however, Susanna had done all she could to reduce the threat to Catherine. Taking her cloak from Una, she

went out again, this time heading downstairs to meet Nick. Another day of searching for Annabel, or for anyone who knew her, was about to begin.

# ✙16✙

*September 21, 1577*
*The High Street, Edinburgh, Scotland*

NICK BALDWIN was in a foul mood as he once again strode along Edinburgh's High Street in the direction of the castle. Two frustrating days had passed since they'd located the house in the Netherbow where Catherine had hidden with Annabel MacReynolds. Since then, Nick had spent most of his time, both with Susanna and on his own, seeking in vain for further information about the Scotswoman. Not one clue had surfaced to lead them to any of her acquaintances in Edinburgh. She did not seem to *have* any friends.

Today Lachlann Dunbar kept him company, not by any choice of Nick's, but because he was going in the same direction. Nick wondered why it was that he disliked the fellow so much. It was not just because he'd insisted upon taking an eight-year-old boy away from his mother. Many lads left home at that age—for school or to be apprenticed. Perhaps, he decided, it was because he acted as if he were concerned about Catherine but did not seem willing to consider that she could be innocent of the charges against her.

As they passed the Tolbooth and Nick caught a whiff of the fish market, he voiced a blunt question: "Why do you believe Lady Glenelg is guilty of murder?"

Dunbar broke stride, but recovered himself instantly. "You question the evidence?"

"What I question, Sir Lachlann, is your ambivalence."

Dunbar turned to meet Nick's gaze head-on. "I would be heartily glad to find an alternative suspect, in my own self-inter-est. My ward's mother taken into custody, mayhap put on trial, would have an adverse effect upon my fortunes."

They had reached the wynd leading to the shop of a dealer in secondhand clothing and Nick stopped. At Susanna's urging, he had begun to visit such establishments. She reasoned that Annabel and Catherine both would wish to go about disguised.

"I bid you good day, Master Baldwin. Happy hunting."

An abrupt departure, Nick thought. And Dunbar had not really answered the question.

So intent was he on watching the man ascend the High Street toward Castle Hill that he did not notice a small, nondescript woman on the opposite side of the wide thoroughfare.

Avise Hamon, eyes wide and frightened, took shelter in a doorway. She recognized them both—Lord Glenelg's guardian and the justice of the peace from Kent. Had either of them seen her? Heart pounding, palms damp with sweat, she waited, scarce daring to breathe, as Sir Lachlann Dunbar passed out of sight.

She peeked out of her hiding place. Master Baldwin, too, had vanished. Without further delay, she scurried out of shelter and plunged into the first narrow lane she came to. Looking over her shoulder at intervals, terrified that in spite of her best efforts she'd be followed, she took a roundabout route back to the safe haven in which she'd left Cordell.

Meanwhile, back in the clothing shop, Nick Baldwin heard the first good news he'd had in days. The proprietor recalled sell-ing clothes to a woman of Annabel's description.

She had purchased a number of garments suitable for a female of much lower status. More suspicious still, he had recognized his own wares when the same gentlewoman returned to his shop, this time wearing them. Her attempt to disguise herself had intrigued the shopkeeper, causing him to remember what she had

purchased. Less than a week past she had again bought clothing suitable for a maidservant, but this time they had been for someone much smaller than herself.

So, Nick thought as he left the shop, it seemed likely that Catherine was posing as Annabel's maid, or that both of them were traveling disguised as servants, just as Susanna had assumed. But where did that information lead him? In truth, he knew nothing more than they had already surmised. The description of the clothing would be no help. Dozens of servants wore garments exactly the same.

Scowling, he strode rapidly along the narrow byways that wound upward toward the castle. There was no indication that the two women had a child with them. What had happened to Cordell, and to Avise, the real maidservant? That question worried Susanna excessively. No one would have harmed the little girl had she been left behind at Glenelg House. Why, then, had she been spirited away? And where on earth had she been taken?

With each passing day, Susanna's concern for Catherine and her daughter had increased tenfold. Nick had tried his best to keep her too busy to worry, but in the long run, asking questions to which she received no answers only made matters worse.

This afternoon Susanna had remained at Glenelg House to make lists. She hoped that by writing down all they knew, she might find some pattern heretofore missed. Nick doubted she would. There were too many gaps in their knowledge.

Of a sudden, Nick's attention was caught by a sign. He stopped. Although he doubted Annabel would have visited this shop, he could not resist entering. The place sold maps and travel books. Nick had a weakness for both.

The elderly shopkeeper was a talkative fellow. Nick soon fell into conversation with him, translating Inglis into English in his head as naturally as he breathed and just as effortlessly speaking in the Scots dialect himself. He did not realize quite how much he

had revealed until the man muttered, "Appleton? MacReynolds?"

The names taken together seemed to spark a memory. "A red-headed lass, she was," he said after a moment.

Nick nodded.

"Annabel, he called her. She brought him here—Appleton. An Englishman. He spent a great deal of money. Bought a *mappa mundi*."

The shopkeeper, Nick realized, was recalling events that had taken place some sixteen years earlier, which he seemed to recall better than what had happened yesterday. The map of the world he spoke of now graced a wall at Leigh Abbey.

"Had lodgings in Cowgate," the old man said, snickering. "Thought that was a fashionable area of the city. Hah! Once upon a time noble families and city councillors resided there, but it lost its appeal to them a good fifty years before the Englishman came. Everyone who could afford to moved into the Canongate, or built country houses—villas, they call them—a few miles away."

"Has the woman ever come back?" Nick asked. "In *recent* years."

"I do not recall seeing her again. In truth, it was not Appleton who returned most often to the shop. He sent his man to buy and the fellow was a shrewd bargainer. Had no trouble with the language, as his master did. Picked it up in the local alehouses, I've no doubt."

Nick was not interested in Robert Appleton's purchases, or his ability with languages. He purchased an account of Jenkinson's travels in Persia that caught his eye and left the shop, discouraged enough to give up for the day.

He might have gone straight back to Glenelg House, but his eye fell on one more place, down a narrow wynd he hadn't noticed before. It was the shop of a tailor. Even the wealthy did not customarily have a great many changes of clothing. Nick had stopped at such establishments before, describing Annabel and mentioning that she might have ordered clothing made in

cinnamon-colored fabric, for such was what Susanna had told him Annabel had worn to Glenelg House and taken away with her.

This time his inquiry prompted the tailor to respond with a wide, gap-toothed grin. "Mistress MacReynolds! A kind and generous patron."

He recalled with great fondness making an expensive riding costume in that color for her, even though the order had been completed almost two years earlier. He also remembered the name of the person who had brought Annabel into his shop in the first place.

"It was Lady Tennant," the tailor said. "They seemed to be great friends."

"Who is she?" Nick asked.

"She lives on Castle Hill," the tailor replied. "She is a lady of modest means herself, but she is kin to the regent."

## ❦17❦

*September 23, 1577*
*Tennant House on Castle Hill, Edinburgh, Scotland*

"IT IS GRACIOUS of you to invite me into your home, Lady Tennant."

Susanna had to raise her voice to be heard over the yapping of a half dozen spaniels. They tumbled about the room with reckless abandon, scoring the floor with their nails every time they skidded to a stop. That surface, plaster of Paris over wood, no longer bore any resemblance to the marble it had been painted to imitate.

Elspeth Douglas, a woman in her late twenties with a florid countenance and a jutting chin, murmured a polite disclaimer, fortunately in fluent English. She had already offered refresh-

ment. Susanna had accepted a cup of wine, sipped once, and set it aside. She was not here to trade pleasantries. She had already been obliged to endure an interminable Sunday waiting for Lady Tennant to return to Edinburgh. The Scotswoman had been visiting the villa her husband, Sir William, currently in England on a diplomatic mission, was building just outside the city.

"Forgive me if I am blunt, Lady Tennant, but I have come to beg your assistance. I am a kinswoman by marriage to Lady Glenelg. I came to Scotland to visit her, only to discover that she had left her home under somewhat mysterious circumstances. I am most troubled by this...sudden departure."

"You need not mince words, Lady Appleton. As I am certain you already know, my cousin, James Douglas, earl of Morton, serves as regent for the young king. Given that family connection, he talks to me and his servants talk to my servants. I am well informed about the goings and comings in Edinburgh."

"Do you know where Lady Glenelg is?"

"No." Lady Tennant settled deeper into her curule chair, the mate to Susanna's, and patted her lap as a signal one of the dogs should leap into it.

The sling-style leather seats and back were surprisingly comfortable but Susanna could not relax. "What about Annabel MacReynolds?"

"She lodges near Netherbow Port."

A second dog began to paw at Susanna's skirts. She ignored it. "She has abandoned the premises."

"Then I cannot help you, Lady Appleton. Stop that, Hecate."

The spaniel obeyed, but only to the extent that it shifted its attentions to the toe of Susanna's boot. "Can not or will not? I mean Mistress MacReynolds no harm, I assure you. And as you doubtless know, she and Lady Glenelg were great friends in the days when Mistress MacReynolds served the queen."

Lady Tennant took a long swallow from her wine cup while stroking the dog in her lap with the other hand. Susanna attempt-

ed to shake off the spaniel now chewing on her toe. It took this for a game and bit down harder on the soft leather.

"Lady Russell's death was quite sudden."

Susanna forgot about the dog. Did Lady Tennant know the woman had been murdered? As far as they had been able to discover, the hue and cry had not extended beyond Canongate. It was possible gossip had not reached into Edinburgh either.

"She died after a fall. Lady Glenelg was also injured. A severe blow to the head, or so I am reliably informed. Before she left so precipitously, she told Sir Lachlann Dunbar that she had suffered a loss of memory."

Lady Tennant put the dog on the floor and canted her body in Susanna's direction, an expression of sympathy on her face. "Lady Glenelg cannot remember who she is?"

"Would it were that simple." Catherine's complete loss of memory would explain her continued silence, but she'd known who she was when she spoke with Sir Lachlann, and earlier with Una. "As near as I can tell, only the events of the hours immediately before she fell are lost."

"Still, it is no wonder you are concerned." Lady Tennant continued, "But if Lady Glenelg is with Annabel MacReynolds, I am certain she is well cared for. When she recovers her memory, she will doubtless return to you."

"How can you be so certain Mistress MacReynolds has her best interests at heart?" Annabel was not best known for her loyalty. "Will you tell me what you know of Annabel MacReynolds, Lady Tennant? Some small thing, scarce remembered, may yield a clue to her present whereabouts."

Susanna thought she was about to refuse, but after a few moments of thought, during which the dogs settled by the hearth, all curled together, the Scotswoman began to speak. "I first met Annabel when she arrived in Edinburgh. That was about two years ago, shortly after my marriage. As she had just done a great service for my cousin James, he sent her to stay with me here

until such time as she could find lodgings of her own. We took to one another from the first. She has led a fascinating life, Lady Appleton."

"I am aware of that, Lady Tennant. Our paths have crossed more than once, the last time shortly before she returned to Scotland."

Lady Tennant's eyes widened and she sat up a little straighter. "You were in Derbyshire?"

"I was. I know what tasks she performed at Buxton and elsewhere on your kinsman's behalf." Indeed, Susanna knew the whole story. She doubted Lady Tennant did. Neither the regent nor Annabel would want the details bruited about, not when they'd gone to so much trouble to conceal them.

"If you are aware of Annabel's achievements, then you know that Lady Glenelg could not be in better hands."

"*If* Annabel means to help her. But why should she?" Susanna could not decide if Lady Tennant understood more or less than she appeared to. Her confidence in Annabel seemed unwarranted.

Lady Tennant stood to fetch the wine pitcher and refilled her cup, waking two of the spaniels in the process. "Annabel will assist Lady Glenelg because they were friends long ago. And because it will amuse her to do so." She sipped her wine. "Doubtless she already knows you are in Scotland. All you need to do is wait for her to send word to you. Do you reside at Glenelg House?"

"For the present. Sir Lachlann has been kind enough to allow me the use of my kinswoman's quarters."

"Well, then. Go there and wait."

Susanna's spirits drooped. She'd had such high hopes when she came to see Lady Tennant. Discovering her whereabouts had been the first ray of light in the bleakness of her search for Catherine. Susanna had been certain that finding Lady Tennant would lead directly to Annabel.

"A most generous and charming man." Lady Tennant's words

were muffled. She'd bent over to scratch one of the spaniels behind the ear.

It took Susanna a moment to realize she must be talking about Lachlann Dunbar. "I did not realize you were acquainted with young Gavin's guardian."

"He courted me once." A faint smile played along the thin line of Lady Tennant's lips as she stood with the spaniel in her arms. "I thought him quite handsome but I chose Willie Tennant instead."

"He mentioned something about seeking a wife," Susanna ventured. She did not know a great deal about the man's private life. His talk at meals was mostly of the court and the management of Gavin's estates.

"Poor Lachlann." Lady Tennant left the dog on an imported chair of Spanish make, an uncomfortable, barrel-shaped piece of heavily carved wood, and resumed her seat in the curule chair. "He married young and his wife died a long time ago. It seems to be a family failing. Two of his three daughters, mere children themselves when they wed, are already widows."

"Have you had dealings with Sir Lachlann since your marriage?" Susanna asked.

"Why would I? And yet, I maintain a casual interest, having so nearly accepted his suit. He did well to purchase young Lord Glenelg's wardship. No doubt he'll marry the lad to the third daughter." Another dog leapt into Lady Tennant's lap. She did not seem to notice.

"Gavin is passing young yet for betrothal, and at present he is at Stirling Castle with the king."

Lady Tennant idly stroked the spaniel's silky coat. "Why, Lady Appleton. I believe you have answered your own question. Where else would Catherine and Annabel go but there?"

"True, Catherine would be loath to leave Scotland without—" she stopped herself in time "—saying farewell to her son." She would not leave at all, Susanna realized, unless she could take him with her. An alarming thought. Assuming Catherine still remem-

bered who she was, it was almost certain she would try to reach Gavin. More than that, she would try to take him away with her.

"Annabel is well acquainted with the countess of Mar," Lady Tennant continued. "No doubt your friend knew her, too, in the old days. Lady Mar was much in Queen Mary's company. Now she is governess of the king's household."

"I am surprised any friend to the exiled queen would be placed in such a trusted position."

"There is some debate about whether Lady Mar hated Queen Mary or was her dear friend. I can tell you that the late John Knox did much dislike them both."

That alone was enough to incline Susanna in Lady Mar's favor. "What did he have against Lady Mar?"

"As I imagine you already know, the earl of Mar was regent for some fourteen months back in 1572. He died a natural death, most unusual for one in that position." She tittered. "Master Knox claimed Lady Mar discouraged her husband from giving his full support to the Reformed Church during his time as regent. For that Knox called Lady Mar a Jezebel."

"Did she deserve the name?"

"Who is to say? I have heard her damned for avarice by some and praised by others as wise and sharp. She is a woman who has always invited comment."

"A lady of mature years, then?"

"No more than ten years older than I am. She had a daughter, a girl who died two years ago at the age of seventeen. Her son is almost of age."

"Would Lady Mar be inclined to arrange a secret meeting between Catherine and her son?"

"I've no doubt she *could* do so, but whether she *would* is another matter. She'd require to be bribed."

Lady Tennant, Susanna perceived, did not care for the countess of Mar. Or else she envied Lady Mar her lucrative post.

Susanna remained with Lady Tennant for another quarter of an

hour but the Scotswoman had nothing else to offer by way of either information or encouragement. Susanna returned to Glenelg House covered in dog hair and in a thoughtful frame of mind.

They had questioned all of Nick's associates in Edinburgh. It was likely Annabel and Catherine had fled the city in any case. A trip to Stirling was neither wise nor safe for Catherine, but she was not always rational where her children were concerned. The more Susanna considered the notion, the more convinced she became that Catherine had hidden Cordell somewhere in Avise's care and was on her way to Gavin in Annabel's company.

At the evening meal, she broached the subject of traveling to Stirling herself. "I am of a mind to visit my godson before I return to England," she said after sampling a pullet served with prunes in the broth.

Sir Lachlann reached for more of the wine Nick had supplied, imported from Bordeaux. "You can save me the trouble, then, of informing him of his grandmother's death."

Appalled, Susanna stared at him. "He does not know?"

"I have not been back to Stirling since."

"You might have written."

"To tell him what?" Sir Lachlann helped himself to a portion of sheep's head broth. "I have already made plans to leave for Stirling on Wednesday. I would be glad of your company on the road, and you are welcome to the hospitality of my house."

She'd hoped to leave on the morrow, but his suggestion made sense. They would have to hire outriders even for such a short journey. It was always safer to travel in a large party. "I accept with pleasure."

Another voice cut in before she could say more. "I, too, wish to visit Stirling."

Everyone turned to look at the speaker.

Malcolm Logan's words had been loud, slow...and in English.

"I do not recall inviting you," Sir Lachlann drawled.

Logan's wide grin, occasioned by their astonishment, was

replaced by a look of petulance. He muttered something incomprehensible to Susanna, which she took to mean that he intended to travel to Stirling with or without encouragement.

Relenting with ill grace, Sir Lachlann assured him he was welcome to join them.

Susanna was uncertain how she felt about having Malcolm along. She still hoped to persuade him to drop the criminal charges against Catherine, but with Malcolm at Stirling there would be more eyes watching her. If she did locate Catherine, she would have to be doubly careful to keep that fact a secret.

As the meal continued, Susanna considered mentioning her visit to Lady Tennant, then decided against it. She was not sure why. Only much later, when she and Nick were alone in her chamber, did she realize that it was because she did not entirely trust Lachlann Dunbar.

"How could he not tell Gavin that Jean was dead?" she wondered aloud. "The boy should have been allowed to attend his grandmother's funeral."

"But to inform him of Lady Russell's death, Dunbar would also have had to reveal the fact of Catherine's disappearance."

Susanna winced as the fine-toothed comb she'd been running through her hair caught on a snarl. She was seated at the foot of the bed, her back supported by one of the walnut corner posts. "I cannot decide what to make of Lachlann Dunbar. He seems to have dealt honestly with us, and yet..."

"Did Catherine trust him? Dunbar said he meant to court her. They must have spent considerable time in each other's company over the last few months." Nick lay on his side, watching her through half-closed eyes.

"Yes—in constant conflict over Gavin's future. Catherine did not encourage his suit. I am certain of that." Encountering another snarl, she tugged impatiently at it but only succeeded in further entangling the comb.

"Might she not have considered it for young Gavin's sake?"

Nick came up on his knees to catch her hands and ease them away from her hair. Turning her so that he was behind her, he freed the comb and set to work on the knot. "She'd have been able to exert greater influence over the boy's future if she married the man who holds his wardship."

"I will be surprised if Catherine ever remarries. She loved her Gilbert far too well."

"All the more reason for her to believe she might find happiness again." Nick's gentle strokes soothed but his words did not. "Many widows, especially those with small children, willingly give up the legal advantages of widowhood in favor of letting a new husband look after their interests."

Susanna's gaze went unbidden to the portrait of Gilbert, the one Catherine had left behind. She wondered, just for a moment, if she knew Catherine's heart in this matter as well as she thought she did.

"Not everyone puts a widow's rights above all else." Bitterness tinged Nick's voice.

Stung, Susanna did not at once reply. They had debated this issue too many times in the past. They were no longer talking about Catherine Glenelg. "I will not quarrel with you, Nick. There is nothing more to be said on the subject."

Susanna had made the decision never to remarry years ago, and no matter how strong her affection for Nick Baldwin, she did not intend to change her mind. Marriage made a woman beholden to her husband for everything, even her life. The years Susanna had been bound to Robert Appleton had taught her the folly of allowing that to happen.

She knew in her heart that Nick was no Robert. But Nick *would* tell himself that he was looking out for her best interests, that he was protecting her. She sighed when he set aside the comb and turned her in his arms. Even the kindest and most decent men eventually sought to control their wives. Why not, when the law regarded a man's wife and children as mere chattel? Susanna

was resolved. Never again would she submit to the yoke.

But she yielded without protest to his kiss.

## 🕱18🕱

*September 25, 1577*
*Glenelg House, Burgh of the Canongate, Scotland*

FULKE ROWLEY arrived in the Canongate just as a group of riders was making preparations to leave Glenelg House. When he recognized Lady Appleton's sidesaddle on one of the horses, he urged his tired mount to greater speed.

"Fulke!" came a greeting from Master Baldwin's man, Toby. "Well met. Will you come with us to Stirling?"

"Stirling?" Young Gavin was at Stirling Castle. "Is that where Lady Glenelg disappeared to?"

"No one knows where Lady Glenelg is, but I warrant Lady Appleton hopes her son will have heard from her."

For a moment Fulke feared he would disgrace himself by falling off his horse. A terrible pressure squeezed at his temples. His breath stilled and he heard the rush of his own blood in his ears. He fought the encroaching blackness, cursing softly under his breath, until at last it receded and he was aware of his surroundings once more.

"And Cordell? What of the child?" His voice sounded so harsh that he could not blame Toby for looking at him askance. "Is she also missing?" He had to clench both hands into fists to keep from shaking an answer out of the younger man.

Toby swallowed hard and repeated what they'd been told upon arriving at Glenelg House. "Lady Appleton has been trying to find Lady Glenelg ever since," he added. "She is looking for

Mistress MacReynolds, too."

Fulke grimaced at the name. He'd been Sir Robert Appleton's man when he'd first heard it. She'd been one of Sir Robert's mistresses. He'd disapproved: a married man should be faithful to his vows. Fulke had not learned till years later that Annabel MacReynolds was also an intelligence gatherer in the employ of England's oldest enemy, France.

"I must speak privily with Lady Appleton," Fulke told Toby.

Within moments, he found himself in Lady Appleton's bedchamber. Master Baldwin was already there, but his presence did not bother Fulke. What one knew, the other soon would. Once the servants had left with Lady Appleton's boxes, Fulke rushed into speech.

"Cath—" He stopped himself. "Lady Glenelg sent Avise and Cordell south. They were supposed to go to Leigh Abbey but they never arrived."

Lady Appleton's eyes widened and with a little cry of distress she lowered herself to the chest at the foot of the bed. "Lord help them. That poor child."

"We thought she was somewhere in Edinburgh," Master Baldwin murmured. "We never imagined—"

"Why would she send Cordell away? Catherine hates being separated from her children."

"To keep her safe," Fulke replied, not without irony, and recited the contents of the missive Catherine had sent to him. "I found no trace of them on my way north," he added. "In truth, I hoped they *would* still be here."

Lady Appleton looked close to tears. "What if Cordell has been kidnapped? I did not take the idea seriously before, with regard to the child or the mother, not for more than a moment, but now—"

"Nor should you," Master Baldwin interrupted. "Not if Catherine wrote to Fulke. Avise has Cordell safe. Somewhere."

Fulke wanted to believe that, but what he knew of Avise's past

did not inspire confidence. She'd come from a world of thieves and whores. What if she'd decided to return there?

"Avise," Lady Appleton murmured. "Could *Avise* have strangled Lady Russell?"

Fulke knew already, from Toby, the essentials of the tale, but he asked to hear them again.

"That's the difficulty," Lady Appleton admitted. "There is much confusion. From all reports, Catherine herself does not know what happened that day, unless she has remembered since leaving here." As she spoke, she fumbled in the placket of her skirt and produced several slips of paper. "I tried to make lists of what we know, but they are woefully incomplete."

Fulke took the papers and read. All Leigh Abbey retainers had been taught both reading and writing, thanks to the forward-thinking ways of Lady Appleton's father.

The first page listed where people had been at the time Lady Russell died:

Una and Dugald—carpet merchant's shop
Cook and scullion—fish market
Two maids—with laundress
Avise and Cordell—Greenside
Sir Lachlann—en route from Stirling
Malcolm Logan—will not say
Annabel—unknown
Catherine—with Lady Russell but also fell down the
     stairs and was unconscious for an unknown time

The second list told Fulke that Annabel MacReynolds had arrived on the scene before any of the household returned. Una and Dugald came next. He remembered the names: Catherine had spoken of her mother-in-law's devoted servants. Then Sir Lachlann Dunbar. Fulke knew that name, too: Gavin's guardian.

"Why is Dunbar written down twice?" he asked. The second

time it was together with two other names, Andrew Borthwick and Malcolm Logan.

"He talked to Catherine, then fetched the bailie. They encountered young Logan on the way back to Glenelg House. By then, Catherine and Annabel were gone. Una is convinced Catherine strangled her mistress. It appears that someone did." Lady Appleton looked more discouraged than Fulke could ever remember seeing her.

He turned to the last page. Suspects, he presumed. Four names were written there: Annabel, Dunbar, Logan...and Catherine.

"Catherine is no murderess!" Fulke blurted.

"No, she is not," Lady Appleton agreed. "She would never deliberately hurt anyone. But if...somehow...an accident—"

"It is difficult to strangle someone by accident," Master Baldwin said.

"Self-defense, then."

"I will not believe such a thing of her," Fulke insisted. "There must be another explanation. That Avise did not do as Catherine asked her to is suspicious, do you not agree?"

Lady Appleton took the papers back, fetched pen and ink, and added Avise as a fifth suspect.

"Do you wish to reconsider the trip to Stirling?" Master Baldwin asked her.

"Perhaps we should stay in Edinburgh awhile longer. We did not think to seek information on Avise and Cordell at Greenside. They went there to hear the town waits play," she added for Fulke's benefit. "Or so Una said."

"Do you believe her? Mayhap her name should also be added to your list."

"She was with Dugald when her mistress died."

"So she says. She might have returned early and gone away again."

"She's the only one who seems genuinely sorry Lady Russell

is dead," Lady Appleton said. "I believe she has told us all she knows."

"If the child is hidden nearby, she's hidden well." Master Baldwin rested one hand on Lady Appleton's shoulder. "Once you've talked to the boy, we will return to Glenelg House. He may have some idea where to look for his sister."

"There is sense in that," Lady Appleton agreed. "Will you come with us, Fulke? I would welcome your insights."

He bowed, acceding to her wishes only because he was unable to think of anything more useful to do for the nonce. He had no inkling where Avise might have taken Cordell. It was possible they were in England, after all.

Or dead.

The latter outcome being too dire to contemplate, Fulke resolved not to think about it. He turned to leave the room and for the first time realized it must have been Catherine's bedchamber before she fled. A portrait depicting Gilbert, Lord Glenelg hung in a place of honor. He stared at it for a long moment before his hungry gaze surveyed the rest of the chamber, seeking further traces of Catherine's occupancy. There was little to see. Lady Appleton had been in residence for nine days. Not even the scent of violets lingered.

*     *     *

WITHIN an hour they were on their way to Stirling. Fulke had resigned himself to another long journey, but once on the road, he found he could not simply go along for the ride. Deliberately, he attached himself to the maid, Una, flirting a bit even if she was far too old for him.

"You lived a long time in England, I do think."

"And would again," Una declared.

Reason to murder the mistress who'd insisted she return to her homeland? Fulke wondered.

"What brought you here, Goodman Rowley?"

Fulke gave the excuse they'd agreed upon—he'd come to

deliver messages to Lady Appleton from her steward. He made no mention of Catherine.

Una chatted freely, seeming glad of his company. She had opinions about everyone in the household, the most likely reason that none of the others wanted to ride with her. Another was her harshly nasal voice. "I never liked that Avise," she declared, repeating the claim she'd made to Lady Appleton that Avise had a lover. Lady Appleton discounted the notion, but Fulke was not so sure. Avise might not trust men, but he'd wager a reformed whore knew a trick or two for attracting them.

"Lady Glenelg must have trusted Avise," Fulke remarked, "or she'd never have let Cordell go with her to hear the town waits."

"Spoils that child," Una declared.

"Lady Glenelg or Avise?"

"Both."

Fulke waited. In truth, now that he was thinking more clearly, he realized he could easily imagine Avise taking a life to protect herself, or Cordell, or Catherine.

"The girl is daft about the sound of bagpipes. Wouldn't stop begging to go till Lady Glenelg agreed to let Avise take her to hear them."

Fulke absorbed this in silence. He'd spent a good deal of time with Cordell when she lived at Leigh Abbey, teaching her to ride as well as taking meals with her and her mother and brother. That the child should have decided she loved the sound of bagpipes surprised him. Most English people, himself included, did not. Then again, like her mother, Cordell had always had a mind of her own.

He thought about the Edinburgh he remembered from that long-ago mission to Scotland with Sir Robert. It occurred to him that he knew more about the city than Master Baldwin, for all that the merchant had useful associations from the outland trade.

Abruptly leaving Una's side, he spurred his horse and cantered up to where Lady Appleton and Master Baldwin rode. "I must go

back to Edinburgh," he told them. "I think I know how to find Cordell."

## 🦚19🦚

*September 25, 1577*
*Stirling, Scotland*

CATHERINE and Annabel entered Stirling through the Barras Port at the southeast corner of the town. It was an elaborate gateway but not well guarded. To the west, on a height of land, stood the castle, a formidable stone edifice nearly as imposing as the one in Edinburgh. Catherine's spirits ebbed. It would not be so easy to penetrate those walls, yet she and Annabel must find a crack in the defenses if they were to rescue Gavin. She looked away, disheartened.

A cairn of stones marked the place where the earl of Lennox died during a raid on Stirling in 1571. Regents did not long survive in this misbegotten land. Gilbert had said that, Catherine recalled with a pang. Lennox, the king's grandfather, was the one who had summoned her husband back to Scotland. Gilbert had not intended to obey, but neither had he planned on dying of the plague to avoid the order.

"The earl of Morton has a house here," Annabel remarked in a conversational tone when they reached the market cross. "It was his before he was regent. Rebels set it on fire once."

Catherine stared without much interest at the house Annabel indicated. The Tolbooth on the southern side of the High Street held her attention longer. It seemed to loom over them as they rode past. Would she end confined within those walls or in a dungeon in the castle? Either fate was dauntingly possible.

They continued on, up the High Street, but the parish church

and the wynds on either side were of as little import to her as the walls on the southern and eastern flanks of the town or the dikes and walls to the north. Only the castle mattered. Only getting Gavin out.

Her insides tightly knotted, Catherine grew more and more agitated the closer they came to her goal. Mouth dry, heart racing, she recognized the signs of fear but would not give in to them. She was thinking more clearly now than she had in weeks. *I cannot fail*, she vowed. *I will not.*

"This way." Annabel rode straight through the gates of Mar's Wark, the newest and largest house in town. "Nice work," she commented, admiring the façade decorated with stone carvings, panels, and gargoyles. "I've been told the building material came from the ruins of Cambuskenneth Abbey."

"This is the countess of Mar's house," Catherine objected, recognizing the carved coat of arms. The late earl had been regent after Lennox and before Morton. "We will be recognized!"

Annabel chuckled as she dismounted. "Have you looked at yourself? At me?" She caught Catherine's arm the moment she was off her horse and tugged her toward the back of the house.

Since leaving Linlithgow, both Catherine and Annabel been dressed as servants. Annabel had also rinsed Catherine's hair with a preparation that made her dark brown tresses dull and drab. Annabel showed alarming skill in the art of disguise, able to change her walk, her bearing, even the contours of her face by adding a squint and padding her cheeks. Moreover, she seemed to enjoy assuming a false identity.

Her attitude made Catherine uneasy. Annabel had warned her repeatedly not to be rash, but Annabel herself, in this mood, seemed ready to take one foolish chance after another.

"Never fear," Annabel whispered. "We are expected."

True to her word, they were admitted by an upper servant and taken to the maids' dormitory. How, Catherine wondered, had Annabel arranged that? And wouldn't the other servants be suspicious

that two new maids should arrive on horseback? Poor, sad crea-
tures, it was true, but better than such persons should have.

"Say nothing," Annabel hissed. "Remember that you are pre-
tending to be simple. Otherwise your speech will give us away."

With the sense she was walking into a lion's den, Catherine
kept her expression vacant and her lips pressed firmly together. A
short time later, she and Annabel had been assigned a boarded bed
to share, most luxurious for servants. The wooden box stood on
four short legs and had a straw mattress and a narrow shelf for a
candle.

The entire house spoke of sumptuous living. Catherine had
thought Jean excessive when it came to furnishing Glenelg
House, but the owners of Mar's Wark had spared no expense to
make the place both comfortable and impressive. Glass, imported
from France or the Low Countries, filled every window. Any wall
not hung with tapestries had been painted in bright colors. Sten-
cils had produced an attractive pomegranate design in Lady Mar's
withdrawing room. The furniture, too, was massive and costly,
and included several heavily ornamented box chairs decorated
with Latin script on the back.

The stone floors were equally impressive, as Catherine soon
had reason to know. Within an hour of their arrival at Mar's Wark,
she and Annabel had been put to work scrubbing them.

Annabel seemed to enjoy even that! For Catherine, it was
agony. Muscles already screaming from the long, uncomfortable
journey, now throbbed with pain. She did not need to worry that
anyone would recognize her, she thought. From now on her face
would be contorted in a horrible grimace.

As the afternoon wore on, Catherine decided that in future—
should she have a future—she would see to it that her maid-
servants were paid higher wages. The flagged stone floor in the
Hall was the worst chore. First it had to be swept, then scoured
with shave-grass, and finally scrubbed on hands and knees with a
brush.

Catherine was turned away from Annabel, attacking a heel-mark on the pale stone, when a sudden flash of memory assailed her. She saw herself at the top of the marble stairs at Glenelg House, struggling to keep her mother-in-law from striking her. Her cheek blazed with pain where Jean had already clawed her. And then they began to fall.

"What is it?" Annabel demanded in an irritable whisper. "You cried out."

"Nothing. It is nothing." Heart racing, eyes wide, Catherine returned to her task with a vengeance.

She'd *remembered* something. For the first time since the fall, she'd recalled a bit of what had happened just before. There had been a struggle, but *Jean* had attacked *her*, not the other way around. At the top of the stairway, Catherine had held her mother-in-law's wrists. Her hands had been nowhere near Jean's throat.

What did it mean? Catherine still could not remember the fall itself. Had she still been conscious when they landed? Had she turned to Jean then, taking advantage of a woman so stunned she was unable to put up a fight, and strangled her? Or had Jean tried again to attack her? Had Catherine killed her to preserve her own life?

A vicious headache was the only result when Catherine tried to recollect more details of that fateful day. She could almost imagine herself striking the other woman to ward off an attack, but to put her hands around Jean's neck, to squeeze until the life went out of her, that was too terrible to contemplate. Nothing could justify such an act.

She was shaking so badly that the brush fell from her hands and slid across the floor. She scrambled after it, head down, and nearly ran into Lady Mar's housekeeper, come to check on the new servants.

The woman muttered something in Inglis. Catherine hunched her shoulders and bowed her head. She did not speak until she

and Annabel were carrying the dirty water to the "sink," a hole in the ground outside the house that had been lined with rocks.

"What did you say to her?" Catherine asked.

"I reminded her that you were simple-minded and told her you were also mute."

Annabel lied well. For the first time, Catherine wondered if she had been wise to trust her old friend. Was Annabel lying to her, too?

There was no reason why she should, Catherine told herself as they finished the floor cleaning by putting down alder leaves to catch fleas. It must be a combination of exhaustion and nervousness that made her jump at shadows and suspect the one person who had been willing to help her.

Catherine could not afford doubts. Not at this stage. Gavin's rescue depended upon Annabel's help. They were here, accepted as maidservants. She would not question how or why. She would trust Annabel and soon, very soon now, they would gain access to Stirling Castle itself.

## ༀ20ༀ

*September 25, 1577*
*Glenelg House, Burgh of the Canongate, Scotland*

THE SERVANTS still in residence at Glenelg House when Fulke Rowley returned were suspicious of him at first, but they all knew Avise, and the cook had a soft spot for Lady Glenelg's little daughter. In time, Fulke won their confidence, but it was full dark outside before he convinced one of the maids to go with him to search the nursery.

Although he was certain Lady Appleton had already examined Avise's possessions, he went through everything with great care.

The maid, a gangly lass named Ailis, cooed in admiration when he located Avise's cache of coins. They glittered in the glow of the candles Fulke had lighted.

"Strange she would leave this," Fulke remarked.

When Ailis said, "That must be what she tried to come back for," he picked her up and twirled her around. He was laughing when he set her on her feet again. "When was she seen?"

Her answer doused his elation and filled him with dismay. Ailis had seen Avise outside Glenelg House just after Lady Appleton departed for Stirling, but she'd gone away again without speaking to anyone. Neither had she slipped into the house to retrieve her money.

Had she come to ask for help for herself and Cordell? That seemed likely, especially if she had heard that an English gentlewoman had taken up residence at Glenelg House. When she'd arrived to find her gone, she'd been unwilling to trust anyone else.

There was hope, then, Fulke decided. Avise was still in the vicinity. If his plan worked, he would soon locate her.

The next morning, he went to Greenside. Cordell loved the sound of bagpipes. That he knew. Likely she'd beg to be taken to hear the waits play when next they performed. Avise, who doted upon her charge, would be hard-pressed to refuse her the treat. After all this time, she would think it safe to come out of hiding for a brief outing. Why not, when she had already ventured as far as Glenelg House?

Unfortunately, the town waits had no performance planned at Greenside until the following week. Fulke could not afford that long a delay. He retraced his steps, then entered Edinburgh. He took along the heavy money pouch Master Baldwin had given him and put into effect the scheme that had sent him rushing back to Canongate in the first place.

In less than an hour, everything was in readiness. He gave the signal and fought the urge to cover his ears. The piper was loud,

and to Fulke's mind, discordant, but he soon drew a crowd and those who came to listen appeared to enjoy the music.

The ploy did not work in Cowgate. They moved on to a spot near the West Port. Next came Castle Hill, separated from the castle itself by an impressive dip in the ridge. Castle Hill, Fulke recalled, was the hill on the way to Edinburgh Castle. That fortress itself sat on top of another height of land called Castle Rock.

A spot on the shore of the Nor' Loch yielded no better success, but at last, in Blackfriars Wynd, surprisingly close to the place where Annabel MacReynolds kept lodgings and the final stop Fulke had planned before moving on into Canongate, he spotted his quarry.

Cordell was a slip of a girl with her mother's deep brown eyes and her father's reddish-brown hair. Beside her stood Avise, plain-faced and middle-aged, as much gaoler as nursemaid. One hand rested protectively on her young charge's shoulder while she swivelled her head in a continual search for potential danger.

Fulke approached cautiously. The child would not fear him, but Avise was another matter. He was still a few feet away when Avise caught sight of him and cried out in alarm.

She would have run, dragging Cordell after her, had not the little girl also turned and recognized Fulke. Her face alight, she broke free from her keeper and ran straight into his arms. "I have lost Mama," she announced, clasping her hands about his neck when he squatted beside her. "You must help me find her."

"Indeed I will, Mistress Cordell, but first I must talk to your good nurse."

He rose, lifting her, and carried her to where Avise waited, poised for flight. Torn between her duty to Cordell and her desire to escape, her eyes had the wild look of an animal caught in a trap.

"Well met, Avise." Fulke spoke to her in calming tones, as he would to a fractious mare. "I must thank you for keeping your young charge safe."

The piper struck up another tune, distracting the child, and under cover of the din, Fulke questioned Catherine's servant.

Unfortunately, she knew naught of what had happened the day of the murder. She had taken Cordell to Greenside. They had been on their way home when Mistress MacReynolds and Lady Glenelg stopped them on the hill.

"Annabel MacReynolds? *She's* the one who told you to go to Leigh Abbey?"

Avise nodded. Mistress MacReynolds had apparently convinced Catherine that it would be safer for all of them if the child was in Susanna's keeping. Avise wisely had recognized the dangers inherent in such a long journey, and instead of setting out for England, had gone to the one friend she'd made since coming to Edinburgh, a baker named Sim Urwen. Fulke did not inquire into the nature of their friendship. He was too relieved that Avise had kept Cordell safe.

"You've heard that your mistress is accused of—" he broke off, mindful that Cordell was now hanging on every word "—that your mistress is sought by the authorities?"

"Aye. In Canongate, but not in Edinburgh."

"And you know that Lady Appleton came to Scotland?"

As Fulke had guessed, that was why Avise had risked a visit to Canongate. But she'd begun to doubt even Lady Appleton when she'd seen that gentlewoman leave in company with Sir Lachlann Dunbar. "He's the poxy roarer brought the bailie to Glenelg House," Avise complained.

"So he did," Fulke agreed, "but it was Malcolm Logan who brought charges."

He'd had only the briefest of contact with Lady Russell's nephew. Lady Appleton had warned him to keep his distance from the fellow when Fulke, upon first hearing of Logan's accusations against Catherine, had unwisely let his anger show.

Avise said something unintelligible in thieves' cant, then spat.

Fulke cradled Cordell closer. She had heard all they'd said,

but he was uncertain how much of it she'd understood. "Are you happy where you are?" he asked the child.

"Sim is nice. He bakes bread and pies and pasties. And bannocks," she added after a moment. "I do not like those so well."

"Will you stay with Sim and Avise a little longer? Until I can find your mother and bring her to you?"

Cordell's solemn nod reassured Fulke and gave Avise no choice but to lead him to Sim's shop.

"I do not know how matters will fall out," he admitted to Avise when Sim had distracted Cordell with a fresh-baked cherry tart, "but you must keep the child close. Do not let anyone take her away but Lady Appleton or Master Baldwin—or Lady Glenelg or myself."

Avise's face was grim as she agreed.

"No one else," Fulke repeated. "And be prepared to go with one of us at a moment's notice. When Lady Appleton succeeds in locating Lady Glenelg, she will try to persuade her to leave Scotland without delay." They could not count on convincing Logan to trade the criminal charges for a civil suit.

"Did she kill Lady Russell?" Avise asked.

Fulke's unhesitating denial seemed to reassure her.

He left the bake shop, reclaimed his horse from the stables at Glenelg House, and set out once more for Stirling. The satisfaction he felt at finding Cordell was dimmed by the doubts he heard expressed at every hand. The threat to Catherine was even greater than he'd supposed. How could he trust anyone, even Lady Appleton, to keep her safe when he was the only one who truly believed her to be innocent?

## 🦢21🦢

SUSANNA HAD no difficulty entering Stirling Castle. Sir Lachlann Dunbar's influence as young Lord Glenelg's guardian paved the way, as did the excuse that Gavin needed to be told of his grandmother's death. In what was now becoming Susanna's usual practice, she conversed in French with Nick assisting in the translation as necessary.

"Poor little lad," commiserated the countess of Mar when she heard the reason for the visit. She sat on a high-backed settle, an embroidery hoop in her lap. At a little distance, on plain four-legged stools, were two waiting gentlewomen, similarly occupied.

Since the countess was nominally in charge of the household at Stirling, Sir Lachlann had recommended that Susanna apply to her for permission to visit the boy. "Sharp," Lady Tennant had called her, but that was not the first impression she gave. She fidgeted a bit, fiddling with the trim on the small velvet cap she wore over her auburn curls. Then she went back to her stitching.

"Why is it you are the one to tell him the news, Lady Appleton?" Lady Mar now kept her head bent over her needlework and her hands busy. "Where is his mother?"

"She was unable to come to court at this time," Susanna hedged. "It is as the boy's godmother that I come in her stead." Since neither she nor Nick had been offered a seat, they remained standing. Susanna glanced at him, but his face was carefully blank, giving away nothing of what he might be thinking.

"We call godparents 'witnesses' here since the Reform," Lady Mar warned. "Have a care you do not misspeak and give Master Buchanan the wrong impression." She signaled to one of her women and told her to fetch a servant to take Susanna to the schoolroom.

Master Buchanan, Susanna knew, was George Buchanan, the royal tutor. She had heard of him while still in England. He was renowned as a Latin poet and satirist for writing he'd done in his younger years and was a distinguished scholar. Now in his seventies, he'd recently published a play.

While they waited for Susanna's escort to arrive, Lady Mar asked idle questions about England. When she realized that Susanna's late husband, Sir Robert Appleton, had been known to her during Mary Stewart's reign, her needle paused over her embroidery. "Indeed," she murmured. "I think you must come and sup with me this evening at Mar's Wark." It was more command than invitation.

Susanna had only time to agree before the young man assigned to be their guide appeared to lead them away.

"She is not what I expected," Susanna whispered to Nick. "For one thing, she never gave me the opportunity to offer her a gift." She had brought a bribe with her, a pendant bought from one of Nick's merchant friends. It was a pretty trifle in the shape of a leafy branch with pearls for berries, and suitably expensive.

"Mayhap that is why she issued the invitation to visit her home," Nick suggested.

They did not have time to speculate further. From the countess's rooms, her servant led them back outside at a rapid pace, taking them through a quadrangle surrounded by royal buildings, into a very grand structure, and up several flights of stairs.

"Master Buchanan's study," their escort said, opening a door.

The man inside sat with one leg propped up on a cushioned stool in front of him. His foot was horribly swollen. Gout, Susanna surmised, which would also account for the sour expression on his face at their invasion of his privacy.

"Lady Appleton and Master Baldwin, sir."

"Another bloody woman," Buchanan muttered. "Young, come here!"

Buchanan's assistant, Peter Young, appeared almost instantly,

and with a minimum of fuss escorted Susanna and Nick into the adjoining schoolroom. When he heard Susanna's name, his reaction was far different from his superior's.

"What a pleasure to meet you," Young said in excellent English. "Your efforts on behalf of your co-religionists are still spoken of in Geneva."

"I did very little," Susanna demurred, though she knew very well that had she been caught smuggling condemned Protestants out of England during the brief reign of the Catholic Mary Tudor, she could have been executed herself. There was a good deal of irony in the fact that, years later, she had also helped certain radical Catholics flee the country to escape punishment at the hands of Mary's successor, Queen Elizabeth.

As Master Young continued to sing her praises, Susanna examined the empty schoolroom. It was distressingly barren, containing only benches and tables with writing implements laid out. The room that served the same purpose at Leigh Abbey was decorated with brightly colored maps and filled to overflowing with books.

"What lessons are given here?" she asked.

"Greek before breakfast. Afterward the boys study Latin, history, composition, arithmetic, cosmography, dialectics, rhetoric, and theology."

"A full day."

"That is just the morning. In the afternoon there is Bible reading and exposition, geography, astronomy, French, English, Italian, and Spanish."

"What of the languages of this country, Master Young? Inglis, I believe the lowland dialect is called, and sometimes Scottis, but Highlanders speak a different tongue entirely, more like the language of Ireland."

"The king was fluent in Latin before he spoke Scottis," Young admitted. Then his infectious grin reappeared. "Many years ago, the Spanish ambassador to the Scots court made an observation

that remains true till this day. The Scottish language, he said, is as different from English as Aragonese is from Castilian, and the languages of the savages who live in some parts of Scotland and on the islands is as different from Scottish as Biscayan is from Castilian. And, in truth, folk in the Orkneys are more likely to converse in the language of Norway than in either of Scotland's native tongues."

She smiled appreciatively back at him. "Your young king is indeed fortunate if he has an affinity for languages."

"At the age of eight, King James was able, extempore, to translate a chapter of the Bible out of Latin into French and then into English."

"Religion, then, is also part of the curriculum? The Church of Scotland, I believe, has undergone a change since the death of John Knox."

Young stiffened at the hint of criticism in Susanna's voice, but she did not elucidate. She'd had no reason to be fond of Knox's brand of reform. Not after reading his diatribe against women rulers.

"The good influence of Geneva has been brought to bear," Young told her. "Never fear that the king and his fellow scholars will neglect their faith. They are well versed in all matters spiritual. In addition to the lessons I spoke of, both morning and afternoon, they customarily read and discuss a chapter of the Scriptures at every meal."

"All that is most commendable, Master Young, but young boys also need exercise and training in the social graces. Are they taught to dance?" She'd not thought that particular skill important when she'd first set out to educate Rosamond. She'd had reason since to change her mind. If naught else, dancing provided excellent indoor exercise.

"The education designed for the king by the Estates of Scotland is not entirely bookish," Young admitted. "There is dancing. And in addition to garden games, the king receives training in

martial exercises, riding, and hunting. At this very moment, the boys are being given instruction in wrestling."

"Surely Gavin is too young to engage in such a vigorous pursuit? I understand the other lads are somewhat older than he is."

"True enough. He is the youngest by several years. For the nonce, he serves as squire to an older boy, the earl of Mar." Young grinned. "He brings Mar water to drink between bouts, as William Murray of Abercairney, another of their company, takes water to the king. It is a great honor to wait upon the king, Lady Appleton, even in so humble a role."

"Can Gavin be spared from such important duties?" She made an attempt to keep the sarcasm out of her voice but was not certain she'd been entirely successful.

"No doubt he can. May I show you the castle library while someone goes to fetch him? You may speak privily with young Lord Glenelg there." This time leaving Nick behind, since Gavin scarce knew him, Young led Susanna into a smaller room.

"I appreciate your consideration. I have been given the unhappy task of telling the boy that his grandmother is dead."

If Young thought this odd, he did not say so. Instead he opened the first of several book chests that furnished the room. "Queen Mary left a good many volumes behind and I have added to them."

Mary, queen of Scots, King James's mother, had abdicated in his favor and fled the country ten years earlier, only to end up as the prisoner of her cousin, Elizabeth of England. As a Catholic, Mary posed a constant threat to both England and Scotland, for there were those who wished to restore her to the Scots throne and usurp Elizabeth in order to return Roman Catholicism as the state religion of both countries.

Mary's books were largely in French but Susanna was pleased to see that the collection contained more diversity than Buchanan's scholastic regimen implied. Among the additions Young claimed credit for were copies of the *Songs of Pantagruel*, the two-volume *History of England, Scotland and Ireland,* and Aesop's *Fables*

in English. Susanna passed the time until Gavin arrived in pleasant discussion of the latter with Master Young.

"You have grown," Susanna told the boy.

He was taller than when she'd last seen him, but he had lost the sparkle in his eyes and the healthy color that had once blossomed on his cheeks. Too much study, she decided, and not enough fresh air.

"I am smaller than everyone else," he said, watching Peter Young until the tutor left the room. Then he turned eagerly to Susanna. "Did Mama come with you?"

"No, Gavin. And I am sorry to say I have bad news for you. You must be brave. Your grandmother has died."

The boy blinked owlishly at her but said nothing.

Disconcerted, Susanna also fell silent. She could scarce tell him the circumstances of Lady Russell's death, but some comment seemed called for. "She had a long life," was the best she could do.

"She was *ancient*. And she did not like me very much. Why did you come and not Mama? Mama promised she would come. She said she would find a way for us to go home to Leigh Abbey."

Susanna yielded to the impulse to take the boy into her arms. He was not too big to hug, no matter what his tutors might say. Both she and Gavin were close to tears by the time she released him.

"I want to go home," he whispered.

"Have you been unhappy here?" she asked in an equally low voice.

He hung his head. "They all tease me because I am small, and pinch me because I am half English." He pushed back one sleeve to reveal a galaxy of bruises.

"Master Buchanan—" She broke off at the look of fear on Gavin's face. "Does Master Buchanan mistreat you?" She knew some schoolmasters believed that beating their pupils was the only way to make them learn.

"He bellows. All the time. And he curses. And once, when the king and Jocky o' the Sclaitiss were arguing, Master Buchanan struck the king." Gavin looked horrified at the memory, as well he should.

Had anyone struck Elizabeth of England, Susanna thought, he'd have ended with his hand on the chopping block, if not his head. But she was also aware that boys were prone to exaggeration.

"Tell me the entire story," she instructed. "Start with Jocky. Who is he and what meaning has his name?"

"Jocky o' the Sclaitiss is the earl of Mar," Gavin explained. "Jocky for John, and *sclaitiss* are slates. The king calls him that because he is skilled at mathematics."

Somewhat enlightened, since she knew young scholars used slates, and pencils made of soapstone to do their sums, Susanna urged him to continue.

"Jocky took one of his mother's birds out of its cage. A linnet. The king wanted to hold it and when Jocky would not give it up, the king lost his temper and tried to wrestle it away. The linnet was crushed as they fought."

"Poor creature."

"The countess was most upset, but then Master Buchanan came. The noise disturbed him in his study—he is writing a history of the reign of Queen Mary—and he came to see what the fuss was about. When he saw the dead bird he gave the king a box on the ear and told him—the king, that is—that he was a true bird of the bloody nest from which he sprang. He is always saying things like that, harping on how the king's mother committed adultery and murdered the king's father and was deposed."

An involuntary protest escaped Susanna. No matter what errors in judgment Mary, queen of Scots had made, no one should speak of her so to her only child.

"Then he thrashed Jocky soundly," Gavin continued, wincing at the memory. "When Lady Mar tried to stop him, he swore at her most horribly."

Gavin sounded reluctantly impressed by the swearing, but when Susanna hugged him again he cuddled closer, accepting what comfort she had to offer.

"Inverahyle says he flogged the king once."

"Is Inverahyle another of your schoolmates?"

Gavin nodded. "His father was Donald the Hammer."

The reference was lost on Susanna, but she did not suppose it mattered.

"Inverahyle told me that Lady Mar was most upset. She told Master Buchanan that the king is the Lord's Anointed and must not be beaten. But Master Buchanan paid her no mind and do you know what he said to her? He said, 'Madam, I have whipped his arse and will again but you may kiss it if you like.'"

The man must be mad, Susanna thought. Did he not realize that the boy he so abused would one day have the power of life or death over him? Chilled by the realization that this same monster had the right to inflict punishment on the boy she held tight against her bosom, Susanna choked out a question: "Has Master Buchanan ever struck you, Gavin?"

"I take great care to stay out of his way." In a faint voice, he added, "That is the only benefit of being small."

"Oh, Gavin, I wish I could take you away with me, but you are a Scots nobleman. Your place is here."

"I do not want to be a lord. Why must I?"

Susanna had no answer to give to him. He had been born into the responsibility. She'd heard of men who refused a new title when it was offered. Sir Henry Sidney, the husband of one of her oldest friends, had done so, saying he could not afford the honor of becoming a baron. But she did not know of anyone who'd voluntarily given up a title he'd inherited.

"I do not like it here," Gavin whispered. "Why must I stay?"

Susanna's heart went out to him. She longed to take him away with her and knew she could not. "The regent himself approved your appointment. To remove you without the earl of Morton's

permission would cause a great deal of trouble. It might even provoke an incident between Scotland and England." Susanna doubted it would start a war, but the Border was always in what Catherine had once called "a tickle state" and one never knew what could explode that particular powder keg.

"Please try. Mama says you are the most clever woman she has ever known. You must be able to think of something to do."

Susanna wondered if being the son of a murderess would be enough to convince the regent to remove Gavin from the king's presence. She doubted it. Not when Master Buchanan made the same charge against the king's mother.

"I will do what I can," she promised the boy. "I lodge at Dunbar House. Perhaps you will be allowed to visit me there."

Gavin brightened. "I know where that is. I stayed there with my guardian before I came to court."

Susanna hesitated. "Did you like Master Dunbar?"

"I did not see much of him." Gavin seemed puzzled by the question. "But his youngest daughter, Sibeal, was there and she was nice to me. She is very pretty, too."

Peter Young interrupted them at that point. "My apologies, Lady Appleton, but the king is asking for Lord Glenelg."

With a sigh, Susanna gave the boy one last hug and sent him back to his schoolfellows. He went so reluctantly that she started to follow him.

"He is not going to the gallows, Lady Appleton," Young assured her. "Come, there is a window nearby that overlooks the bowling green."

She watched from that vantage point as Gavin rejoined the others. She was relieved to observe that they welcomed him back with no more than the usual friendly joking and shoving common among boys.

The only one who showed impatience with him was a tadpole-shaped lad of average height who advanced on Gavin with uneven, erratic steps. He had spindly legs and one foot turned

outwards, which explained the awkward gait. Susanna's gaze narrowed. The boy had thick, light brown hair darkened by his recent exercise, heavy-lidded eyes, and a face pitted by a bout with smallpox. There was something familiar, she thought, about that long nose and small mouth. It came to her an instant later.

Susanna had never met Mary, queen of Scots, but she had seen the woman's portrait. This was unquestionably her son, King James VI of Scotland, the boy who would, in all likelihood, also be king of England someday.

The young king reached Gavin's side. Without warning, he lashed out, giving Gavin a hard box on the ear.

Susanna gasped. Young caught her arm to prevent her from doing more.

Seething helplessly, she could only watch and listen as James of Scotland proved he'd learned one of George Buchanan's lessons well. He launched into a denunciation of Catherine Glenelg, in English, in tones so ringing that the words carried easily to the window where Susanna stood.

Between Gavin's departure to visit his godmother and his return to the bowling green, someone had told the king that Lady Russell had been murdered and that Lady Glenelg had committed the crime.

## 22

*September 28, 1577*
*Dunbar House, Stirling, Scotland*

"WHO COULD have sent word to the king?" Nick asked when he'd settled Susanna on the wooden bench he'd hauled close to the hearth. She had just finished giving him an account of her conversation with young Lord Glenelg and the aftermath.

They were in the Hall of Sir Lachlann's house. Hung with painted cloths instead of tapestries and boasting only a few massive pieces of furniture, this fine, high room was surpassing drafty. As servants seemed in short supply, Nick kindled the fire himself.

"Any number of people, I suppose."

"Lachlann Dunbar?" he suggested.

"Why? Such an action makes no sense if he wants his ward to remain in favor at court."

Susanna rubbed her hands together before the flames to warm them. Nick did the same, but he suspected the chill came as much from their sense of betrayal as from the coldness of the room. "Perhaps he thought it wise to tell King James before someone else did," he said.

"Not if he told us the truth when he said he hoped Catherine would escape from Scotland."

"Oh, he'd be pleased to have us smuggle her out of the country, so long as our activities do not go against his own interests. They come ahead of those of his ward, and certainly well before the welfare of Gavin's mother."

"But Nick, now that the king knows Lady Russell's death was murder, he could demand that Catherine be hunted down and put on trial. And if he sends young Gavin away from court, how will that advance Lachlann Dunbar? How would it help anyone but Gavin himself? The boy most earnestly wishes to leave the king's service."

"Not at the cost of his mother's life!"

"No, and no one with Gavin's interests at heart would do anything that might harm Catherine." Susanna turned to face Nick, her gaze intense. "Dunbar would not send word to the king, but Malcolm Logan may have. His position as Master of Glenelg would give him that much clout. Mayhap that was why he was so insistent about accompanying us to Stirling."

Nick pondered the idea. Logan had made the journey with them and was lodged here in Dunbar House, but he'd kept to

himself. Since he'd offended no one lately, it had been easy to overlook his presence.

"I've no doubt he'd welcome any chance to cause more trouble for Catherine, and her capture would be to his advantage if he seeks monetary compensation for Lady Russell's death. But—" He broke off as he suddenly realized where Susanna's speculations had taken her. "You think Logan wants Gavin away from court, away from the protection that surrounds the king?"

It made a terrible kind of sense. Logan stood to inherit the title if young Lord Glenelg died. Nick poked at the fire, jabbing a log into place with more than necessary force. Had that been his plan all along? Bring criminal charges against Catherine. Wait for the king to hear of them…but the king did *not* hear, prompting Logan to take matters into his own hands.

"Malcolm was in residence at Glenelg House when Lady Russell died," Susanna said. "He refuses to say where he spent that day." The color leached from her face. "What if he killed his aunt in order to create the opportunity to frame Catherine and draw Gavin out so he could be murdered?"

"A convoluted plot. Is Logan capable of such Machiavellian thinking?"

Susanna sent Nick a defiant look. "This theory makes as much sense as *Catherine* strangling someone."

"But it has a flaw. How could Logan count on Catherine's losing her memory?" Privately, Nick thought Catherine *had* killed her mother-in-law, but he forbore saying so.

Susanna's shoulders sagged. Her expression bleak, she contemplated the fireplace. "Mayhap you are correct and I am too quick to condemn young Logan, equating his rough manner and his envy of Gavin with a propensity for violence, but there must be some reason he will not say where he was when his aunt died."

Nick reached along the bench to squeeze her hand.

"We must find Catherine, Nick. We must help her, no matter what happened that day at Glenelg House."

She looked so unhappy that Nick spoke without regard for the consequences. "We will," he promised, sliding a comforting arm around her shoulders. "I will arrange for a ship to be waiting at Leith when we need it. We will get her away before she can be seized by the authorities and brought to trial."

She smiled her gratitude. Neither spoke aloud of what else they had just tacitly agreed to. They would discover the truth, even if the truth was that Catherine Glenelg was a murderess. And if...when, they found Catherine, they would help her escape from Scotland.

## 🎕23🎕

*September 28, 1577*
*Mar's Wark, Stirling, Scotland*

"STAY OUT of sight," Annabel hissed.

Catherine retreated into deeper shadow, but she could not make herself leave the Hall. The evening was well advanced. The only light came from candles. She told herself that she could hide indefinitely in plain view of those at table. No one ever noticed servants.

Susanna Appleton was there, and Nick Baldwin. Lady Mar had invited them to sup. Amazing, when Catherine thought about it. Everyone must know by now that she was suspected of killing Jean. One would have expected the countess to shun Catherine's friends. Curiosity had won out, she supposed, over revulsion. Or perhaps Lady Mar hoped some profit would come from her kindness to the English visitors.

"The scene disturbed me," Susanna said, catching Catherine's attention. "The king struck Lord Glenelg for no more reason than that he'd heard foul gossip concerning his mother."

Catherine barely suppressed a gasp. She forced herself to remain where she was, to listen to the rest of the story. Still clearly upset by her visit with Gavin, Susanna was careful not to criticize the king, but it was obvious that she was seeking reassurance that Gavin would not have to endure further punishment.

"His Majesty falls prey to the occasional fit of temper," Lady Mar admitted, "but on the whole he is a good-natured boy, amiable and not unkind." She toyed nervously with her knife and spoon.

"Doubtless you are a calming influence, my lady," Susanna murmured.

Catherine held her breath as Annabel placed more bread on the table, moving to within a foot of Susanna as she did so. Susanna paid no attention to either food or servant. She'd scarce touched the smoked herring or the oysters, though she had tasted the sour-milk cheese. It was a fish day and the culinary offerings were paltry, a selection of salt fish and stock fish from household stores augmented by whatever could be found in the local marketplace.

"Indeed, I try to soothe ruffled feathers." Lady Mar chewed thoughtfully on a bite of merling. "It does no harm to young boys to be cosseted, no matter what Master Buchanan says."

Buchanan. Just the mention of his name made Catherine's headache worse. She gritted her teeth and tried to focus. Lady Mar would shower affection on King James. Of that Catherine was certain. But the other boys? That was less sure. And Lady Mar had no reason to be kind to Gavin.

"You mentioned that you knew my late husband," Susanna said. "Was that when he was in Edinburgh at the end of 1561?"

"It was. A good many years ago, 'tis true, but I never forget a handsome man."

"Did you also know Lady Glenelg in the old days? She was there a few years later." Susanna sampled the haddock, then helped herself to a larger portion.

Lady Mar reluctantly admitted to also knowing Catherine.

"She was great friends with one of Queen Mary's lesser ladies, I believe," Susanna continued. "One Annabel MacReynolds."

Lady Mar paused with a bit of bread halfway to her mouth. "A most unsuitable choice."

"Oh?" Susanna widened her eyes and looked interested. She'd abandoned all pretense of eating.

"She left court without permission. Vanished. There was quite a scandal at the time. Everyone assumed she'd run off with a man."

"Had she?"

"If she did, she had rid herself of the encumbrance by the time she returned to Scotland."

"Have you seen her recently, then?"

"Why all this interest in Mistress MacReynolds?" Lady Mar sounded annoyed.

Annabel nudged Catherine in the ribs. She found this conversation amusing. Catherine did not.

"I believe Mistress MacReynolds may know where Lady Glenelg has gone," Susanna said.

Lady Mar stopped eating. "Lady Glenelg is missing?"

"Her present whereabouts are unknown." Susanna did not elaborate. "Tell me, Lady Mar, have you seen either Lady Glenelg or Mistress MacReynolds since Lord Glenelg joined the court?"

Lady Mar hesitated. Her hand lifted to fuss with the biliments decorating her headdress. Susanna detached the pendant she wore pinned to her bodice and placed it on the table.

"Lady Glenelg has not visited her son since he came here." Lady Mar's free hand closed over the piece of jewelry. Her uncertainty about how to deal with her guests abruptly vanished, along with the nervous little movements she'd been making.

"And Annabel MacReynolds?"

"I have not seen her since she left Queen Mary's court."

*Lady Mar lied.* Catherine's hands clenched into fists and she took an involuntary step toward the table.

Annabel caught her by the arm and tugged her away.

Reluctantly, Catherine followed her friend into the pantry, deserted now that the meal had been served. The rest of the servants were at table, albeit at the lower end of the board. "Mayhap we should leave here," Catherine said. "It is only a matter of time before we are recognized."

"Nonsense. No one will believe we could be so brazen as to be at Mar's Wark. Now listen, for I have learned more about Lady Appleton and her lover from his servant, a young man called Toby. They arrived here in company with Lachlann Dunbar and Malcolm Logan and are lodged in Dunbar House. They brought one servant from Glenelg House—Una—and Baldwin's man. But when they first set out for Stirling they were also accompanied by another retainer attached to Lady Appleton, one Fulke Rowley."

Catherine's breath caught. "What happened to him? Why did he not arrive with the others?"

Annabel laughed. "Such concern for a mere friend! Your Fulke turned back only a few miles into the journey. I could not discover why."

Catherine gave a little sob of relief. In spite of her desire to keep Fulke safely away from the danger she and Annabel were sure to encounter in the days ahead, she smiled. Just knowing he was nearby, that he wanted to help her, warmed her soul.

# 🏵24🏵

*September 29, 1577*
*Dunbar House, Stirling, Scotland*

SUNDAY WAS a day of rest, and to Susanna's mind, a waste of valuable time. She had no choice but to go to church and to humor Lachlann Dunbar when he provided a hearty dinner that far outshone the supper the countess of Mar had served.

That did not mean it was palatable, but at least there was meat. Minced fine, it was presented as a dish called *hachis*, served with raw tangle, which was a type of seaweed. Seaweed, she recalled, was considered good for the sight, but she did not care for the taste. Another course included ox feet. She ate a little of everything and was hungry enough to devour two servings of *crokain*, a lemon pudding.

Sir Lachlann claimed to have been unaware that the king knew Lady Russell had been murdered until Susanna told him. She found his annoyance oddly reassuring.

"What is the king like to do?" she asked.

"God knows, Lady Appleton, but I take comfort that no one sent word to me of this matter. If King James meant to banish Lord Glenelg from court for his mother's crime, he would already have done so."

"And if he had been sent back to you in disgrace? What would you have done with him then?"

"Taken him to Dunbar Island," was his answer, spoken without hesitation. "I am responsible for him, after all."

"You would consider no alternative plan?"

"Such as sending him to England with you, Lady Appleton?" Sir Lachlann's eyes narrowed. "I think not. I paid an exorbitant sum for the privilege of overseeing the Glenelg estates and arranging Lord Glenelg's future. I'd scarce let control of the lad himself slip out of my hands."

"I assure you, Sir Lachlann, I do not intend to arrange a

marriage for him or otherwise interfere with your prerogatives."

They both knew that what she wanted to was reunite Gavin with his mother. Unfortunately, Lachlann Dunbar's sympathy for Lady Glenelg went no further than his purse strings would stretch.

Throughout the afternoon, until it was time to attend evening services, Susanna had little to do but fuss and fume. The shops were closed. She knew no one to visit in Stirling besides Lady Mar. She had not the slightest idea where to start looking for Annabel and Catherine.

When Nick went off to his bedchamber to write letters, Susanna tried to interest herself in a book. She had little success. She was struggling to read a volume of French poetry in the small first-floor room Sir Lachlann had put at her disposal, when Fulke arrived.

"I have found Cordell," he announced.

"There's a mercy!" Weak with relief, Susanna sank back into the room's only chair, another of those heavily carved but ill-padded pieces of furniture that had never been designed for comfort. "She is well?"

"Very well, as is Avise."

When Nick joined them a few minutes later, Fulke recounted the steps he had taken to find the girl and her nursemaid and assured Susanna that they were safe in hiding still. Only with reluctance did he specify where he had left them.

Susanna exchanged a glance with Nick. "You need not fear we will turn Catherine over to the authorities when we find her," she said after a moment. "Master Baldwin leaves on the morrow to secure transportation. A ship to take Catherine and Cordell to some safe place."

"And Gavin? You know she will not go without him."

"She may have to, for her own safety. She'll be no good to either of her children if she's caught and hanged."

Fulke winced at her blunt words.

"We have only three choices," Susanna continued. "Find

Catherine and take her out of Scotland. Persuade Malcolm Logan to drop the charges against her. Or discover that someone else killed Lady Russell and bring that person to justice."

"Annabel, Avise, Dunbar, Logan." Fulke recited the names he recalled from Susanna's list. "Not Avise."

"Nor it is likely to be Annabel's doing," Nick put in. "She had no reason to kill the old woman." He'd been quiet for some time, standing as was his wont with one shoulder propped against the mantelpiece.

"That leaves Dunbar and Logan."

"We have given some thought to Malcolm Logan," Susanna said, and repeated most of the conversation she'd had with Nick the previous day.

Fulke listened avidly. Susanna could see from his manner that his faith in Catherine's innocence never wavered. She wished she still had as much confidence in her friend. The more they'd examined the possibility that someone else had killed Jean Russell, the less likely it seemed. Certes, there had been extenuating circumstances, but Susanna had begun to accept that only Catherine had been in a position to kill her mother-in-law.

"Where is Logan now?" Fulke asked when she came to the end of her recitation.

"He did not return to Dunbar House after church." She hoped he would not vanish again, as he had in Edinburgh, but took heart that he'd left his belongings behind. She'd sent Toby to make sure of that fact.

"He seems the most likely villain to me. And he has more reason to act against the English branch of his clan. I know something of Dunfallandy," Fulke added. "Years ago, when I was in Scotland with Sir Robert, he went there in search of information about another Lord Glenelg."

Susanna nodded. "Lady Russell's brother. Gilbert succeeded to the title because he died childless."

"Sir Robert did not take me with him to Dunfallandy. He

went in company with Mistress MacReynolds and several of her kinsmen. But he told me afterward that the Fergusons are an insular clan, suspicious of foreigners, though more than willing to give shelter to both Catholics and bandits."

Cap in hand, Fulke remained just inside the door. His stance appeared subservient on the surface, but Susanna knew better than to underestimate any of her retainers. Fulke was deliberate and slow-spoken but he was abundantly blessed with good sense and had the ability to see straight to the core of a dilemma.

"Is it worth a trip to Dunfallandy to find out more about Malcolm Logan?"

"No, madam. They'd not talk to strangers even if they had the English to do it in. Besides, Logan is here." Fulke's big, work-roughened hands curled into fists. "I do think he can be convinced to answer your questions."

"More violence will not solve anything." She spoke too sharply, and quickly moderated her tone. "It may still be possible to persuade him to drop his charges against Catherine."

"I'll *persuade* him," Fulke muttered.

"You will do nothing. Not yet. Except keep an eye on Malcolm Logan. To act too precipitously will avail us nothing and may endanger Catherine and her son. Besides, the boy is safe as long as he is with the king."

In spite of Susanna's confident words, she was as worried as Fulke about what Malcolm Logan might do. She retired to her chamber that night in a troubled state of mind. She allowed Una to help her undress, then dismissed the maid with a sense of relief. Perhaps, in solitude, she would be able to think of *something* to do, for more than anything, she hated waiting for events to overtake her.

She stretched out atop the bed, wrapped in a warm wool robe, and contemplated the tester above her head. No flash of brilliance illumined the shadows. No solution to Catherine's dire predicament, or Gavin's, magically appeared.

Exhaustion crept over her, though she had done little of a physical nature this day to tire her. She had just begun to drift into sleep when a scratching sound at the window jerked her back to wakefulness.

Puzzled, Susanna turned her head to stare at the wooden shutters. They opened inward, and there was no glass on the other side. For a courtier's residence, Dunbar House was not extravagant in any way.

She rose and approached the window as the tapping continued. A bird? There was a small courtyard below, but her chamber was in the upper story of the building. She was not unduly concerned about burglars.

Cautiously, she unlatched the shutters and pulled one toward her far enough to peer out into the night. A pair of bright eyes stared back at her.

"May I come in?" Lord Glenelg asked.

Bereft of speech, Susanna opened the shutters wide and watched as the boy scrabbled lithely over the sill and landed inside the room. He's only eight years old, she thought, impressed and alarmed in equal parts.

She said aloud the next foolish thing that came into her mind. "Have you come out all alone?"

"I escaped." Pride in the accomplishment reverberated in his boyish treble.

"How?"

"There is a hidden way out of the castle," Gavin explained. "The king's grandfather used it when he went out among his people. He liked to pretend he was a commoner."

Susanna did not know what to say to that, either.

"One of the servants told me about the secret passage," Gavin continued. "She is very old. She remembers King James the Fifth and how he would go out by way of a low sally port in the inner wall, little used even then. Once through that, he'd take the road to Ballangleich. That means 'windy pass.' The way leads up Hurly

Haaky Hill. A 'haaky' is a cow. King James used to coast down the slope on a cow's skull." He frowned. "That sounds most uncomfortable to me. I would rather use a sledge."

"Did no one see you? Did no one try to stop you?" Susanna peered out the window before she closed and latched the shutters, but she saw nothing stirring below.

"The guards do not know about the way through the wall. It is much overgrown. It is a good thing I am so small."

Susanna fumbled for a candle and lit it before she turned back to Gavin. He looked up at her with an unrepentant grin that begged for praise.

"Gavin, you must go back."

His lower lip crept forward into a pout. "I do not want to go back. I want to live with Mama again."

"That may not be possible, my darling." As gently as she could, she explained how Lady Russell had been found and why some people blamed his mother.

"I know that. The king told me. Mama murdered her in cold blood."

"The king is wrong."

"I do not care if she did strangle Grandmama," Gavin declared. "I will not go back to court."

"Is there nothing you like about living there?"

He hesitated. "I like the peacocks. We chase them around the fishponds and the flowerbeds in the gardens. Even the king."

"About the king, Gavin—did he say anything else to you about your mother? Did he threaten you in any way?" He'd not dismissed the boy from his service, but there were a hundred other methods to punish him for his imagined sin.

"No, madam." Gavin grinned. "In truth, he seems to have forgotten all about it. I do not think he will speak of it again."

"What about Master Buchanan?"

The boy paled and his smile vanished. In a voice that shook a little he said, "I do not think he knows yet, madam."

Susanna hoped that was true, and prayed no one would trouble to tell the schoolmaster. She knelt in front of Gavin, placing one hand on each of his shoulders and squeezing gently. "You have to go back, my dear. If you do not return, they will think your mother stole you away. They will hunt for her, and they will not stop until they find you both."

"They will not know where to look. If you cannot find her, no one can."

"If more people are looking for her, that will make it more difficult for me to locate her. And it may become impossible to spirit her away. Would you put her life at risk?"

Shocked at the thought, he shook his head. His earnest expression convinced Susanna he fully comprehended the danger, but when he spoke again his words sent a chill straight through her.

"When she is safe away from Scotland, I will escape again and join her."

"You must not attempt such a dangerous thing!" Alarmed, she tried to think how to dissuade him. He was clever enough, witness tonight's actions, to succeed, in at least the first part of his plan. "I will find a way for you to be together," she promised rashly. "Will you swear to wait for word from me before you leave Stirling Castle on your own again?"

"You promise you will not leave me there?" Suddenly he was a small boy again, and it made Susanna's heart ache to watch him struggle to hold back tears.

"I promise. Somehow, once your mother is safely out of the country, I will find a way to rescue you."

Susanna wished she had some idea how to keep such an impulsive pledge, but now that she had given her word, she would indeed try her best. As a last resort, she supposed she could beg the queen of England to intervene. Susanna had avoided contact with Queen Elizabeth in the past, but there were things she knew, things the queen would not want made public, that could be traded for a favor.

"Are you ready to go back to the castle?" Susanna asked.

In answer, Gavin hugged her fiercely, clinging to her as she was sure he wanted to cling to Catherine. Susanna feared she was a poor substitute, but it was a long time before she gently extricated herself from his grip and held him at arm's length.

"It is time for you to return to your schoolfellows, Gavin. Now, how can we manage it so that no one knows you ever left?"

He looked toward the window. "I can climb back down the vines."

She smiled. "I think it is safe enough to exit through the house. Everyone is surely abed by now."

She considered waking Nick, for someone should accompany Gavin as far as the sally port he'd spoken of, but she decided Fulke was a better choice. As soon as Susanna found her slippers, they set off for the stables, where Fulke had chosen to sleep.

They had traveled only so far as the Hall, and Susanna was feeling her way along in a darkness broken only by the embers of a dying fire in the hearth, when a torch suddenly flared. Caught in its light, she froze and tightened her grip on Gavin's arm.

"*Bide awee,*" said Lachlann Dunbar. "*Ye maunna gang yer ain gait afore we claik thegither.*"

## 🎄25🎄

FULKE ROWLEY was roused from a sound sleep by Lady Appleton's urgent repetitions of his name. She had her hand on his shoulder and was shaking him. In the shadows behind her, he recognized Lachlann Dunbar…and Gavin, Lord Glenelg.

The boy giggled when Fulke started to rise. Still half asleep, he belatedly remembered that he wore only his long linen shirt

for sleeping. He jerked the coverlet back up over his bare legs when Lady Appleton's face flamed.

"*Busk an' boune*," Dunbar ordered. "*Yon wee laddie maun win hame.*"

"Speak English," Lady Appleton snapped. "Or French, at the least!"

"He says to rise and dress," Fulke translated, "because young Lord Glenelg must be taken back to the castle. But how did he get here?"

When Lady Appleton turned her back on the rough bed, Fulke hurriedly donned breeches over his shirt and reached for his boots.

"He slipped out of the castle when some visitors left," Lady Appleton said. "He is small enough that no one noticed him, but he must go back before his absence is discovered."

Dunbar muttered something about beating the lad to impress upon him the folly of his act.

Lady Appleton rounded on him, eyes flashing. She had no authority over either man or boy, but she knew how to win her point. "The need for speed and secrecy outweighs the value of punishment."

Fulke looked from one to the other over Gavin's head. A word from Lady Appleton and he'd gladly incapacitate Sir Lachlann and help her carry off Catherine's son. That would fall in well with his own inclination.

Something of this willingness to do violence must have shown in his face. Lady Appleton shook her head, a warning not to act impulsively.

Fulke reached for his cap. If Lady Appleton did not think the time was right, he would abide by her decision. In all the years he'd served the Appletons, he'd never doubted that Lady Appleton was the most intelligent person he'd ever met. She was clever, too. And she was rarely wrong about anything.

He followed the others out of the stable into a night brightly

illuminated by a full moon. They left Lady Appleton at Dunbar House and made their silent way westward along the Hie Gait, slipping through the sleeping town toward the castle past the Tolbooth and the kirk and Mar's Wark. There were narrow wynds on either side. Young Gavin had made use of them on his way to Dunbar House to escape detection by the watch. Clever lad, Fulke thought, his heart swelling with pride. He had his mother's strength of character, too.

Dunbar called a halt just short of the great spur-shaped artillery battery of Stirling Castle, before they could be noticed by the castle guards. It was clear he did not trust Gavin to return on his own and yet he was loath to alert the king's men and have the boy escorted to his bed. That could well provoke the very outcome he hoped to avoid, Gavin's dismissal.

The boy had apparently reasoned this out for himself. "I do not want to go back," Gavin piped in a high voice.

"*Haud yer gab, laddie,*" Dunbar warned, once again falling back on the local dialect.

"I will not—"

Fulke clamped a hand over Gavin's mouth and leaned close to whisper in the boy's ear. "Patience, lad." In a louder whisper, he spoke to Dunbar. "Sir Lachlann, if you will make sure no one was alerted by his outcry, I will convince him to cooperate."

Dunbar did not like taking orders, but he saw the sense in this one. As soon as he had disappeared behind the smaller flanking battery, Fulke released Gavin.

"I did not get out this way," Gavin said in a low voice. "Lady Appleton made that up."

"You have your own exit?" Fulke asked.

He nodded. "I can escape any time."

"Good. Now listen close, Gavin. Tell no one within that you have a secret way out of the castle, and do not let Sir Lachlann see where it is located. I believe you will need to use that route again."

"As soon as Mama is safe." Both eyes and teeth gleamed in the

moonlight as he gave Fulke a conspiratorial grin. "Tell me how I will know when to leave."

"Watch for a signal." Fulke frowned, thinking hard. "Look for a banner flying from one of the chimneys of Dunbar House. A red cloth. That will mean we have found your mother and the time has come for all of you to leave Scotland."

Stealing Gavin away from court went beyond what Lady Appleton had planned. Fulke did not need anyone to tell him that. She would advise caution in dealing with a king, even a boy king. But Fulke had been turning matters over in his head all the way from Dunbar House to Sterling Castle. Little as he liked to admit it, this might be one of those rare occasions when Lady Appleton was wrong.

Dunbar's return prevented Fulke from saying more to the boy. Dunbar reported that no one seemed to have heard Gavin's outburst. Then he squatted down beside Gavin, told him he was very stubborn—*unco thrawn*—and a great deal of trouble, and that he'd best behave himself from this moment forward.

"Yes, Sir Lachlann. I will go back the way I came out. I am small. No one will notice me."

Dunbar gave him a suspicious look but asked only if he was certain he would not be caught. When Gavin had reassured him, and given his word to return to his bed in the castle straight away, Sir Lachlann agreed it was best to let him go on alone. It was, as Lady Appleton had earlier explained to Fulke, to Dunbar's advantage to keep Gavin out of trouble.

"Fare thee well, boy," Fulke said, ruffling the lad's hair in an affectionate gesture.

"God be with you, Fulke," Gavin replied. Then he was off, racing around the perimeter of the castle.

"You are over-familiar for a servant," Dunbar said in his halting English.

"I taught the lad to ride," Fulke replied in Inglis. "We have spent many hours together at Leigh Abbey."

"You arrived here from England somewhat later than your mistress. Why is that?" Dunbar set off for his house, expecting Fulke not only to follow but to submit without argument to further interrogation.

"I brought messages from home."

"You left with us for Stirling, then rode off on your own."

"An errand for Lady Appleton."

"What errand?"

"A packet to dispatch back to England." The lie came easily and seemed to satisfy Sir Lachlann.

Fulke wished he could ask questions in return, but it was not his place to demand answers from his betters. He was not accustomed to second-guessing their decisions, either, yet now he must. Instead of dismissing the accusations against Cathcrine out of hand, as Fulke did, Lady Appleton seemed to believe it was possible that Catherine *had* killed Lady Russell, mayhap acting in self-defense.

If the old woman had died from the fall, perhaps Fulke could have accepted that theory. But she had been strangled. Catherine could not, would not, put her hands around another creature's throat and squeeze until life was gone. It was not in her to do such a thing. She might strike out with her fists to protect herself. Might even have fallen together with Lady Russell down a flight of steps. But lay violent hands on someone with intent to kill? So far lose her reason as to choke the life out of another person? No. Never!

Was it possible someone had come into Glenelg House while Catherine was unconscious? Annabel? Malcolm Logan? Or mayhap Lachlann Dunbar? It occurred to Fulke that they had only Dunbar's word for it that Catherine had lost her memory.

A reason for Sir Lachlann to want Lady Russell dead eluded Fulke, but he *could* think of an explanation for Catherine's behavior. Sir Lachlann was Gavin's guardian. He had only to threaten Catherine's son to coerce her into helping him cover up his crime.

If she'd run, it could have been in fear of him. And, if so, she'd avoid her friends, much as she might want to come to them, simply because they were presently keeping company with Dunbar.

Back at Dunbar House, Sir Lachlann retired to his chamber. Fulke was too restless to sleep. He stood in the moonlit stable-yard. The pale light was deceptive, making some things stand out clearly and hiding others. This matter of murder was like that, too. It required a light beamed into a dark corner to illuminate the truth.

Fulke was torn. If Catherine *was* in Stirling, she might be located at any moment. Lady Appleton would then lose no time taking her out of Scotland and Fulke, who had tonight made a commitment to get Gavin out as well, would need to be close at hand to carry out his plan.

On the other hand, since Catherine had remained hidden all this time, there was no reason to believe she would show herself as long as she was a wanted woman. Fulke did not pretend to understand Scottish law, but he gathered that Malcolm Logan might be persuaded by the promise of profit to abandon his criminal suit for a civil one. If he did so, Catherine would not have to leave Scotland at all. She could remain here as long as she liked. Fulke could take his time reuniting her with Gavin.

And so, he concluded, a few days' absence from Stirling should not matter. Lady Appleton had considered sending him to Dunfallandy to make inquiries about Malcolm Logan. He would ask her leave to travel instead to whatever place Sir Lachlann Dunbar hailed from.

# ❦26❦

WASHERWOMEN took the laundry away twice a week—table linens, undergarments, shirts, handkerchiefs, and plain coifs. Catherine supposed these items were washed in the Forth, or in a smaller stream nearby, then spread on the ground to dry or hung over convenient hedges. As the weather grew colder, the process took longer and was harder on the laundresses.

Just now, however, she envied those hardworking women. At least they were out of doors. She and Annabel had been relegated to a small, windowless alcove to refresh Lady Mar's stored clothing. It had been packed away with powdered, dried orange peel mixed with powdered and dried elecampane roots.

Catherine sneezed. "Lavender would have done just as well, or wormwood. My mother always preferred wormwood." She shook out a woolen skirt and set about stroking it with a soft brush. She had been a child of ten, she recalled, when her mother had begun to teach her about the care of clothes.

She rarely thought of Euphemia Denholm these days. The lies and betrayal had gone too deep. Now that she had, however, she could not get the woman out of her mind, nor could she forget the chilling truth that there was a strain of madness in her mother's family. Had she been tainted with it, too?

"This needs wine," Annabel said.

Catherine blinked and tried to focus.

Annabel had detached the fur cuffs from a pair of sleeves. The fur must have grown hard through being damp, Catherine realized. The remedy was to sprinkle the fur with wine and leave it to dry, then rub it until it was soft again.

Putting the skirt aside, Catherine reached for the next garment. Her hand froze halfway into the chest. Plain as if it were happening right then and there, she saw her mother-in-law's face, appalled and angry.

*"You did what?" Jean bellowed.*

*"I employed Annabel MacReynolds to ask questions on my behalf. She has learned something I may be able to use to free Gavin from his duties at the royal court."*

*"You set a spy upon those responsible for the boy?"*

*"I did. And she found out something, too, information that will convince the regent to give Gavin back to me."*

Catherine had not had the opportunity to reveal exactly what Annabel had discovered. Jean had flown at her, features contorted with rage.

"Just look at this stain!" Annabel exclaimed. "I suppose she'll expect us to get it out, but I doubt even raw arsenic mixed with *Mertum Cudum*, water, and cinquefoil will work on grease."

Catherine dragged her thoughts back to the present. "A little Castile soap applied with a clean feather is good for grease stains." Catherine's voice caught. "I do not even know what *Mertum Cudum* is."

Annabel gave her a sharp look. "Some kind of ground mineral, I believe. Catherine, what is the matter with you?"

"I've remembered," Catherine said.

"Lady Russell's death?"

"No." She rubbed her aching forehead. "What came just before. When she scratched my face. I'd just told her that you had uncovered—" how had she put it? "—information that would convince the regent to give Gavin back to me."

"The only thing I learned was that Master Buchanan has a vile temper and beats his pupils. That is nothing." Annabel set aside the stained bodice, a beautifully embroidered garment of cloth of silver, and pulled out a pair of velvet sleeves. "Schoolmasters regularly whip their charges to ensure that they study hard."

Catherine knew that, and yet what Annabel had discovered went beyond normal practice. "One boy was seriously injured."

"That was a servant, not a young nobleman. And he recovered."

"And Master Buchanan struck the king!" Catherine was as shaken by that fact now as she had been when she'd first heard it. A king was God's representative on earth, head of the church as well as of the state. No one should have had the right to abuse him. "If he would dare do that—! Gavin is so small. I—"

"What I learned from Lady Mar is not likely to help your case, Catherine. I told you that from the beginning. Accusations against Master Buchanan might result in his being removed, but Gavin would remain at court."

"But you had agreed to tell Jean and Sir Lachlann what Lady Mar said."

"And so I would have, had I arrived in time. I only doubt that it would have made any difference."

"She was his grandmother! How could she not care about his safety? For all I could not like her, she was a good and gentle mother to my husband."

Industriously plying her clothes brush on the sleeves Annabel handed her, Catherine struggled to recall more details of that last encounter, anything that would prompt her fickle memory and tell her what she most wanted to know—had she killed Jean Russell?

"I thought I could convince them that Gavin should be taken away from court to protect him. I do not care if it is common practice for schoolmasters to take a switch to their charges. It is a barbaric custom and can scarce instill any love of learning in those who are made to suffer." In the school Susanna Appleton had established for Rosamond, the girls excelled at languages, at mathematics, at a dozen other disciplines, all without the threat of corporal punishment.

"I've no doubt Lady Russell thrashed your Gilbert a time or two. She was the sort who'd be convinced boys are the better for strict discipline. Even a king, when that king is a child, cannot be allowed his way in everything."

"That statement comes perilous close to treason." Catherine

brushed harder. "In any case, Master Buchanan's actions surely crossed over a line. He struck out in anger, if Lady Mar told you true. Someone should have brought charges against him."

"Is that what you intended to do? Oh, Catherine. Foolish woman. No one would have taken you seriously. Lady Mar and the other young scholars would have denied everything."

"Even the king?"

"If he's afraid of his tutor, yes."

"Not Gavin."

"Whether Gavin supported your claim or not, he'd have suffered for your interference."

"How can Lady Mar—"

"She wishes to keep her post. No doubt she would have made complaint herself if she thought it could have rid them of Buchanan's presence, but he was chosen to guide the young king's education. I suspect he was told he could discipline the boys, even the king, as he saw fit."

Catherine let out a huff. "Gavin is the only one who matters to me and I will do whatever I must to keep him safe." Another flash of memory intruded. "I said as much to Jean. I swore I'd use any means to get my son away from court, that I would trumpet the truth to the rooftops if that was what it took. I said there had been a crime committed—for what else was Master Buchanan's attack on the king?—and I said I would make all this great villain's misdeeds known if Gavin was not returned to my care."

"She was that upset for Buchanan's sake?"

"It is not a matter for levity!" Catherine frowned. "I am not certain I ever got the chance to say it was Buchanan, or what he had done. I wanted to wait until you arrived to repeat what you'd told me in full. When Jean flew at me, scoring me with her fingernails, she was furious at the very thought that I might undo all her hard work in arranging Gavin's appointment. I tried to defend myself. We struggled. I remember that we were close to the top of the staircase."

"And you both fell," Annabel supplied when Catherine abruptly stopped speaking.

"Jean was surpassing proud of that staircase. She'd had it installed when she renovated the house."

Catherine gripped the clothes brush so tightly in her right ' hand that her knuckles showed white. The velvet in her left hand was likewise crushed.

"She was strangled, Catherine. It was not the fall that killed her."

"I know that, but I cannot *remember* it, nor striking my head. The next thing I knew, you were there, ordering me to get up."

"Then no doubt I strangled her while both of you were unconscious." Annabel's voice held a tinge of irony.

Slowly, Catherine set aside both clothes and brush. "Someone could have," she whispered. "I have no idea how long I lay there, senseless."

"I did but jest, Catherine. What reason would anyone have to do such a thing? And if you will propose next that there was some mad killer loose in Canongate, then why did he not murder you, too?"

As they continued their assigned tasks at Mar's Wark, Catherine tried to force her reluctant memories to return. The only reward she got for her trouble was a blinding headache.

## ☙27❧

*October 3, 1577*
*Dunbar House, Stirling, Scotland*

BY THE THIRD DAY after Nick left for Leith and Fulke set out for Dunbar Island, Susanna had despaired of her progress in finding Catherine. From the start, she had hoped that Catherine

would hear of her presence in Stirling and send word to her, but she had been at Dunbar House for nearly a week and had heard nothing. Was it Sir Lachlann's presence that kept Catherine away? Or Malcolm Logan's? Or did she simply fear arrest should she show her face to anyone?

Susanna had tried repeatedly to convince Malcolm Logan to change his mind about prosecuting Catherine. Not only would he not discuss the matter with her, he would not even acknowledge that he spoke English.

Each day she had gone out, letting herself be seen in Stirling. She had been obliged to take Una with her because of the language barrier. Perhaps for that reason, Catherine had not come near them. Susanna had accomplished nothing but the purchase of a costly trinket to have on hand in case she needed to keep Lady Mar sweet.

On this Thursday morning, she went into Stirling alone. She could manage well enough, she told herself. She had picked up the rudiments of Inglis, and her French was much improved by conversation with Sir Lachlann.

The crowds and noise were familiar and welcoming, no matter what language was spoken. One marketplace was much like another, rural or urban, large or small. Shopkeepers let their pentices down to display wares. Hawkers cried out to catch the attention of passersby. Riders vied with foot traffic for space, and dozens of different smells, some pleasant and some not, hung in the air. It was a cool early October day but the sun was shining brightly down, making it unnecessary to wear a cloak for warmth.

Keeping one hand on the money pouch concealed in the placket in her kirtle, Susanna went from shop to shop. She was examining a pair of gloves when something barely noticed out of the corner of her eye suddenly arrested her attention. She turned to look, studying the graceful form of a maidservant who had just left a chandler's shop. At first she saw nothing unusual about the woman walking away from her. Like most others in service she

wore her kirtle girdled so as to fall shorter than a lady's. It came
to a stop well above her ankles. And that, thought Susanna, was
what was different. Bare feet should have shown beneath the hem,
not sturdy, well-made boots.

She started toward the woman, taking in other details. A pair
of blue gauntlet gloves covered her hands and a coverchief draped
over her head hid her hair. Susanna could not see her face, but
there was something about the way the maidservant carried her-
self, the way she walked. It was Catherine Glenelg. Susanna was
certain of it.

Her heart raced as she walked faster, hoping to catch up. It
made sense that Catherine was dressed as a servant. They'd found
her abandoned finery in Edinburgh. They'd known Annabel had
purchased servants' clothing. Disguises for the journey to Stirling,
or so Susanna had thought. But why not find work as servants
once they got here? What better way to hide in plain sight?

She moved a bit faster, wishing she dared call out Catherine's
name. The figure ahead was hurrying, too. She carried a package
under her arm and before Susanna could overtake her, she disap-
peared into the narrow passage that led to the back of Mar's Wark.

Susanna walked on past the elaborate town house. It would
never have crossed her mind to look for Catherine there. This was
Annabel's doing, no doubt of that. The Scotswoman had never
wanted boldness.

Reluctantly, Susanna left Mar's Wark behind and returned to
Dunbar House. She could not ask questions of the servants with-
out drawing unwanted attention to herself. But Toby could. She
sent for him to come to her in the small parlor.

She must stop thinking of him as a lad, Susanna realized when
he stood before her. He was five and twenty with a fine full beard
to show for it. She smiled slightly, remembering how she'd met
him first as a beardless boy. Pale fuzz, she recalled, had marked his
first attempt at growing facial hair.

"You wished to talk to me, Lady Appleton?" Toby was less

nervous around her now than he had been in his youth, but he had not entirely lost his awe of her. He held his cap too tightly. Indeed, it was in danger of ending as a crushed and twisted lump of cloth.

"You accompanied me to Mar's Wark when Master Baldwin and I went there to sup. Did you have the opportunity to speak with any of Lady Mar's servants?" If he'd overcome the language barrier with Lady Russell's Ailis and Marta, no doubt he'd managed to converse well enough with Lady Mar's maids. They'd have flocked to him, she thought, for he was a good-looking lad. Man, she corrected herself.

"There were one or two I spoke with." Toby shuffled his feet and kept his head down.

"That is a good thing, Toby. Now, you know what Lady Glenelg looks like. Was there a maidservant among them of her height and coloring?"

Toby's head jerked up and he blinked at her in surprise. "I did not notice anyone, madam. But would she not have stayed out of my sight if she were there?"

"Yes, no doubt she would." She sighed. "Well, then, what of a woman of considerable girth. About so high." She held her hand at approximately Annabel's height. "Her face is heavy, too. Jowly and—" She broke off at the light of recognition in Toby's eyes. "You saw such a one?"

"Saw and talked to her, madam. She was most interested in you." Realizing what he'd said, Toby's jaw dropped. "I did not tell her anything important, madam. I swear it. Just where we came from and where we were lodged and who came with you to Stirling."

"Nothing important," Susanna agreed. "Did she tell you anything about herself? A name, mayhap?"

"No madam. I...I did not ask."

If she'd been young and pretty, he would have. "Did you hear anything about her? Or about new maids being hired at Mar's Wark?"

Toby brightened at once. "Oh, yes, madam. Did you know the regent has a house in Stirling? Hardly ever visits it, but he has a housekeeper, and she hired two of Lady Mar's maids away from her. So Lady Mar had to hire a mute girl and the woman who talked to me."

Catherine and Annabel. Susanna had no doubt of it. While Toby waited, she wrote a brief message for him to take to Mar's Wark, asking Catherine to meet her that night in the hour after midnight in the Dunbar House stables. With Fulke still absent, no one slept there. And she could add a bit of poppy juice to Sir Lachlann's ale to make sure that, this time, he did not show up at an inopportune moment.

She sealed the missive with a blob of wax but did not use her signet ring. Best for everyone, she decided, if the note remained anonymous.

"Give this only to Lady Mar's mute servant," she told Toby. "Then come straight back here."

Either Catherine would do as she'd been bidden…or she would disappear again.

## 🎇28🎇

*October 3, 1577*
*Mar's Wark, Stirling, Scotland*

ANNABEL TORE the note into tiny pieces. "Are you mad? Would you walk into a trap? What if there are guards waiting to arrest you for Lady Russell's murder?"

"Susanna would never betray me." Although they were the only ones in the garret that housed the maids' dormitory, they kept their voices low.

"Will you risk Gavin's safety in that belief?"

Annabel had moved steadily forward with the plans they'd made to rescue Gavin from Stirling Castle. For sheer audacity, the scheme had a good chance of success, but Catherine was still plagued by misgivings. From the moment she'd learned Susanna Appleton was in Stirling, she'd wanted to seek her out and ask for her advice. It was not that she did not trust Annabel, but Susanna was so much more sensible. And she had influence, at least in England.

Aloud she said, "If we try to take him and fail, we will both be in gaol."

"Think, Catherine. If you involve Susanna Appleton now, you will do naught but implicate her in whatever happens next. Is that what you want?"

"But she is far more clever than I am. She may already have come up with a better, safer way to reunite me with my children." Susanna had known her well enough to be certain she'd come to Stirling for Gavin. Her mere presence was proof of that.

"There is nothing wrong with the plans we've already made." Annabel sounded put out and Catherine could not blame her.

When they'd stopped at her cousin's house in Linlithgow, Annabel had taken the first steps to implement an elaborate scheme to fake Catherine's death and those of her children. She would soon have papers for a ship that did not exist. While Catherine rode for the Border with Gavin, the authorities would search in vain for an imaginary vessel. Catherine would be able to stop for Avise and Cordell at Leigh Abbey in perfect safety, although afterward they would be obliged to go abroad to start a new life. They could scarce reappear in England once they were "dead."

Annabel was convinced her scheme would work. Catherine was not so certain, nor was she as sanguine as Annabel about the plan she'd devised to extract Gavin from the royal court.

"If you think she can find a way for you to remain in England," Annabel sneered, accurately divining Catherine's one regret, "you delude yourself. You are a fugitive, Catherine. If you care at all for

your own safety and that of your friends, do not go near Susanna Appleton."

But the more Annabel argued against meeting with Susanna, the more determined Catherine was to keep the appointment. "She knows we are here. If I do not meet her, she will come to Mar's Wark. Better to talk to her now and warn her to stay away."

Exasperated, Annabel threw her hands in the air in a gesture of surrender. "Meet with her, then, but tell her to leave Stirling entirely. The longer she lingers here, the poorer our chance of success. And do not tell her what we mean to do. Better for *her* if she does not know." With that, she left the garret. There were more chores waiting.

Catherine followed a few minutes later. A sense of calm had come over her now that the decision had been made. She trusted Susanna. There was nothing to be afraid of. They would talk. Catherine would listen to what Susanna had to say. And then she would do what she thought best for herself and her children.

And so, when midnight came, Catherine crept out of Mar's Wark. Scarce daring to breathe, she slipped from shadow to shadow through the moonlit streets of Stirling until she could let herself quietly into the stables at Dunbar House. With a sigh of relief, she closed the door behind her. Safe. She had eluded the twin threats of footpad and town watch.

She breathed deeply, inhaling the familiar, comforting smells of hay and horses. Off to her left, one of the animals sensed her presence. A questioning whuffle was followed by a snort. Pausing a moment to let her eyes adjust to the darkness, Catherine thought of Fulke. Would he come with Susanna?

But only Fulke's employer appeared, carrying a dark lantern. "In here," she whispered, leading the way into the tack room.

As soon as they were private, Susanna opened the lantern to illuminate the cramped space. She set it on the floor and caught Catherine in a quick, hard embrace, then stepped back. Catherine saw the concern on Susanna's face as the other woman

looked her over. Then Susanna's eyes narrowed and she reached up to lift the edge of Catherine's coverchief. "What on earth have you done to your hair? No, never mind. It is of no importance." She huffed out a breath. "Well, Catherine. You have led me on a merry chase."

"I did not intend that you become involved in this business. Go back to England, Susanna. Look after Cordell for me until I can come for her."

"Cordell is not at Leigh Abbey."

Blindly, Catherine reached out for support. A great weight pressed down on her chest, constricting her breathing. She braced herself against a wall hung with bridles and tried to quiet the pounding of her heart.

Susanna spoke sharply. "Catherine, calm yourself. She has come to no harm. Fulke left Leigh Abbey after receiving your letter because there had been no sign of them. Avise hid the child in Edinburgh rather than risk the dangers of the road. Fulke located them and has bidden them stay where they are. They are safe."

"My baby," Catherine said in a broken whisper. "I never should have sent her away."

"You should not have gone into hiding in the first place. Was that Annabel's idea?"

Catherine nodded. She was still trying to come to grips with the fact that Cordell had never left Scotland.

"We will speak more of that anon. Are you here in Stirling because you think to spirit Gavin away from court?"

Catherine had to struggle to focus her thoughts on her son when Cordell still occupied so much of her mind. "I do not wish to involve you in my plans for Gavin. It is best if you do not know what they are."

"Your wishes do not signify. I am here to help you whether you want my assistance or not. Listen carefully, Catherine. I have talked to Gavin twice. For the nonce, you must leave him at court. He will be safe there."

"Safe! Susanna, how can you say so? All those poor boys are at the mercy of a monster."

"Master Buchanan struck the king. Yes, I know. Gavin told me. But—"

"And another boy. Buchanan, in his rage, injured a servant most severely. The lad nearly died. Please, Susanna, tell Sir Lachlann about his abuses of power. Buchanan is a danger to those in his charge. And Gavin is so small. . ." Her voice rose, then broke.

"Hush, Catherine. I will tell him about the servant but I do much doubt he will change his mind. He does not consider Buchanan a threat to your son."

"That is what Annabel says!" Did no one understand? "She says that even if I had told Jean and Sir Lachlann what she discovered about Buchanan, it would have made no difference. Sir Lachlann would have dismissed the charges against Master Buchanan as the fussing of a foolish female coddling her child."

"Ah, yes. Annabel. Tell me, how did she become involved in your affairs?"

"I asked her to make inquiries on my behalf. I did not know about Buchanan's brutality when I sent her to Stirling. I only hoped she'd discover something I could use to free Gavin."

"So Annabel visited Stirling." Susanna looked thoughtful.

Catherine nodded. "Lady Mar told her about Buchanan."

"Lady Mar claims she's not seen Annabel for years."

"Mayhap she regretted being so forthcoming with an old acquaintance." That was of small importance. "Susanna, I am afraid for my son. Why will no one listen to my concerns? Why does no one care?"

Susanna moved a saddle from a bench and sat down. "I care, Catherine, but I believe I have a bit more perspective than you do. Let us leave that topic for a moment and speak of the day Jean died. Everyone had gone out, even Malcolm Logan?"

"Yes." Catherine was too agitated to sit, but there was no room to pace in their cramped quarters.

"Sir Lachlann was expected. You planned to tell him that Buchanan was no fit tutor in the hope he would remove Gavin from court and return him to you. Did you know Sir Lachlann had decided you would make him a suitable wife?"

"What? No!" The suggestion astonished her. He'd never so much as hinted he intended to court her.

"You'd have been able to influence him with regard to Gavin's future if you married him."

Catherine tried to visualize herself wed to Sir Lachlann Dunbar. The intimacies of marriage were not repulsive to her, but when she pictured herself in a man's arms, it was not Sir Lachlann who held her. She quickly banished the image that did appear in her mind's eye.

"I...Sir Lachlann never hinted at such a possibility." She cleared her throat.

"Well, then, what did he expect when he arrived at Glenelg House that day? He says he did not know what you wanted to talk to him about."

Catherine nodded. "When I wrote to him, I hinted at troubling discoveries but gave no specifics." She frowned, trying to ignore the first throb of a returning headache. There was something more. Something about Sir Lachlann and Annabel. But she could not force the memory to come clear.

"Tell me everything you remember about the day Lady Russell died," Susanna said.

"There's the rub. I recall that the servants all left on errands but nothing after that but fragments until I came to my senses on the landing. Jean was dead. Annabel had just arrived." She met Susanna's eyes without flinching. "It is likely I killed my mother-in-law. If not for the children, I would turn myself in and face trial."

"Nonsense. There is no need for that."

Catherine gaped at her. "*You* do not help murderers. You bring them to justice."

Even by the fitful light given off by the lantern, Catherine could see Susanna's surprise. "My moral principles aside, you said you lost your memory. How can you be certain you killed Lady Russell?"

"Who else could have? And there is a strain of madness in my family. Remember my mother? My cousin?"

"You are not mad, and if you want the truth, I do not care whether you killed Lady Russell or not."

"The law——"

"Scots law is not much concerned with executing murderers." She explained briefly what she had learned since her arrival in Scotland. "So, you see, the Crown has no interest in bringing charges against you. It is Malcolm Logan who pursues the prosecution and I am hopeful I can yet persuade him to ask for monetary compensation instead."

"Compensation for what?" Catherine asked, confused.

"His aunt's death."

"He benefitted very little from her life."

"Did she ask him to move into Glenelg House or did he invite himself to stay?"

"I am not certain. She did not approve of him. Then again, she did not approve of me, either."

"Does Malcolm Logan have any reason to push for your trial and execution? Any personal reason to want you dead?"

"I scarce know the man. He resented the fact that Gavin inherited the Glenelg title and lands, but I had naught to do with that."

"As I thought. Had you not gone into hiding, no doubt he'd have made his price clear by now."

Catherine considered the surly young man from Dunfallandy. He'd had little to do with anyone at Glenelg House, but he had never been blatantly hostile toward her. "Shall I turn myself in, then?"

But Susanna shook her head. "Far simpler to leave Scotland as soon as may be. Nick has gone to Leith to arrange for a ship. We will collect Cordell——"

"And Gavin."

Susanna went still. "You cannot take your son with you."

"I will not leave without him."

"Catherine, I promise you, I will find a way to reunite you with your son, but I cannot do so until *after* you are safely out of Scotland."

"I will not leave without him." Catherine sighed. "You and Nick should go. Take Cordell and make haste to England."

"And Fulke?"

Catherine felt her heart give a little flutter at the reminder that Fulke had also come to Scotland to help her. "Where is he?"

"He's gone to Dunbar Island to ask questions about Sir Lachlann."

"Why?" Astonishment pitched the word more loudly than she'd expected and she clapped her hands over her mouth.

They waited, listening, but no one came to investigate.

"Fulke is certain you did not strangle your mother-in-law," Susanna said. "He suggested the possibility that someone came into the house while you were unconscious."

"Annabel did."

Catherine noted that Susanna did not say she shared Fulke's uncompromising view of Catherine's innocence, but she had declared herself ready to help even if it turned out that Catherine *was* a murderess. Catherine's chest tightened as she thought again what an extraordinary thing this was for a woman of Susanna's convictions.

"What if Annabel did more than rouse you?" Susanna held a hand up to forestall Catherine's protest. "I can see you do not believe that. But if Annabel came in after you and Lady Russell fell, then why not someone else before that, someone who strangled Lady Russell and might have done the same to you save for Annabel's arrival? That is Fulke's contention, and he believes Sir Lachlann Dunbar the most likely suspect."

"But why would Sir Lachlann want to kill Jean? Besides, he

was late because his horse went lame. He borrowed his man's mount and came on."

"So no one was with him when he arrived. He could have been there earlier than he said, left when he heard Annabel coming, and returned again a short time later with his story of a horse gone lame."

The pounding in Catherine's head was nearly unbearable now. "He had no reason to kill Jean," she repeated. "She was his ally. You're grasping at straws, Susanna."

"Fulke is, I think, and yet we must explore every possibility. What of Malcolm Logan? He refuses to say where he was that afternoon."

In spite of her pain, Catherine laughed. "That is no mystery. He has a mistress, a merchant's wife. He thinks he has kept it a great secret, but half of Edinburgh must know of it. The merchant himself likely does, and is embarrassed to have been cuckolded by such a lout."

# ❦29❧

*October 4, 1577*
*Dunbar Island, Scotland*

FROM THE BOAT Fulke had hired in Prestwick, the nearest mainland town, the wild, rocky outcropping that was Dunbar Island appeared to be in imminent danger of reclamation by the sea. It was a place no bigger than Leigh Abbey and its surrounding demesne lands, naught but a tiny speck in the waters between Scotland proper and the Island of Arran.

By all reports, the folk who lived on Dunbar Island were insular, suspicious, and not inclined to talk about Sir Lachlann's business. Given all that, Fulke contrived to arrive by a means un-

orthodox enough to confound the usual reaction. He was a strong
swimmer. With a little effort and a generous bribe to his friendly
boatman, he gave the appearance of having been shipwrecked. A
gash on his forehead would give credence to the claim that he
could not remember who he was or how he'd come to wash up
on Sir Lachlann's property.

Two men found him soon after he collapsed on the rocky
shore. He pretended to be unconscious as they argued, their
words incomprehensible. This was not the reception he'd hoped
for. It belatedly occurred to him that this island would be an ideal
base for pirates or smugglers or both.

He was hauled unceremoniously to his feet and half walked,
half dragged toward the dilapidated castle that dominated the
island. The men deposited him before the hearth in the Hall and
one remained to guard him.

Sodden, exhausted by the long swim, and weakened by the
self-inflicted head wound that had seemed such a good idea at the
time, Fulke slumped dejectedly.

"Good day to you," said a high, cheerful voice, speaking in Inglis.

Startled, Fulke jerked upright.

A bright-eyed, golden-haired child, no more than twelve
years old, stood at a little distance, studying him with unabashed
curiosity.

"Good day to you, mistress." He struggled to his feet and
managed an awkward bow.

"You are English!" she exclaimed, for he had replied in that
tongue.

"Am I? I fear I cannot remember."

"You are very well-spoken," she mused. "I think you must be a
gentleman."

Fulke did not know what to say to that. He had borrowed the
idea of a lost memory from Catherine's recent misfortune, but
he'd made no attempt to appear other than what he was, an upper
servant to the gentry.

"I am Sibeal Dunbar," the girl continued. "If you were younger I would think you were a silkie come from the sea in the guise of a prince."

He had to grin at that fanciful notion. "I am sure you will have human suitors aplenty when the time comes."

"Oh, I have one of those already, but he is just a little boy."

So, Fulke thought, this was the sister Gavin had met in Stirling.

Face wreathed in smiles, Sibeal prattled on. "He is a nice little boy, but he must be fourteen before he can consent to marry me and that is a dangerous age. If I find someone older, mayhap we will have a long, happy life together."

"Sibeal!" This second voice was more mature, but just as pleasing. Another vision appeared beside the first. The torch she brought with her danced on the red-gold highlights in her hair.

"This is my sister, Catriona," Sibeal said.

"I wish I could introduce myself," Fulke said, "but this bump on my head seems to have robbed me of my name. I do not know who I am or how I came to be here, or even where 'here' is."

His appearance of vulnerability and his good manners seemed to banish any doubts Catriona harbored. Sending the guard to fetch food and drink, she and Sibeal willingly answered any question he asked about the island and its inhabitants. Catriona had just informed him that she was a widow when the third sister, Fionnghuala, arrived. Clearly the eldest by several years, she was still no more than twenty. How young, he wondered, had she and Catriona been when they'd been wed and widowed? Although a boy had to be fourteen to wed, a girl could be younger.

Fionnghuala took charge, sending Fulke off with a manservant to change into clean, dry clothing that had been found for him. When he was presentable, he was escorted back to the Hall for the promised refreshments. He wondered at the lack of an older woman to look after the three sisters, but Fionnghuala dismissed his concern with a laugh.

"Catriona and I are not young virgins," she declared, "but widows in control of our own lives. We are wealthy, too."

"You must have wed surpassing young."

"Aye. I was thirteen and John a year older. Father was his guardian and arranged it."

"He was young to wed, and young to die."

"It was his own fault," Fionnghuala said with a dismissive wave of one lily white hand. "He neglected his studies, so Father locked him in a tower room with his books and pen and ink, and commanded the servants to stay away from that wing, though he did not tell them why. He meant to release John when he'd learnt his lesson—" she grinned at the pun "—but a summons came from court, demanding Father's presence, and he rushed off without remembering to tell anyone where John was. Everyone here assumed John had gone with Father to court, so no one searched for him, and no one heard his cries for help because the walls are very thick. He starved to death before Father remembered and sent word."

Appalled, Fulke stared at her.

"Father was most distraught. I was not yet breeding and there was another heir to claim the lands."

"You did not do so badly," Catriona reminded her. "You got to keep part of John's fortune, just as I kept part of Andrew's."

Fulke was almost afraid to ask. "Andrew?"

"My husband," Catriona said.

"How old are you?"

"Sixteen."

"And when you wed?"

"Thirteen."

Fulke's gaze went, unbidden, to Sibeal.

"I am nearly that old," Sibeal said cheerfully, "but I must wait six years to wed Lord Glenelg. Have you a wife?"

Fulke swallowed hard. "No."

"You remember?" Fionnghuala's eyes narrowed.

"No. That is, I do not think I have a wife." He managed a self-deprecating smile at her before shifting his attention back to Catriona. "What happened to Andrew? Was he also one of your father's wards?"

Catriona nodded. "His story is even more tragic than John's. We had been wed for a year. He did not like it here on the island. He was always trying to leave." She pouted a bit. "Then one day he disappeared. Everyone thought he had succeeded in bribing someone to take him to the mainland, though Father keeps tight rein on all the money and jewels. We searched, certes, but no one thought to look in the old well. He'd fallen in, you see. He was stifled by the damp."

She seemed no more affected by the loss of a husband than her sister had been. She helped herself to another piece of marchpane and bit into it with every appearance of pleasure.

"A terrible accident," Fulke murmured. And most convenient for keeping the widow's third of a ward's fortune in the family.

"Father was most distressed when he learned of it," Catriona said, licking sugar from her fingers.

"He was not here at the time?"

"He lives in Stirling," Sibeal explained.

"I am surprised, after two such unfortunate occurrences, that he risked fate by taking on the responsibility for yet another boy."

"One for each of us," Sibeal explained. "He said that was only fair. When I am widowed, I will move away from here. I visited Stirling once. I liked it there."

She snatched the last piece of marchpane away from her sister and popped it into her mouth.

## 🎀30🎀

*October 5, 1577*
*Dunbar House, Stirling, Scotland*

"MASTER LOGAN," Susanna said, bearing down on the elusive Glenelg heir. He had retreated to a corner of the Hall with a cup of strong ale. "I would have a word with you."

He squinted at her and muttered something incomprehensible in the language of the Highlands, but he had traded his saffron shirt and short red jacket for doublet and hose since coming to Stirling. She wondered why.

"Come, come. I know you both understand and speak English. And I know something more. You have refused to answer my questions before out of a sense of chivalry. That is most commendable, Master Logan, but unnecessary. You do not need to protect your lady's reputation with me. And I am sure she would be the first to offer to free you of suspicion by confirming your whereabouts when Lady Russell was killed."

His expression barely changed, but Susanna caught a flicker of surprise in his eyes, almost as if it had not occurred to him that anyone would suspect him of Lady Russell's death.

"Do you mean to preach at me?" His English had a trace of an accent but was perfectly comprehensible.

"For immoral behavior?" She smiled. "I assure you I want nothing more than to discover what really happened the day Lady Russell died. Will you tell me what you remember?"

Since he did not say no, she pulled up a stool and sat across from him. "When did you leave the house that day?"

"I had not yet returned," he admitted, grudgingly. "I spent the night with my leman and stayed through the morning and into the afternoon. Her husband was away. By the time I came home, Aunt Jean was dead, Lady Glenelg had fled, and Sir Lachlann was just arriving with the bailie."

"You caught no glimpse of Lady Glenelg, or of her friend, Mistress MacReynolds?"

"Was she there again? No, I did not."

"Had you met her before?"

"I'd heard her." He drank deeply of his ale.

"Overheard, do you mean?"

"Aye. She visited Lady Glenelg a few days before my aunt died. I happened to be passing an open door and could not help but catch a word or two."

"What words?" He enjoyed toying with her, Susanna thought, but she was willing to play his foolish games if the prize was information.

"I gathered that Mistress Reynolds had visited Stirling and discovered that Master Buchanan, the royal tutor, had beaten a boy almost to death." Logan grinned. "A pity it could not have been my cousin Gavin who roused his temper."

Susanna ignored this bit of nastiness and pressed Logan for more details.

"Lady Glenelg said she wanted Mistress MacReynolds to tell Sir Lachlann what she'd learned. She said she was going to send for him. That is all I heard. I grew bored and went on my way."

"Do you often eavesdrop?" Susanna inquired. "You seem to have no qualms about listening to private conversations."

"How else can a man learn what deviousness women are up to?"

"I see I must reconsider my praise of your chivalrous instincts."

He laughed loudly at that. "I have none, nor does Sir Lachlann." He gestured toward the door.

Susanna was in time to glimpse a flash of crimson doublet. "Sir Lachlann," she called. "Come back and join us."

His face was a good match for his clothing when he returned. Unlike Malcolm Logan, Susanna did not think he made a practice of eavesdropping, but he had been standing in the doorway for some minutes. He had overheard what Malcolm Logan told her about Annabel.

"I do apologize," Sir Lachlann said. "I was startled into listening. Lady Glenelg seemed so anxious to talk with me, sending for

me to come to her in all haste, and I never knew why until now. Buchanan!" He shook his head, looking chagrined.

"His behavior would concern any mother."

"I rushed to Edinburgh from Stirling, thinking it a matter of great importance."

"What could be more important than the welfare of a child?" Susanna inquired. "It is a guardian's sacred duty to protect—"

"There we differ, Lady Appleton," Sir Lachlann interrupted, "as you already know. It is the duty of servants to look after the children in their care and of tutors to educate them. The responsibilities of one who holds a wardship are twofold, to see that the ward's lands and chattel are well cared for during his minority and to find him—or her—a profitable marriage."

"High thoughts from a man who listens in on private conversations." Malcolm Logan had the audacity to sneer at his host.

Sir Lachlann regarded him with admirable tolerance. "Are you yet living, Master Logan?"

"Alive and well," Logan assured him. "And anxious to convince this good lady of my willingness to reform and lead a...chivalrous life. I believe I will go to church services in the chapel at the castle on the morrow and ask divine forgiveness for my sins. Will you do likewise?"

"I am without sin," Sir Lachlann declared, bristling.

Logan hooted with laughter. "You, who would leave my poor young cousin in danger?"

Offended, Sir Lachlann bowed to Susanna and abruptly left the room.

Susanna regarded Malcolm Logan with a jaundiced eye. "Why *did* you come to Stirling?"

"Why, to give you another chance to persuade me to spare your friend."

"Are you ready now to accept compensation in lieu of blood?"

"Perhaps. If the price is right. But Lady Glenelg's lands are in England and I've no taste for foreign travel."

"I am certain we can reach some accommodation." Susanna tried to hide her relief that he was finally inclined to be sensible. She made an offer. Before another hour had passed, they had negotiated the price of Catherine's freedom from criminal prosecution for murder.

## ❧31❧

*October 6, 1577*
*Stirling Castle, Stirling, Scotland*

WORSHIP SERVICE was nearly over in the royal chapel when two women in loose ploddan cloaks made their way across the second drawbridge and were admitted through the inner gate and the Forework gateway into the Lower Square. The guards took them for laundresses, for between them they carried a large buck-basket.

Catherine did not know how Annabel had persuaded the washerwomen of Stirling to give up one of these huge wicker baskets, used to carry very dirty linen to the bucking place where it was laundered by boiling it in lye. It was possible she had stolen it. Nor did she understand why the guards had so easily let them pass, though she was gratified by their carelessness. By rights, they should have been suspicious of anyone working on the Sabbath.

Catherine shuffled faster along the road that passed between the Palace and the Great Hall. A few moments later, when they reached the Upper Square, she could hear, faintly, the sounds of prayer from within the chapel.

Catherine peered out from the concealing depths of her hood. Magnificent buildings rose on every side, making her feel very small and inadequate. Royal guards were posted at regular intervals, armed and alert for any threat against their young

master or his household. Catherine was painfully aware that they had invaded the home of the king of Scotland, and suddenly fearful. Annabel was mad to think her scheme could succeed. Susanna was right. Diplomacy would free Gavin. Rash action would only complicate matters.

But Annabel seemed undaunted. Indeed, she looked years younger. Her eyes gleamed with barely suppressed excitement. "Come," she whispered. "This way." And she led Catherine to a shaded spot off the passage that led from one square to the other. "Now we wait."

Catherine kept her doubts to herself. They had come this far. At the least she would see Gavin again before they were forced to abandon their plan. Annabel was no fool. Perhaps she'd realize they could not prevail. They could go quietly out of the castle again with no one the wiser.

This was one of the Sundays when the townspeople were encouraged to worship with their king. In a few minutes, the square would be swarming with churchgoers. That was what Annabel had been waiting for, the reason they'd lingered so long in Stirling without acting.

Catherine tugged nervously at the laces holding her cloak together. She had only to show herself to Gavin, Annabel had said, and he would come to them. It would be the work of a moment to help him into the basket. Then they'd carry him out like so much dirty laundry. In the crush, Gavin's disappearance would go unnoticed long enough for them to spirit him away from the castle.

She cut her eyes to the nearest sentinel. More likely they would be caught at once.

Catherine's breath hitched as people began to emerge from the chapel. The king was among the first to appear, resplendent in court dress. With him were his tutors, in somber black. Then came a scattering of officials and the boys of the household, including Gavin. Catherine's gaze fixed on her son, willing him to see and recognize her and praying he would not react by calling

out. She paid no attention to the townspeople who followed the royal retinue from the chapel until Annabel cursed softly.

A small, well-dressed party stood to one side as the king greeted his subjects. Catherine felt like cursing, too, when she recognized Susanna. To her right stood Sir Lachlann Dunbar, to the left, Malcolm Logan. Both men were too busy watching the king to notice Catherine, but Susanna had caught sight of her. Their eyes met for a long moment.

"We must give up our plan," Catherine whispered to Annabel.

"No. See—Gavin is looking this way. Beckon to him."

Her son's gaze passed over her and went on. He did not recognize her.

"Push back your hood," Annabel hissed.

Catherine hesitated. She was a fugitive. If Sir Lachlann saw her, or Malcolm Logan...

Annabel reached up and jerked the fabric away from Catherine's face.

Gavin was looking at King James and did not notice.

The milling crowd created as much confusion as Annabel had predicted. For a moment, Catherine lost sight of both the king's party and Susanna's. She stepped back into the shadows, closer to the buck-basket, and nearly jumped out of her skin when Susanna suddenly appeared at her side.

"What folly is this?" Susanna whispered. "You should not be here."

"Do not interfere," Annabel warned.

All three women started at the sound of a shout. Catherine gasped. The handle of a dagger still quivered from the force with which it had imbedded itself in a door. That it had been thrown to kill was horrifyingly obvious. It had come within an inch of striking the king as it passed between his head and Gavin's.

Too stunned to move, heart racing, Catherine stared at the knife. Now, when it was too late, Gavin saw her. His cry of "Mama!" was drowned out by another voice, nearer at hand.

"She threw it!" Malcolm Logan cried…and pointed straight at Catherine.

Susanna was quick-witted enough to deflect suspicion by turning to look behind them, as if Malcolm's accusation had been directed at someone standing there. The ploy might have worked if Annabel had not reacted just as quickly.

"Get rid of the cloak," she ordered, shedding her own as she brushed past Catherine and Susanna and veered away from them. Beneath she wore the clothes of a gentlewoman.

With trembling fingers, Catherine obeyed, too shaken to consider if the action made sense or not. She had on the same clothing she'd worn since leaving Edinburgh, a plain garment of coarse quilted grey cloth that hung loosely from her shoulders over a petticoat. Indoors she went barefoot, but she'd donned her boots for the trek to the castle.

Susanna grasped her arm, tugging her away from the buck-basket. At the same time she caught hold of Malcolm Logan and fixed him with a quelling glare. "Say not a word," she commanded. She was speaking to them both.

Catherine had to bite her lip to keep back a cry of alarm as Annabel bolted in the opposite direction.

Shouts of "There she is!" and "Catch her!" went up from the guards.

For a few moments, Annabel was able to elude them, but she was corseted and tightly laced and was quickly out of breath. When she paused to look back, five armed men converged on her, their captain calling out for her to surrender.

Annabel had no intention of going quietly. Instead she attacked the guard who was about to lay hands on her, kicking him in the groin to send him to the ground in agony. She leveled a second sentinel with a resounding blow to his helmet, delivered with a walking stick she'd appropriated from an elderly gentleman in the crowd.

The other three guards fell upon her. Had she been a man,

Catherine had no doubt they'd have killed her during the ensuing scuffle. Instead of bludgeoning or stabbing her, they contented themselves with wrestling her to the ground and taking away the walking stick. In a matter of moments, Annabel was a captive, her hands secured behind her and two guards holding her up to the stunned spectators for inspection.

The king stepped forward. "What is the meaning of this?"

"She threw the knife," said the captain of the guard.

"I did not," Annabel said.

"Let the witness come forward," the captain called.

But no one moved. Catherine scarce dared look at Malcolm Logan. When she finally did, her eyes widened. Out of sight of everyone else, Susanna held a pistol pressed against the young man's side.

"Keep your head down, Catherine," Susanna whispered.

She stared at the cobbles and belatedly remembered that she'd stuffed a simple coif into her pocket. She fumbled it into place, completing the disguise.

When she glanced up again, the royal guards were hustling King James away, and with him, Gavin. Her son looked back, his face a mask of misery, but he did not betray her presence.

In short order, the townspeople were also herded out of the square. No one tried to stop anyone but Annabel from leaving Stirling Castle. No one noticed that the party from Dunbar House was now larger by one.

Catherine stumbled along, her thoughts awhirl. She kept her face averted, lest Sir Lachlann or Una recognize her, but she knew it was only a matter of time before someone did.

Why had Annabel drawn attention to herself that way? What had she been thinking? And what was she saying now, under questioning? Catherine shuddered. Annabel would not just face interrogation. She would be tortured unless she confessed to—

Catherine's head snapped up. Annabel would be accused of trying to kill the king, but she had not thrown that knife. She had

not been the one accused of throwing it, either. Malcolm Logan had meant the guards to seize Catherine.

Had he thrown it himself? Her stomach twisted as she belatedly grasped what Susanna must already have guessed. Malcolm Logan *had* thrown the knife, but not in an attempt to assassinate King James. He'd been aiming at Gavin!

## ⚜32⚜

*October 6, 1577*
*Dunbar House, Stirling, Scotland*

"TIE HIM UP," Susanna ordered when she had both Catherine and Malcolm Logan safe in her bedchamber. Only after Catherine had complied, using the velvet cords from the bed curtains, did Susanna lower the pistol Nick had insisted upon leaving with her for protection. She had not wanted to take the little gun. In the wrong hands it could be deadly, and in most emergencies it was fairly useless.

The wary glower Malcolm kept fixed on the pocket-dag confirmed Susanna's suspicion that he knew nothing about firearms. This was not surprising. Most gentlemen preferred to protect themselves with blades. Only among the vagrants who came before Nick and other justices of the peace in England had there been such a proliferation of handguns in the last few years that a proclamation against "dags," as these small guns were called, had become necessary.

Rather than lose her advantage, Susanna treated the weapon as if it could be used at a moment's notice. She set it aside with the brass barrel pointed away from her and the wooden stock close to hand. The truth was, before she could fire the pistol, she'd have to insert a round lead ball and a charge of black

powder, then hope the powder would ignite when she pulled the trigger. The few times she'd practiced, with Nick as her teacher, she'd wondered why anyone thought this an effective way to deal with an enemy. Not only had she been thrown backwards by the blast, but the cloud of white smoke and the smell of sulphur had set her to coughing uncontrollably.

"Susanna," Catherine said in a desperate whisper. "We must help Annabel."

"She offered herself up to allow you time to escape. Would you have her sacrifice be in vain?"

"But they think she tried to kill the king. She is not even the one who threw the knife. He did." She glared at Malcolm Logan with loathing. "He meant the blade to strike Gavin."

"Did not," Malcolm muttered.

"Liar!" Catherine spat the word.

Now that she thought about it, Susanna found it suspicious that Malcolm had suggested attending services at the castle at all. He *must* have planned this. Since he could not arrange things so that Gavin came to him, he'd gone to the one place the boy would have to be out in the open. He'd seized his opportunity and, when his aim had been off, he'd taken advantage of Catherine's presence to claim the king was the target and shift blame for the attack to her.

"No one saw who threw the knife," Malcolm said, some of his old arrogance returning. "Mistress MacReynolds had her own plan. Mayhap she threw the knife. Doubtless she intended to kill the king!"

"Why should she?" Catherine rounded on him, hands curled into fists.

Susanna dismissed his accusation for far more practical reasons. "If Annabel had thrown that knife, we would have seen her do it. Besides, she would have hit whatever she aimed at. Now, Catherine, tell me what you were doing there."

It did not take long for Catherine to summarize the scheme

Annabel had devised to smuggle Gavin out of Stirling Castle in a buck-basket. Susanna vaguely recalled seeing the huge wicker container but it had made no great impression on her at the time. Would it have worked? She doubted it, but now they would never know.

"And when you had him safe, what then?"

"We meant to leave the country, never to return." She sent another glare in Malcolm Logan's direction. "You could have claimed the title then, you greedy fool."

"Only if my young cousin were dead."

Catherine opened her mouth, then shut it again.

Susanna took the pistol with her as she led the younger woman to the farthest corner of the room where, she hoped, they would not be overheard. "What else did you plan?"

"To make everyone think we were dead, lost at sea. Myself, Cordell, and Gavin." She outlined the plan and did not seem surprised by Susanna's reaction to it.

"What foolishness! Think, Catherine. How would you live in exile if you were thought to be dead? You would lose the income of your estates. You would be destitute."

"I was to make a will naming someone I trusted as my heir."

"Annabel, I suppose? Well, she might have spared you a pittance."

"I will not argue with you. I am not certain myself that Annabel is trustworthy. But I do know that I am indebted to her. Whatever her reasons for helping me, I cannot let Annabel take the blame for what Malcolm did. Nor do I want him to go unpunished for trying to kill my son. But if we turn him in and tell the truth—"

"You will be imprisoned also, since Malcolm is not now likely to drop the criminal charges against you. And Annabel will scarce be set free, since she attacked and injured several of the king's men."

"If I come forward, she will be spared the charge of treason."

It galled Susanna to make the promise, but Catherine was unlikely to be persuaded to leave if she did not. "I swear I will help her, Catherine, but you and your children come first. You must leave Stirling before Annabel is…persuaded to name you as her accomplice."

Catherine looked stricken. "She will not betray me."

"Can you be certain? Will you stake your life on it? The lives of Cordell and Gavin?"

Catherine closed her eyes, her lips pursed. When she opened them again she met Susanna's eyes. "I am not even certain Annabel is sane. You saw how she attacked the guards. She must have known she could not prevail."

"That seems an act of madness, yes," Susanna said thoughtfully, "but I do not believe Annabel has lost her mind. She rarely does anything on impulse." Not even killing a man. "Still, I do not think we can rely upon her to keep your name, or mine, out of this matter for long. We would do well to leave Stirling as soon as may be."

"Not without Gavin."

"Catherine—"

"*Not* without Gavin."

With a sigh, Susanna capitulated. "No, not without Gavin."

There was a way, though the risks to all of them would be great. Susanna wished now that she had told Catherine more when they'd met in the stable. Confiding details of Gavin's late night visit to Dunbar House might have prevented this disastrous attempt to free him.

"Gavin can leave the castle at any time," Susanna said. "We have only to get word to him to come to us." She explained about the king's grandfather's escape route, then added, "I will ask to see him again, to say farewell before my return to England, and appoint a time for his escape."

"If you meet with him right before he vanishes, you will immediately fall under suspicion of having a hand in his disappear-

ance. I cannot bear the thought that you will end up in prison, too."

"Nor am I anxious to share a cell with Annabel," Susanna assured her, "but I think there is little danger. The authorities will be loath to arrest an English gentlewoman." She had no idea if that was true, but she wanted Catherine to believe it.

The stubborn look Susanna knew so well in Rosamond, inherited from Robert, appeared on the face of Robert's half sister. "Find another way to send word to Gavin. Do not risk yourself."

A voice from the other side of the room startled them both. They had forgotten they were not alone.

"I'll go," Malcolm Logan volunteered.

## 🕸33🕸

*October 6, 1577*
*Stirling Castle, Stirling, Scotland*

LADY MAR looked at Annabel with extreme distaste. "Yes," she said. "That is Annabel MacReynolds." If she also recognized Annabel as the servant who had briefly worked in her household, she did not admit it.

For Lady Mar's convenience, Annabel had been brought into the same well-appointed room in the palace where they had met once before, when Annabel had come to find out how young Lord Glenelg fared. This time there were others present. Sir Alexander Erskine of Gogar, Master of Mar, was only a few years older than his charges. He was the king's official guardian and uncle to the young earl of Mar, Lady Mar's son Jocky. Beside him stood two more Erskines, half brothers, Annabel presumed—David, lay abbot of Camburskenneth, and Adam, lay abbot of Dryburgh.

Among other duties, they'd taught the king to ride and hunt. A little to the rear were the master of the king's household, Cunningham of Drumquhassle, and several guards. An impressive lot, Annabel thought, and smiled equably at them all.

"You entertained her here," Sir Alexander said, a hint of accusation in his voice.

"I entertain many people. I have many friends." For once Lady Mar's hands were still, gripped tightly together in her lap.

"She is a friend of yours, then, madam?"

"She was one of the lesser ladies in attendance on the king's mother when I was a member of that court." Lady Mar's voice could have frozen fire.

"What did she want of you?"

Annabel was curious herself to hear the answer. Lady Mar had been willing to spew abuse at Master Buchanan in private with her, but would she admit it to the gentlemen of the household?

She did not. She claimed she could not remember what they talked of, but that there had been no treason in it. The name of "Glenelg" was not mentioned.

"Mayhap she is mad," Lady Mar suggested.

Annabel cleared her throat. "Mayhap," she suggested in a mild voice, "you should send word to the regent that you have one of his agents in custody."

Having gained their full attention, she smiled again.

"I was sent here by the earl of Morton to test the ability of your men to guard the king." She shifted her position to emphasize the bonds that held her. "As you can plainly see, in the end all remains secure, but I do not believe I should have been able to penetrate your defenses at all. And there is the matter of the knife thrower. He managed to escape in the confusion caused by my capture."

# ❧34❧

<p style="text-align:center">*October 7, 1577*<br>*Dunbar House, Stirling, Scotland*</p>

UNA'S SCREECH woke Susanna.

"Murderess! Help! Ho! Do not let her escape!"

Susanna flung herself out of bed and caught the maidservant before she could open the bedchamber door and rush out. "Silence," she commanded.

"But, Lady Appleton, she killed my mistress!"

"You cannot be certain of that."

Rubbing sleep out of her eyes, Catherine sat up in the bed they'd shared. She opened her mouth, no doubt to admit that she might have killed Lady Russell, but Susanna spoke first.

"Sit, Una, and tell us again what happened that day."

Although she kept casting nervous glances in Catherine's direction, Una obeyed. Nothing had changed about her story, and when she got to the point of discovering bruises on Lady Russell's throat, she lost her fear and glared at the woman she thought responsible.

"Great huge marks they were," she said accusingly. "Thumbs, so—" she touched two spots at the front of her own throat "—and fingers there." The second gesture indicated the back of the neck.

Susanna frowned, trying to picture what Una described. "Wait." She turned to Catherine, unwilling to take the risk of frightening Una, and placed her own hands on the younger woman's throat. "Look here, Una. My hands are small and so, I wager, are Lady Glenelg's. Are you certain the finger marks were so large, and spaced so close together?'

Una's own hands went to her mouth as her eyes widened.

Catherine looked almost as thunderstruck. "I never thought," she murmured. "She is right. And it would take great force to bruise her throat through her ruff."

"Use your brain, Una. Lady Glenelg fell, too. No one disagrees about that. She'd have been weak after the fall. She would not have had the strength to crawl to Lady Russell's side and strangle her. Moreover, if the marks were as you say, then they must have been made by someone with large hands using great force."

"A man," Una said, leaping to the conclusion Susanna hoped she would.

Susanna did not offer her the possibility that Jean Ferguson might have been strangled before the fall, or point out that Catherine's hands were, in fact, uncommon large for a woman.

"But there was no man in the house when my mistress died," Una objected.

"That we know of," Susanna said.

She thought at once of Malcolm Logan, Master of Glenelg, with a title to be gained if Gavin were out of the way. How Lady Russell's death would serve that purpose, however, still eluded her. Had he hoped to have the chance to kill Gavin when the boy came to attend his grandmother's funeral? That seemed improbable, and did not account for leaving Catherine alive when he could have disposed of her at the same time and in the same way.

She would question him again later, she decided. At the moment, he was unconscious, having been drugged with poppy juice so that he could be locked in a cupboard in the attic room allotted to Toby. Late the previous night, they had taken Nick's man into their confidence and solicited his assistance.

Even with Una's reluctant vow to say nothing to anyone of Catherine's presence, Susanna knew she and Catherine did not have much time. They could not keep her hidden in Dunbar House indefinitely. Nor could they count on keeping Malcolm quiet. Since Susanna had no desire to poison him, she was reluctant to give him too much of the sleeping potion. There was no predicting when it would wear off.

"If Nick does not return today, we must consider leaving here without him," Susanna said. She hoped he had not encountered serious difficulties arranging for a ship.

"Then we must get word to Gavin. How?"

"I will think of something."

"When will Fulke return?" Restless as a caged cat, Catherine roamed the bedchamber, picking things up and putting them down, sitting a moment, then springing up again.

"I do not know, Catherine. Soon, I hope." What a waste of time for him to have traveled to Dunbar Island. She should have insisted he remain in Stirling. Fulke would have known how to deal with their prisoner.

"What about Annabel?" Catherine asked. "There must be something we can do for her."

"Not without implicating ourselves."

"Give them Malcolm Logan."

"He knows too much of our affairs." His offer to take a message to Gavin had been rejected out of hand. Had the fellow really thought they would be so foolish as to give him another opportunity to harm his cousin?

"We cannot abandon her."

"There is one thing I can do," Susanna mused. "I can approach Sir Lachlann, full of concern because I belatedly recognized the woman who tried to kill the king as Annabel MacReynolds. I will even confess what he must already guess, that I believe you came with Annabel to Stirling. I will tell him that I am certain you have fled. I will convince him that I have given up any hope that you will send word to me. I will talk of returning home. Then I will beg him to go to the castle and find out if Annabel has told the authorities anything about you. For the sake of Gavin's position at court, he will want to know, too. I believe he will find out all there is to know."

"Can he take a message to Gavin?"

Susanna considered this. She did not trust Sir Lachlann to that

extent. "Be patient yet a little while," she told Catherine, "until we discover what Annabel has said."

If she had not implicated either of them, then, in spite of Catherine's objections, Susanna meant to pay a "farewell" visit to her godson.

## ※35※

*October 8, 1577*
*Dunbar House, Stirling, Scotland*

UPON WAKING for the second morning at Dunbar House, Catherine stared bleakly up at the tester. She had not heard Susanna get up, but her old friend had always been an early riser. And she could roam freely. Catherine faced yet another long day hiding in this chamber. What point was there in leaving her bed?

Nick Baldwin had returned the previous afternoon. Catherine had been overjoyed to learn that he'd secured a ship. They had the means to escape from Scotland. But then Susanna had given him an account of all that had transpired in his absence, and sketched out the plan she and Catherine had made to rescue Gavin. Nick had been dumbfounded by the former and appalled by the latter and declared Susanna as mad as Annabel MacReynolds.

He did not approve of her determination to help Catherine kidnap her son. Catherine supposed she could not blame him. Hard on the heels of her spectacular failure to carry Gavin off in a buck-basket, another attempt must seem nothing less than suicidal.

He had not needed to point out that, if they were caught, Catherine could be charged with treason. Susanna would be suspected of espionage, at the least. Scots justice might be lenient

when it came to prosecuting murder, but Gavin's removal from the royal household would doubtless be construed as an attack on the king.

Fighting the sense of impending doom that hung over her, Catherine dragged herself from the bed. When she'd thrown on a night gown to cover her nakedness, she sloshed water from the basin onto her face. It did little to revive her. Towel in hand, she walked to the window and pulled back the curtain, thinking to judge the time by the angle of the sun.

The window overlooked a small courtyard. Beyond, Catherine glimpsed the stables and the horseman who had just ridden in.

Catherine's heart gave a little kick of recognition. *Fulke.* Heedless of her need to stay out of sight, she leaned out the window for a better view.

His slow dismount spoke of tiredness, but she saw no overt sign that he'd encountered difficulties on his journey. With a familiar gesture, he removed his hat and smoothed his hair back from his face, then straightened his jerkin. He shrugged his shoulders, easing away the stiffness of travel. Then he tilted his head back…and saw her.

Fulke's lips parted on a smile and he mouthed her name like a prayer.

Of its own volition, her hand lifted, acknowledging his silent greeting.

Belatedly, she remembered she was a fugitive and withdrew into the room, but a great calm had come over her. How surprising, she thought, and the more so because of what she'd just realized about herself. Her feelings for Fulke should have been cause for alarm. Instead she was grinning like a fool.

Catherine hurriedly dressed and was attired once more in her servant's garb when Susanna came into the bedchamber. Nick and Fulke were right behind her. Catherine would have walked straight into Fulke's arms had not Susanna put herself between

them to prevent the embrace. She gave Fulke a little shove onto a chest and settled herself and Catherine on the end of the bed opposite.

Nick, looking bemused, glanced from Fulke to Catherine and back again. Understanding dawned slowly, producing a frown. "This is a complication no one needs."

Was their affection for each other so obvious, then? Catherine supposed it must be, but she could not regret this turn of events. The warmth in Fulke's gaze gave her pleasure and bolstered her confidence.

"Are you well, Catherine?" Fulke asked. By rights he should have addressed her as Lady Glenelg, but no one bothered to correct him.

"Very well, now, and soon to be better. You suffered no ill effects from your journey?"

A cloud passed over his face. "I will tell you of my adventures shortly. First explain why Master Baldwin is so wroth with you."

"Master Baldwin," said Nick, "can speak for himself."

In short order he had acquainted Fulke with everything that had happened in the last few days, including their imprisonment of Malcolm Logan in the garret of Dunbar House. Fulke said nothing throughout the account, although his troubled gaze went to Catherine more than once.

"I do not think Master Logan killed Lady Russell," Fulke said when Nick had explained why they believed their prisoner might have committed that crime in addition to making an attempt on Gavin's life.

"He claims he was with his mistress," Susanna told Fulke, "but he has lied about other matters."

"What does she say?"

"She has yet to be questioned. Moreover, if she is enamored of him, she may well say he was with her longer than he was."

"'Tis certain he was nearby that day," Catherine said. "Within a mile of Glenelg House."

"So was Sir Lachlann. Let me tell you about my visit to Dunbar Island."

Fulke held Catherine spellbound with his tale, from the ruse he'd used to gain access to the castle to the stories the three girls—three sirens would be more apt, Catherine thought—had told him about their father and his wards.

"Accidental deaths?" Susanna mused. "Convenient, if so. Yet girls that age do exaggerate. At least, Rosamond does."

"They were in earnest," Fulke insisted, "and they had a kind of innocence about their avarice that made me think they'd find it difficult to lie. I do not think it has occurred to any of them that those accidents could as easily have been murders."

"You think he killed both boys so that his daughters could claim their inheritances?"

"I do."

"Do you not find it odd that Sir Lachlann should have been so careful to keep his daughters and their husbands close and yet took no precautions against strangers visiting his island to talk to them?"

"Mayhap he counts on the remoteness of the place to keep people away. Certes I had no difficulty leaving when I wished to. A servant rowed me across to the mainland."

"If the deaths were accepted as accidents at the time, it will be difficult to prove otherwise now." Nick stood at ease, one shoulder propped against the window casement, but his eyes betrayed how troubling he found Fulke's tale.

"And yet, it is not something Sir Lachlann would want bandied about," Susanna said. "He might find it passing difficult to obtain more wardships in future."

"And so he should if he meant to marry Gavin to his third daughter, then kill him, too." Catherine felt her face go hard with disgust and loathing.

"He will not get the chance, now." Susanna patted her hand. "Strange, though. It would have made more sense to let them

produce heirs before he disposed of them. He'd still have been able to repeat the scheme, getting them other husbands, but he'd have had the advantage of new young heirs in his keeping."

"You cannot exonerate him just because he was less greedy. The girls got their widow's third. Neither they nor he should get away with what he's done." Catherine had no sympathy for those young women. They were predators, just like their father.

"We can send word to the proper authorities once we are safely out of Scotland," Nick suggested.

Susanna nodded in agreement. "What Fulke discovered is horrible, but I cannot see that it adds to our knowledge of who killed Lady Russell. Leaving boys to die is far different from strangling someone. Besides, how could Jean Ferguson's death profit Sir Lachlann? He did not inherit anything as a result. She was no threat to him. Killing her makes no sense."

"It would have made more sense to kill me," Catherine agreed.

"There is more," Fulke said. "I stayed the night on Dunbar Island, to recover from my ordeal at sea. A manservant was assigned to look after my needs, since I was presumed to be a gentleman. He was same man who accompanied Sir Lachlann from Stirling to Canongate."

"I wondered what had happened to him," Susanna murmured. "When I asked, Una said he'd gone back to Stirling and I thought no more about it."

"He was sent to Dunbar Island, just in case someone took a notion to ask him about the day Lady Russell was killed. He does much resent his exile there and it took little prompting on my part to learn all he knew."

"But what could he know?" Catherine thought back on that afternoon. "I was upset. Sir Lachlann took me in his arms to offer comfort." Catherine tried to ignore the flash of emotion in Fulke's eyes, but she knew what it signified. "I told him Jean was dead and I had lost a portion of my memory. He said he should have been at

Glenelg House sooner, but that his horse had come up lame. He'd
been obliged to take his servant's nag and ride on ahead of the fel-
low. I presumed the injured animal required to be walked the rest
of the way to Glenelg House."

"Sir Lachlann rode on ahead, but on his own horse, and early
in the day's journey. He was most anxious to reach Glenelg House
and had no patience with the speed of the plodding nag the ser-
vant rode," Fulke said.

"Mayhap I misunderstood him."

"Mayhap he lied to you. The servant had nearly reached Glen-
elg House himself when he met his master riding *away* from
Canongate. Sir Lachlann dismounted and bade his man do the
same. He said his horse had gone lame and ordered the servant to
trade horses with him, then take the injured animal to the local
farrier."

"And then he came on to Glenelg House."

"And then, I do think, he *returned* to Glenelg House."

Susanna cleared her throat. Catherine had all but forgotten
she and Nick were in the room.

"Unless someone saw Sir Lachlann arrive earlier," Susanna
said, "on a different mount, this is all speculation. You can prove
nothing. The servant knew nothing."

"He knew there was naught wrong with Sir Lachlann's horse.
The farrier will confirm it."

"I will do my best to see that both Malcolm Logan and
Lachlann Dunbar receive their just deserts," Susanna promised,
"but vengeance must not distract us from our present purpose. To
spirit Catherine and her children safely out of Scotland, we need
Sir Lachlann free. When I told him yesterday of Annabel's arrest,
he was shocked and dismayed by the revelation. He went to
Stirling Castle at once to find out if she had implicated Catherine
but was unable to learn anything useful. Annabel is being kept in
close confinement. When I broke my fast with Sir Lachlann this
morning, I encouraged him to try again. It is my hope he will

return with good news ere long. Once we are assured of Annabel's continued silence—and I do think it likely since, had she betrayed Catherine, Dunbar House would have been searched by now—we will put the rest of the escape plan into action."

"What plan?" Fulke asked.

"More madness," Nick muttered.

"I will ask to visit Gavin and tell him where to meet us. A simple and straightforward action. Then we will leave Dunbar House, telling everyone we are bound for Edinburgh, and double back for the boy."

"When he disappears, they will remember your visit. They will come after us." Nick let his anger show. He'd tired of pleading with Susanna to use common sense.

"That cannot be helped." Irritated, she rose and shooed Fulke off the chest so she could begin to pack. "We will have a good head start. God willing, we will reach the ship at Leith well ahead of any pursuit."

"Do not quarrel. Please." Catherine had enough else on her conscience without becoming the cause of a rift between Susanna and Nick. "There must be some other way to get word to Gavin. You must not risk yourself, Susanna. I never wanted that."

"Friends help each other, Catherine." She glared at Nick. "And those who love those friends, support them."

Nick looked exasperated but resigned. He crossed the small room to Susanna's side and she let him slip his arm around her shoulders.

Only then did Fulke speak up. "I know how to alert Lord Glenelg. I arranged it with him when I escorted him back to the castle. All we need to do is fly a red banner from one of the chimneys of Dunbar House."

# ❦36❦

THE SUN was low in the sky when Annabel was taken from her cell and once again escorted to Lady Mar's private chamber. She was not surprised to find Elspeth, Lady Tennant with the countess and the Erskines.

"Lady Tennant has brought word from the regent to confirm your story," Sir Alexander told her.

Annabel knew her smile was smug as she glanced at Lady Mar. If the countess had any suspicion that Annabel and Catherine had lived in her house, posing as servants, she would not speak of it now.

A short time later, Annabel left the castle in a closed coach in Elspeth's company. The vehicle was impractical for long journeys over Scotland's notoriously bad roads, but it added to the regent's dignity when he was in town. They reached his house within minutes of leaving the castle.

"It seems you were correct," Elspeth said, when Annabel had bathed and donned some of her own clothing, brought from the house in the Netherbow. "The king's security was in need of improvement. I think my cousin had his doubts when you suggested this scheme."

"Your cousin, the regent, was willing to trust my judgment."

They both knew that had not been his primary motivation. Annabel had persuaded the earl of Morton to let her try her plan because she'd been willing to fund the effort herself. She'd approached him in Edinburgh the day after she'd spirited Catherine away from Glenelg House after Lady Russell's murder. She'd always been good at planning ahead.

The two women had scarce settled themselves in a small parlor, its walls painted in a pleasing pattern of geometric shapes, when Elspeth's spaniels—she'd brought only three of them with

her—set up a great racket with their barking. Sir Lachlann Dunbar had arrived and was asking for Annabel by name.

"How did he know how to find me?"

"Mayhap you should ask him." Elspeth shushed her dogs and gave orders to admit their visitor.

"Ladies." He doffed his hat and bowed to them, every inch the courtier and even speaking French to show his gentility.

"Sir Lachlann," Annabel replied in the same language. "I am surprised you knew to look for me here."

"One of the men sent to arrest Malcolm Logan told me."

"I expected the Master of Glenelg to be halfway to Dunfallandy by now. He must have known I saw him throw that knife."

"They found him in his bed, soundly sleeping. In truth, they could not rouse him and had to carry him away unconscious."

Annabel saw Susanna Appleton's hand in that. Poppy syrup, no doubt. "Does everyone know of my release?" she asked with affected casualness.

"If you mean, is Lady Appleton aware of it, then the answer is no. She and her party left this afternoon to return to Edinburgh."

And with luck, Annabel thought, she had taken Catherine with her.

"*Ken ye ocht*—" Sir Lachlann caught himself and switched back to French. "Do you know where Lady Glenelg may be found?"

"Why should I?" She idly scratched one of the spaniels behind the ear, sending it into ecstasies, and pretended disinterest in Catherine's fate.

"Because you are her friend. Lady Appleton told me that Lady Glenelg asked you to help her find certain...information. She—Lady Appleton—said you discovered some distressing facts about Master Buchanan. I only ask out of concern for my young ward," he added in a rush, and he did, indeed, look worried.

Obligingly, Annabel repeated what she'd heard about Buchanan's temper and his treatment of the boys in his care, including the king.

It was Elspeth who reacted most strongly. "It is treason to strike the king!"

"Evidently not," Annabel drawled. "I took the liberty of mentioning the incident to the regent. He was not unduly concerned. And Master Buchanan has been given leave to teach as he sees fit."

"That is the way boys learn," Dunbar agreed. "With discipline, and with corporal punishment when it is needed." He permitted himself a small smile. "If that is all Lady Glenelg was concerned about, then her fears were misplaced."

"That is what she wanted me to tell you," Annabel confirmed. "She asked that I meet with you, and with Lady Russell, the day Lady Russell died. I did warn her that you would not regard Master Buchanan's actions with much alarm. Certes, you would not be concerned enough to remove young Gavin from court on that account."

Sir Lachlann laughed. "It is good to keep the boy away from her. She would smother him with her worrying."

"She loves him, Sir Lachlann."

"Do you know where she is?" he asked again.

It amused Annabel that Sir Lachlann did not suspect that Catherine had been under his own roof since Sunday morning. It pleased her that, for once, she could tell the truth: She had no idea where Susanna Appleton had taken their mutual friend.

## ❧37❧

*October 9, 1577, just after midnight*
*outside Stirling Castle, Stirling, Scotland*

FULKE GRIPPED Catherine's shoulders as Gavin emerged from the darkness and trotted toward them. "If you overwhelm him with emotion, you will frighten him," he warned.

She could not stop the tears from flowing, but she managed to content herself with one brief hug before they started along the path used so many years before by King James's grandfather.

"Any difficulty getting away from your schoolfellows?" Fulke asked.

"I have been pretending that I suffer from toothache," Gavin whispered, voice bursting with pride. "After the first night, no one paid attention to me when I moaned and tossed and turned and finally got up to rove about. They were glad not to have to listen to me."

"Did no one offer you a remedy?" Catherine asked.

"I had to use donkey's milk as a mouthwash." Although Catherine could not see it, she knew he made a face. "I told them it did not work."

"Be glad, boy," Fulke told him, "that you were not obliged to bite the head off a live mouse and hang it round your neck."

"Does that cure a toothache?" Gavin asked.

"Some think so, as long as the sufferer makes certain there are no knots in the thread or ribbon he uses to suspend the mouse."

"If there are no knots, how can it be held in place?" the boy demanded.

"Figure that out, and likely it will cure you."

Catherine smiled in spite of the dangers and uncertainties that still lay ahead of them. Fulke was good with children.

He was good with her.

# 🕸38🕸

*October 9, 1577*
*Linlithgow, Scotland*

"YOU NEED have no fears for Annabel MacReynolds," Nora MacCrimmon told Catherine. "She has a way with her. I've never seen a bit of trouble yet she hasn't been able to talk her way out of." Annabel's cousin kept her hands busy with mending while she talked, stitching up a rip in one of her children's shirts with a skill Susanna envied.

They were gathered around the fire in the Hall after a light supper—Nora, Catherine and Gavin, Fulke, Nick, and Susanna. Toby stood guard over the horses. Una, along with Nora's servants and her children, had already retired for the night. Una had been exhausted by the fast pace of their journey. If Lady Russell's maidservant had any questions or qualms, they had been put to rest by a generous pension and the promise of rent-free lodgings in London for the rest of her life.

"To be arrested and charged with an attempt to assassinate the king is more than a bit," Susanna pointed out.

She wondered if Malcolm Logan had been found yet. They'd left him behind, drugged and helpless. The temptation to silence him permanently had been great, but she had not given in to it. Their situation would not be helped by another murder. Nor would she ever condone the wanton destruction of a human life.

It must be clear by now, even to the dullest of councillors, that the disappearance of Lord Glenelg and the attack on the king on Sunday were connected. Malcolm, once freed, would undoubtedly repeat his claim that Catherine had thrown that knife. Even though Annabel had not betrayed them, Catherine was still a fugitive. Only now, she was wanted for murder and for kidnapping both.

"Will you leave at first light?" Nora asked.

"A bit earlier, I do think." Nick removed a cat from his lap.

Another promptly took its place. They reminded Susanna of Lady Tennant's spaniels, save they were much quieter.

Nick was of one mind with Susanna now, agreeing that they must stop no longer than necessary to rest their mounts and themselves. The ship Nick had purchased awaited them at Leith, the port for Edinburgh. If all went well, they could reach there by tomorrow afternoon.

"I wish there had been some way to rescue Annabel from Stirling Castle," Catherine said again. "She is a prisoner because of me."

"I warrant she was glad of any excuse to break the monotony," said Annabel's cousin.

Susanna could well believe it. The absurdity of trying to smuggle Gavin out in a buck-basket was only surpassed by Annabel's notion that she could convince the authorities that Catherine and her children had boarded an imaginary ship that had subsequently sunk with all aboard.

"When last you were here, Annabel suggested you might go to Italy," Nora remarked. "To Cremona. Did she tell you why she chose that city?"

"Something to do with Queen Catherine of France, I believe."

"In a way. The French queen was Italian by birth, and that made her look favorably upon Annabel's connection to that part of the world, but the Medici did not come from Cremona. Cremona was the birthplace of the MacCrimmons of Skye, hence our name." She chuckled. "You must tell no one. It is supposed to be a deep, dark secret."

"Why?" Gavin asked. Curled sleepily against his mother's side on the floor beside the fire, he had been listening closely to everything said around him.

"Because the Scots do not like outsiders. Strange, when most royal courts brag of their Italian musicians, but Scotland is a contrary place. My great-grandfather came here from Cremona and brought his bagpipes with him. But before a generation had

passed, my kin were claiming to have come to the isles from Ireland, as many Scots families do. These days no one admits to the truth."

"Except you," Susanna pointed out.

"And my cousin Annabel. We still have distant kin in Cremona. Annabel met some of them during her travels abroad. She was certain they would take you in, Lady Glenelg, if you told them she had sent you."

"Shall I repeat your family's history in reverse?" Catherine asked. "No doubt, in a generation or two, no one would suspect that my descendants had not lived in that province for a hundred years."

"You will not return to Leigh Abbey?" Fulke's face wore a mournful expression in the best of times. Now he looked as if he'd just been asked to put a horse with a broken leg out of its misery.

"How can I? I had no legal right to take my son. Queen Elizabeth will not want to disrupt relations with an ally. She will order my arrest and send Gavin back to Scotland. She might even prosecute those who helped me. Better simply to disappear."

"My ship will take you anywhere you wish to go." Nick had given up trying to discourage the cats. Two striped felines now reclined across his knees and he was stroking one with each hand.

If it were to be Italy, Susanna thought, she had her own friends in Padua, people she'd trust to protect Catherine and her children. People about whom Annabel MacReynolds knew nothing.

"Will anywhere be safe?" An edge of panic made Catherine's voice sharp. "Where can we go where no one will follow? Muscovy? Persia? To the ends of the earth?"

"You'd not like either Muscovy or Persia." Nick spoke from experience.

Susanna toyed with the laces at her waist. "I do not want to lose your company, but you are right. It will be safer if you

disappear … for a few years at least. In time, you may be able to
return to England." She glanced at Nick. "It occurs to me that
Annabel's plan to make everyone believe you were lost at sea
has some merit, provided financial matters are seen to before-
hand."

Nick frowned but caught her meaning. "A fictitious ship
would never have worked, but we have a real one. And Lady
Glenelg could leave a will making you her heir."

"Can you make it seem that it has been lost at sea?" Fulke
sounded doubtful. "The crew——"

"The crew can be exchanged for men loyal to me before the
'shipwreck' takes place."

"If a ship is to 'sink' with Catherine and her children aboard,"
Fulke said, "then you cannot be with them, Lady Appleton. Pas
sengers and crew alike must *all* disappear."

"He has the right of it," Nick said.

"Then I will proceed south by land. Everything will appear
normal. I did, after all, leave Stirling to return home."

"I will ride ahead," Nick said, "and meet the ship at Spittal." At
her questioning look, he explained that this landing was just south
of Berwick, on the English side of the Border. "I'll send word
ahead to have a new crew waiting there. The Scots currently man-
ning her will return home with good English coin in their pock-
ets, none the wiser for having helped a fugitive escape."

"They may be questioned later," Fulke objected.

"By then we'll all be out of Scotland," Susanna put in. "Even if
the authorities decide we aided Catherine's escape, her death and
those of her children will already have been reported. No one
will pursue the matter."

"You will never be able to return to Scotland," Nick warned
her.

"As it happens, I had no plans to cross o'er the Border again in
any case." Susanna reviewed the details in her mind and could find
no fault with the plan, save that it would take Catherine and her

children away from her for a long time to come. "Will you wait for me in Spittal?" she asked Nick.

"I will take lodgings in Berwick," he promised. "When you arrive, we will go on to Kent together."

And so it was decided.

*      *      *

LATER, when Susanna was alone with Nick in the minuscule garden behind Nora MacCrimmon's house, she asked the question that had been preying on her mind. "How many laws must you break to arrange this elaborate deception?"

"Does it matter?"

"No." She sighed, and leaned back against his broad chest, comforted by his presence. "What has happened to us, my dear? We were once most law-abiding."

"Laws are meant to create order. Ofttimes they fail, and when they do, or when they prevent justice, law-abiding men and women must find other means to right wrongs."

"You have given this a good deal of thought," she said in surprise.

"I have," Nick agreed.

They remained in the garden a little longer, staring up at the stars. A day or two more, Susanna thought, and those she loved most in the world would be safe. She would not regret leaving Scotland behind herself, but she did hate to go with so many questions still unanswered. Once the ship sailed and Nick had left Leith, she decided, she would take Fulke and Toby and return briefly to Glenelg House in Canongate. This would support the pretense that she was ignorant of Catherine's whereabouts. If luck was with her, it might also provide the opportunity to tie up a few loose ends.

## ❦39❦

FULKE WAITED until Lady Appleton and Master Baldwin came in from the garden before suggesting to Catherine that she might like a breath of fresh air herself. She went willingly, having seen Gavin safely into bed. On the morrow she would be reunited with her daughter. She exuded happiness.

"You did not murder anyone," he said bluntly. "You do not deserve to be forced into exile."

Her smile faded. "I wish I could remember what happened that day. It is possible I did kill Jean. Indeed, that solution makes more sense than accusing either Malcolm Logan or Lachlann Dunbar."

"Lady Appleton told me that the bruises were too large and spaced too closely to have been made by a woman's fingers."

"Lady Appleton did not see them. She is indulging in wishful thinking, and she was anxious to convince Una that I could not have slain her mistress, else Una would have betrayed my presence at Dunbar House. But I am not convinced." She ducked beneath a rose arbor, almost as if she were trying to hide from him. "Jean had a very thin neck. In truth, a woman could have killed her as easily as a man. I could have dispatched her with no trouble at all."

"You did not murder anyone." He still thought Sir Lachlann the most likely suspect. God knew the man had not hesitated to slaughter children. Why not one old woman?

"In the end it matters little, I suppose. I have been charged with killing her." She gave a short, mirthless laugh. "And yet, it is not for that crime that I will be pursued, but for rescuing my son. The regent, the king, Sir Lachlann, the queen—all will say I acted against Gavin's best interests, that I took him away from his birthright."

"Dunfallandy? That is no loss. What kind of future would he have as the lord of a backwater barony populated by Catholics and bandits? How long do you think he'd last if he were to be sent to govern there in person?"

Catherine shuddered at the thought. "Let Malcolm have it, title and all."

"He does not deserve to reap any benefits after trying to kill your son."

"To become Lord Glenelg is not much of a reward."

He caught her hand, drawing her forth from her shelter, and they walked together in silence for a few minutes. Then Fulke asked, "What does Gavin think of giving up his title?"

"He agrees with my decision. He is young, but he knows his own mind. He wishes to spend the rest of his life as plain Gavin Russell." Maternal pride infused the statement.

"He will have to change his name," Fulke reminded her. "Something that sounds Italian."

"I suppose he will. Well, he will find something he likes, I've no doubt of it. We will start over. It will be a great adventure."

Her enthusiasm seemed forced, but Fulke did not chide her for it. He had other things on his mind: the most important, persuading her to let him come with them.

"I am told Italy is a pleasant place, but I have never been there."

"And I doubt you have any desire to go." Her laugh contained no mirth. "You have said often enough that you had your fill of travel in my brother Robert's service."

"I have that desire, and others." Fulke took her hand.

She went very still.

"And I have a suggestion as to what you might call yourself in Italy."

"What name do you propose?" Her voice was so choked with emotion that he had to strain to catch her words.

"You could call yourself Mistress Rowley."

"You are kind to offer to share your name with me, but—"

"I want to share more than my name, Catherine."

Fulke tugged at the hand he held until she looked up at him. He wished there was light enough to see her expression, but at

least she was listening. She had not turned and fled back into the house.

"If you must go into exile, let me come with you. We will take Jamie, too. Master Baldwin can give orders for his ship to make one more port of call before leaving English waters."

"There is no need for you to risk yourself, let alone Jamie. We can manage on our own."

Fulke hesitated. "I know you can, but you do not need to. And I take a much greater risk now to admit the whole truth to you. I love you, Catherine. I have for a long time. The offer of the name comes with a condition. I want to marry you."

He stopped speaking, appalled at his audacity. What had possessed him? He was Lady Appleton's master of horse, a servant. Catherine was a noblewoman by marriage. She—was kissing him.

"I love you, too, Fulke," she whispered. Her voice trembled with amazement and sincerity. "I will be honored to marry you."

## 40

*October 11, 1577*
*Tennant House, Castle Hill, Edinburgh, Scotland*

AT THE SAME hour when a certain merchant ship departed Leith, taking with it Catherine, Gavin, Cordell, Avise, and Fulke, Susanna left Glenelg House for Castle Hill. Nick was already on his way to England, and believed she was, too, but she had one last matter to see to first.

"Are you sure this is wise, Lady Appleton?" Toby asked.

Nick had left his servant behind, charged with hiring outriders to guard Susanna and Una on the journey from Edinburgh to Berwick. Susanna had dismissed them, telling them to come back the following day.

"There is no harm in paying a call on Lady Tennant," Susanna assured him. "Never fear, Toby. I know what I am doing."

He muttered something Susanna did not catch. She decided it was just as well.

Lady Tennant did not seem surprised to see Susanna, nor did she have any objection to answering her questions, but she did suggest they speak in private. Trailed by two of the spaniels, she led the way to her husband's study, a small, richly appointed room. The walls were wainscoted halfway up, with brick above, and hung about with rich tapestries and a flattering portrait of the boy king. Rush matting covered the floor and a Turkey carpet lay across a table beneath a brass candlestand on a solid, round base that held thick wax candles on spikes. These provided the only illumination in the windowless room.

While Susanna settled herself in one of two curule chairs, a match for the pair in the chamber where she'd last spoken with Lady Tennant, her hostess shooed the spaniels out and closed the door against their insistent yapping. "Now we can hear ourselves think," she remarked, and sat also.

"I am in hopes you can answer a few questions for me, Lady Tennant," Susanna began. "About Sir Lachlann Dunbar. What can you tell me about the two boys who were his wards before Lord Glenelg?"

"Sir Lachlann's previous wards? Only that there were two of them and that they died, poor lads."

"You did not find anything peculiar in that?"

"Why should I? Death is not uncommon in the young."

"Did you ever hear how they died?"

Lady Tennant pondered for a moment. "For one of them an accident of some sort, or so I believe. I know no details."

Susanna told her what Fulke had discovered about both deaths.

"A sad tale," Lady Tennant allowed, "but if you mean to prove Sir Lachlann an unfit guardian, you had best reconsider. By your

own admission, he was not on Dunbar Island when these deaths occurred. And he was not at Glenelg House when Lady Russell died," she added shrewdly, guessing where Susanna's questions might be leading.

"How interesting that you know that," Susanna remarked.

"I know many things, Lady Appleton."

"I recall you are kin to the regent," Susanna said. "Have you his ear?"

"At times," Lady Tennant admitted.

"Then you might consider dropping a word or two in his presence about Sir Lachlann. And should there be time, another word concerning Master Buchanan's treatment of his students would not be amiss. He——"

"That tale I know already," Lady Tennant interrupted, "from Annabel."

Susanna blinked at her. "When did you see Mistress MacReynolds?"

"Yesterday." She smiled at Susanna's astonishment. "She is no longer a prisoner in Stirling Castle, Lady Appleton. Did you not know? She committed no crime. Indeed, she went to Stirling on the regent's behalf."

Her version of what Annabel had been up to was a story singularly devoid of any mention of Catherine Glenelg, although it did include Annabel's claim to have seen Malcolm Logan throw a knife at the king. "I am told that young man was found at Dunbar House," Lady Tennant said, "and was carried off for questioning."

"Who told you that?"

"Why, Lachlann Dunbar, who else? He paid us a visit in Stirling, just before we left for Edinburgh. You had already departed from Dunbar House. He seemed most anxious to learn what Annabel had undertaken to discover for Catherine. She told him about Master Buchanan's abuse of the king. He knew something of this already, but seemed relieved to have confirmation."

"Relieved? An odd reaction." She wondered for the first time

if it was something else he thought Annabel had found out, not Buchanan's treatment of the boys at all. "You are uncommon forthcoming with information, madam."

"It is a talent of mine to pick when to speak and when to hold my tongue."

Susanna considered that for a moment, together with what she knew of Lady Tennant. Elspeth Douglas was the regent's cousin, and Annabel's friend, and the wife of a diplomat currently in England.

"Is it also one of your talents to provide useful information to your husband and his friends? Do you frequently write to your husband, sending on all the news of Edinburgh?"

"We maintain a regular correspondence."

"Does he speak of his English friends to you, mayhap one named Sir Roger Allington?" Susanna had wondered, when Sir Roger wrote to her of Catherine's troubles, how he had come to hear of them.

"Sir Roger and my husband are on excellent terms and often exchange bits of...news."

"So your husband told him about Catherine's troubles," Susanna said, half to herself. "But I thought you said you did not know Catherine Glenelg."

"I knew *of* her." She smiled and seemed about to say more when the tapestry behind Susanna suddenly billowed outward and a tall, red-bearded gentleman garbed in the latest London fashion stepped into the room.

"Good day to you, Lady Appleton. Allow me to present myself. I am Sir William Tennant, newly arrived from England. I trust you will forgive my rudeness in listening to your conversation from a place of concealment."

"It seems to be a common practice here in Scotland," she muttered. As it was in England. Her own housekeeper, Jennet, was an adept practitioner of the art.

His thin lips twisted in a parody of a smile. "I perceive, from

what I just overheard and from what Elspeth told me earlier, that you wish to prove your friend did not kill Lady Russell. You do realize that it scarce matters, now that Malcolm Logan has been charged with a more serious crime?"

"How can the truth not matter?"

"I am told your friend cannot remember the truth."

"There is one other person who knows what really happened that day—the person who killed Lady Russell."

Sir William looked resigned. "Sir Roger said you had a reputation for stubbornness."

Since she had only met Sir Roger once, Sir William's statement annoyed Susanna, but even she had to admit that Sir Roger might be right in his assessment of her. "You will understand, then, that I must make one last attempt to right this wrong before I leave."

He studied her face, judging her resolve, and in the end gave a curt nod. "Tell me how I can help."

"What if Lachlann Dunbar arrived at Glenelg House on schedule to meet with Lady Glenelg and Lady Russell?"

"Go on." His eyes were half-closed, his demeanor relaxed, but Susanna had the feeling he missed very little.

"What if Catherine only hinted to him at what she learned from Annabel? If she was waiting for Annabel to arrive before she went into detail, she might have mentioned Annabel's name but not said what she had discovered. Is it possible Sir Lachlann knew of Annabel's past as an intelligence gatherer?"

Sir William frowned. "These things are never such closely guarded secrets as one supposes."

"He was never averse to listening to rumors," Lady Tennant confirmed. "Indeed, three years ago when he was courting me, he ofttimes encouraged me to speak of things I should not." Under her husband's steely-eyed glare, she smiled. "I was always most discreet, my dear, but that is one of the reasons I chose to marry a different suitor."

"I had not realized your...acquaintance with Sir Lachlann was so recent," Susanna said. "His second ward could not have been dead very long when you knew him."

"He affected to be most distressed by the boy's accidental death. Such expressions of grief can seem most appealing in a man. I admit I was tempted to offer comfort."

Sir William Tennant's scowl silenced her. "Let us not distract Lady Appleton from her theorizing, Elspeth. Continue, Lady Appleton, I beg you."

"What if Sir Lachlann knew Annabel had once been an intelligence gatherer? If there was no mention made of what she had discovered, what more natural than for Sir Lachlann to leap to the conclusion that she'd been sent to gather information about him? If he was responsible for the deaths of those boys, and if Catherine seemed to be hinting that his own misdeeds would soon be brought to light—"

"He'd fear exposure," Sir William cut in. "But how does that lead to the death of Lady Russell? More reasonable to assume Lady Glenelg meant to blackmail him into helping her get her son back."

Susanna could not blame him for looking skeptical, but she plunged ahead nevertheless, sketching out what she now believed might have happened at Glenelg House that day.

"An entertaining tale, Lady Appleton," Sir William said when she was done. "That I'll grant you. But you have no proof."

"What if I can persuade Sir Lachlann to confess?"

He looked at her askance and was even more taken aback when she asked for his help.

# ※41※

*October 12, 1577*
*Glenelg House, Burgh of the Canongate, Scotland*

LACHLANN DUNBAR strode into the Hall and stopped short at the sight of Susanna seated before the hearth with her feet up on a stool and a book in her hands. "You! I'd have thought you'd be back in England by now. Are you not yet satisfied with the trouble you have wrought?"

Susanna turned to face him. "There is one matter left outstanding," she informed him. Weeks of speaking French had left her confident of her ability to carry on a conversation with Sir Lachlann alone, but she could not help a brief, futile wish that Nick were still with her for this confrontation.

A betraying tremor of nervousness snaked through her. Sir Lachlann was a dangerous man. If she was right, he had killed three times, would have strangled Catherine without a qualm, and had intended to dispatch Gavin at some point in the future.

He flung himself onto the cushioned settle opposite her and glared, impatience radiating from every pore. A message from the regent himself had called Sir Lachlann back to Edinburgh in all haste, but he had not been told why he was wanted.

"What matter is it that you are concerned with, madam? The abduction of my ward, mayhap?"

She feigned surprise. "What? Has something happened to my godson?"

"As if you did not know! Do not play the innocent with me, Lady Appleton. You were aware he had his own way out of the castle when you sent him back with me."

"If *you* knew such a thing, Sir Lachlann, it was remiss of you not to tell someone."

An odd sound came from Dunbar's direction. It took Susanna a moment to realize he was grinding his teeth. She hid a smile as she set aside the book of poetry she'd been reading while she waited.

"The king has washed his hands of young Gavin," Sir Lachlann announced. "You will no doubt be pleased to hear that he will not be required to return to court when he is caught. He is, however, expected to take up his duties in Dunfallandy, under my guidance."

"And Catherine? Is she still sought by the authorities?"

"I will make certain of it."

"Even if she is innocent? The matter I spoke of is the mystery surrounding Lady Russell's murder."

"Lady Glenelg killed her. You know that."

"I know nothing of the sort. Have you time for a story, Sir Lachlann? I would take you through what I have discovered about the events leading up to Lady Russell's death."

With a dismissive wave of one hand, he indicated that she had leave to continue. He wanted, she supposed, to find out how much she knew before he decided how to deal with her. That was acceptable to her.

"Very well, then. The story starts when Mistress Annabel MacReynolds provided Lady Glenelg with certain information about Master Buchanan, information Lady Glenelg hoped would be enough to convince you, as Gavin's guardian, to remove the boy from court."

"I know this already, Lady Appleton."

"Yes, you do, now. Lady Russell did not. She knew only that Lady Glenelg wished to remove her grandson from Stirling Castle. She was determined that he should stay, since she had been in large part responsible for getting him his position there. Lady Glenelg asked both you, Sir Lachlann, as Gavin's guardian, and Annabel MacReynolds, to come to Glenelg House to discuss the situation with Lady Russell. You planned to make the journey from Stirling and stay overnight, probably longer."

He nodded agreement, but his eyes had narrowed. He did not like the direction her recitation was heading.

"Lady Russell sent her two most trusted personal servants on an errand to pick up carpets shipped from Antwerp—a ship had

arrived during the week with that cargo and it had been delivered to a merchant in Edinburgh. Una was to select the best. Dugald was to carry her choices back to the house. Meanwhile, Lady Glenelg's nursery maid, Avise, had taken Cordell to Greenside for the open-air performance of the town musicians. Of the other servants, the cook and the scullion had been sent to the fish market and two maids had been dispatched to fetch laundry from the washerwomen. Young Malcolm Logan was with his mistress."

"Yes, yes." Sir Lachlann tapped his fingers impatiently on one knee. "What profit in going over all this? It alters nothing."

"Patience, Sir Lachlann. This is the point at which the story changes. You arrived here before Mistress MacReynolds. When you heard her name, you recalled what you knew about her, that she was an intelligence gatherer of some renown. You did not know what information she'd uncovered, but you feared the worst—that she'd discovered *your* secrets. If the circumstances of your wards' deaths became known, there would be an investigation. At the least, you would lose custody of Lord Glenelg."

She paused for breath, studying Sir Lachlann's face. It was set in stone, giving nothing away.

"You assumed, misinterpreting Lady Glenelg's words, that she meant to bring your misdeeds to light. You did not have time to discover your mistake. Lady Russell took exception to her daughter-in-law's obvious intent to remove Gavin from court. She was infuriated by Catherine's efforts to reclaim her son, thus undoing all Lady Russell's hard work in helping to win him a place with the king. She attacked Catherine, clawing at her face. Catherine tried to defend herself. Both women, struggling, tumbled down the stairs and were rendered unconscious."

"The fall I grant you," Sir Lachlann said. "I was not here to see it, but it likely happened just that way. A terrible accident."

"But Lady Russell did not die from the fall, Sir Lachlann, as well you know. She was murdered. The fall just made things convenient for you."

"You think I strangled Jean Ferguson?" Sir Lachlann's contempt for the idea gave Susanna pause. Had she been wrong about him? Had Malcolm Logan been the killer? Or Catherine, after all? Regardless of her doubts, she soldiered on.

"You were here when they fell. Do not trouble to deny it. I know your horse did not go lame. Upon seeing both women were injured and unconscious, you seized the chance to protect your secrets. You intended to kill them both. You'd dispatched Lady Russell and would have gone on to strangle Catherine, too, but you were frightened off by the noise of someone else entering Glenelg House. You could not tell who it was, or if they'd come alone. No doubt, if you had known it was Annabel arriving, you'd have stayed and killed her, too."

"You have an excellent imagination, Lady Appleton." He leaned back in the settle, stretching his legs out toward the hearth, but the pulse at his throat jumped and his lips had compressed into a grim smile. He did not like what he was hearing. If she had not hit upon the exact truth, she was close to it.

"As I said, you were interrupted before you could kill Catherine. I cannot guess your original plan. Mayhap to ransack the house and make the murders look like the work of thieves. But you had no time to carry out this fiendish plot. You did not dare risk being recognized. You ran off." She eased her feet off the stool and flexed her legs. In spite of his attempt to look relaxed, she felt the tension in him. He was as tightly wound as a crossbow, and she did not want to be caught in the line of fire if he went off.

"A mistake," he allowed, "*if* I had done all you say." A faint thread of amusement laced his voice. It almost sounded genuine.

"Once away from Glenelg House you must have realized there would be a hue and cry raised for you when Catherine regained her senses. You could not have guessed that she'd suffer a loss of memory, that she would not recall that you had been there at all. So, you conceived a new plan. You had seen Lady Russell

scratch Catherine's face. What could be simpler than to accuse Catherine of killing her before Catherine could accuse you?"

Sir Lachlann's eyes smoldered with some strong emotion Susanna could not identify but he did not interrupt her again.

"You met your servant as you rode away from Canongate and decided you'd claim your horse had gone lame, that you'd arrived only *after* Lady Russell was already dead. It would be your word against Catherine's. You duly exchanged mounts with your man and returned to Glenelg House. There you discovered that Catherine did not know you had been with them earlier. She did not remember anything about the quarrel with Lady Russell or their fall. She thought, in truth, that she had killed her mother-in-law, and you were pleased to let her go on believing so."

"Because that is what happened," Sir Lachlann said. "Or do you tell me now that Lady Glenelg has regained her memory and has made these charges against me?"

Susanna simply smiled at him, hoping he'd believe it. She leaned forward a bit in her chair, holding his gaze. "Unfortunately for you, it was Annabel MacReynolds who interrupted you. She roused Catherine and discovered that she was unable to remember anything of the afternoon's events. Nor did she have any idea how long she'd been unconscious. Then Una and Dugald returned and Lady Russell's body was carried to her bedchamber. Una found the signs of strangulation, and noticed blood under her fingernails, which she took to mean her mistress had been defending herself. Catherine, realizing her face was scratched, had to face the horrifying possibility that she strangled Jean."

"And *that*, Lady Appleton, is the point at which I arrived," Sir Lachlann said. "Not before."

"That is the point at which you *returned*. Annabel faded into the background before you noticed her and waited to see what would happen next."

"I offered sympathy and vowed to assist Lady Glenelg in any way I could."

"Yes, and when she admitted she had no idea how the law works in Scotland, except that it differs from the way things are done in England, you offered to take care of everything. When you left to fetch the authorities, Annabel reappeared and convinced Catherine not to wait around to be arrested. That suited you well. In truth, you hoped she would return to England and never bother you more."

"I thought that best," he agreed, "and you would do well to take the same advice, Lady Appleton. Without sharing your unfounded suspicions with anyone else."

"Do you threaten me, Sir Lachlann?"

"I do but warn you, Lady Appleton. You have invented a story out of nothing to exonerate your friend. My version—the truth—is different. And I will be believed."

Susanna had rarely felt so frustrated. He was supposed to say or do something to give himself away. She had not expected a full confession, but she had anticipated at least a small slip, a crack in the smooth surface of his lies. Once the first fissure appeared, others would follow. The holes in his story would widen into chasms.

But Sir Lachlann Dunbar was not cooperating. He had not lost his temper. He had not given in to the temptation to boast about getting away with murder. As Susanna tried to think of something else to say to prick his composure, he stood and executed a mocking bow. "I will expect to find you gone at first light, Lady Appleton."

"And if I am not?"

"I will send for the bailie to evict you and your servants. And if you repeat this absurd bit of fancy to him, I will see you imprisoned. You cannot defame a man's character and hope to escape unscathed."

He was bluffing, she thought. He would not want his dirty linen aired in public. Unfortunately, he was also the one likely to be believed. She was an outsider, and worse, a *sasunnach* woman.

She knew when she was defeated. Her only consolation was that when news reached Scotland of the "death" of Lord Glenelg, his estate would revert to Malcolm Logan. Sir Lachlann would lose the profits of his crime.

And then it came to her, one last ploy to try. Sir Lachlann was nearly at the heavy, carved, floor-to-ceiling screen that separated the Hall from the entrance to the house, reducing drafts and giving the illusion of privacy to anyone who sat and conversed by the hearth. "She has remembered, you know."

Her blatant lie brought him to a halt. He turned slowly to face her.

"Catherine did remember that you were here. Had she not been obliged to flee the country with her son, she would have stayed to bring criminal charges against you for the murder of Lady Russell."

"And where is Lady Glenelg now?"

"I do not know." She could swear to that with complete sincerity. The ship with Catherine and her children aboard could be anywhere along the coast by now. "But she left behind a deposition."

At last, Susanna saw a flicker of panic in Dunbar's eyes.

"Let me see it. If she accuses me, I have a right to read the charges."

Praying she was not about to make a fatal mistake, Susanna stood and withdrew a paper from the pocket hidden in the placket of her skirt. "I have it here, Sir Lachlann. Proof of your guilt."

With a cry of triumph, he pounced, wrenching it from her hand and tossing it, unread, into the fire. With the same movement, he shoved Susanna, hard, so that she, too, tumbled toward the flames.

Balance gone, she barely stayed on her feet. Flailing with both hands, she remained upright, but could not retreat in time. Her right sleeve caught fire first, then that side of her skirt.

Susanna had been witness to enough kitchen accidents to

know what to do, but Dunbar stood in her way, jabbing at her with the poker he'd snatched up from beside the hearth, preventing her from dropping to the floor and rolling over onto the burning cloth to smother the flames. She watched her own arm, transfixed in horror as the fabric flared and fire threatened to engulf her.

Searing pain penetrated the sleeve. Sudden heat warmed her lower limbs. The stench of burning wool spurred her on as she beat at the cloth with her bare hands, but all that did was make her palms blister. Choking on the smoke as it rose from her clothing, sickened by the first whiff of burning flesh, she managed a strangled scream.

Abruptly, something heavy dropped on top of her, followed by the feel of hands beating at her body. Her shoulder struck the floor with jarring force. Then the combined agony of burns and bruises increased to an intolerable level and a merciful blackness descended.

*        *        *

SUSANNA awoke in her bedchamber to nausea and a wooziness that left her confused and disoriented. Una, Lady Tennant, and a strange man who was, by his dress, a physician, hovered around her, concern writ large on all their faces. The physician held a feather. After a moment, Susanna realized that he was using it to anoint a patch of blistered skin on her arm with an oily green concoction.

"What is that made of?" she whispered.

Lady Tennant answered her. "Plantain leaves, daisy leaves, the green bark of elders, and green germanders, stamped all together with fresh butter and strained through a linen cloth."

"A poultice made of common house leeks will work just as well," Susanna murmured. "Do not let him bleed me."

The second time she awoke, the fuzziness was gone from her mind. She remembered what had happened in the Hall, and that Sir Lachlann had tried to kill her. She stared blankly at her hands,

which were swathed in bandages. Her arms and legs were likewise wrapped. Everything throbbed.

"Ah, you are with us once more," said Lady Tennant.

"So it appears. Where is Sir Lachlann?"

"I will let my husband tell the tale."

Although Susanna peppered her with questions, she insisted upon waiting for Sir William. Fortunately, he was close at hand.

"You have what you wanted," he told Susanna. "Sir Lachlann is in custody. I will bring charges against him myself, for I was witness to the attempt on your life." Sir William had been hidden in the screens passage to listen to what Susanna had hoped would be a confession.

"Did you save me from the fire?"

"He did." Lady Tennant beamed with pride. "He smothered the flames with a wall hanging."

"Did Sir Lachlann attempt to flee?"

"He seemed stunned by my unexpected appearance on the scene and was slow to react. By the time he tried to escape, both your man and Lady Russell's had arrived to prevent it."

Toby and Dugald. "I wish I had been conscious to see it."

"You are lucky to be alive," Sir William scolded her. "Why did you not tell me you had Lady Glenelg's deposition?"

"Because that was a lie."

Bushy red eyebrows that matched Sir William's beard shot up in surprise. "What paper did Sir Lachlann burn, then?"

"My list of suspects. I do much doubt that Catherine will ever recover that last bit of her memory."

"And I do not suppose you know where Lady Glenelg is now?"

"In truth, I do not."

He had no choice but to believe her and to promise that she would receive the best of medical treatment for her burns. Susanna examined them for herself and was relieved to discover that they were not as extensive as she'd at first feared. With God's grace, they would heal without becoming infected.

"Will my testimony be needed against Sir Lachlann?" she asked.

"Mine should be sufficient to hold him, and I will insist on a full investigation into the deaths of his two young wards on Dunbar Island."

Susanna had to be satisfied with that. Truth be told, the only thing she wanted now was to return home and forget all about this unhappy sojourn o'er the Border.

# 🎖42🎖

*April, 1578*
*Leigh Abbey, Kent, England*

"A LETTER has come!" Rosamond bounded into her foster mother's study without bothering to knock.

Susanna held out a hand for it, pleased to see that the scars on her fingers grew less noticeable with each passing day.

"From Padua," Rosamond added. "From Catherine."

"Did you read it?"

"Would I do such a thing?"

"Yes."

"Well, I did not." She pouted. "You can see the seal is unbroken."

"And I happen to know that you mastered the art of loosening wax seals some time ago." While Rosamond debated between confessing and staunchly maintaining her innocence, Susanna opened the letter and read the first page of the missive. "Catherine received my letter about Lachlann Dunbar."

"She must be glad to find out that she did not kill anyone."

"I am sure she is."

Susanna had been delayed in Scotland until Sir William Tennant's physician had deemed her fit to travel and so had missed Catherine's brief visit to Leigh Abbey. She'd had no opportunity to tell Catherine her news in person. Nor had she been available to talk Catherine out of her decision to marry Fulke.

Susanna was still in a quandary when it came to Fulke Rowley. He was a good man, and Catherine said she loved him, but Susanna could not help but think of their marriage as a *mésalliance*. He was a servant. She was gently born, and a noblewoman by her first marriage. The two were barely supposed to speak privily together, let alone wed.

Then again, some might level similar criticisms at her for taking up with a merchant after Sir Robert Appleton's death. Susanna sighed. She knew she was the worst sort of hypocrite to be so troubled by Catherine's choice of a husband. Catherine was a woman of mature years. She had earned the right to make her own decisions. This one, though, was difficult for Susanna to accept.

"I miss Jamie," Rosamond said. "Do you think he likes living in Padua?"

"With Cordell and Gavin for company? I am certain he does."

After the fictitious shipwreck, Jamie had been collected from Leigh Abbey in secret, although Rosamond, Jennet, and Mark knew the truth about where he and Fulke had gone. Everyone else in Susanna's household thought the boy had been sent to live with an aunt after Fulke's tragic death. There had been, she'd heard, a good deal of weeping among the maidservants.

"May I write to him?" Rosamond asked.

"Jamie? I see no reason why you should not. When I reply, I will include your missive with mine."

In her next letter to Padua, Susanna supposed, she should also report on recent events in Scotland. Things were once again in turmoil. The new English ambassador, Sir Thomas Randolph, sent regular reports back to England and the content of some of these

had been conveyed to Susanna by Cordell, Lady Allington, who had been a frequent visitor during Susanna's recuperation. Sir Roger's wife had not asked any awkward questions, but Susanna had a feeling she knew Catherine had been given a new identity and approved.

It was from Lady Allington that Susanna learned of the earl of Morton's fall from power. A faction led by the Erskines of Mar had recruited allies to act against the regent "in defense of the king." Then Master Buchanan had became embroiled in an altercation with Morton over a favorite horse, and his allegiance to the regent had dissolved. Shortly thereafter, the earl of Morton had resigned his position and the king, at age eleven, had been declared competent to rule. God help them all!

Rosamond took Catherine's letter to read for herself but she barely glanced at it before she had another question. "She says she and Fulke are very happy and that she hopes to have more good news to impart in her next letter. What do you think she means by that?"

As Susanna had not yet read the second page, she reclaimed the missive and did so. Once again, she was beset by mixed emotions. "I can only suppose she means that she and Fulke will soon be adding another little Rowley to the world."

"A baby? Oh, how lovely!" Then Rosamond's joy faded. "But they are so far away. Can they ever come home?"

"I hope they will. One day." But to what, she wondered. They could not resume their old lives.

Rosamond sighed.

Susanna turned to her, prepared to offer further words of comfort. She expected to see a deep sadness in the girl's expression but found instead a dreamy-eyed countenance she could interpret all too easily.

Fulke had dashed to Catherine's rescue. They'd fallen in love and eloped, making their escape on the high seas. They'd sailed off into the sunset, ending up in a distant, exotic place. Rosamond

did not see their marriage as a *mésalliance*, but as the happy ending to a tale full of adventure and steeped in romance.

Susanna considered delivering a little lecture on the dangers of letting the heart rule the head, but any hint of disapproval would only make Rosamond idolize Catherine more. In the end she said nothing. After all, it would be years yet before she had to worry about Rosamond falling in love.

**❧FINIS❧**

# A Note from the Author

AS ALWAYS, a bibliography of my sources is to be found at www.KathyLynnEmerson.com For this book I also needed the assistance of an expert on things Scottish. Thanks go to fellow author Candace Robb, who put me in touch with Elizabeth Ewan at the University of Guelph in Canada. It was my great good fortune that Dr. Ewan happened to be working on the records of the Burgh of the Canongate. She kindly clarified the intricacies of the Scottish legal system in the sixteenth century for me, provided the names of Canongate officials for the year 1577, and supplied numerous details about other residents. Any errors are mine. Happy reading!

Sandy Emerson

KATHY LYNN EMERSON has been interested in the Elizabethan period all her life. In addition to ten books and many stories in the *Face Down* series, she has used that setting in several non-mysteries, and has written nonfiction for writers and scholars about it. She is also the author of a historical series set in nineteenth-century America.

Emerson lives in Maine with her husband. She welcomes visitors and e-mail at www.KathyLynnEmerson.com.

# MORE MYSTERIES
## FROM PERSEVERANCE PRESS
### 🕱 *For the New Golden Age* 🕱

JON L. BREEN
Eye of God
ISBN 978-1-880284-89-6

TAFFY CANNON
ROXANNE PRESCOTT SERIES
Guns and Roses
*Agatha and Macavity Award
nominee, Best Novel*
ISBN 978-1-880284-34-6

Blood Matters
ISBN 978-1-880284-86-5

Open Season on Lawyers
ISBN 978-1-880284-51-3

Paradise Lost
ISBN 978-1-880284-80-3

LAURA CRUM
GAIL MCCARTHY SERIES
Moonblind
ISBN 978-1-880284-90-2

JEANNE M. DAMS
HILDA JOHANSSON SERIES
Crimson Snow
ISBN 978-1-880284-79-7

KATHY LYNN EMERSON
LADY APPLETON SERIES
Face Down Below
the Banqueting House
ISBN 978-1-880284-71-1

Face Down Beside
St. Anne's Well
ISBN 978-1-880284-82-7

Face Down O'er the Border
ISBN 978-1-880284-91-9

ELAINE FLINN
MOLLY DOYLE SERIES
Deadly Vintage
ISBN 978-1-880284-87-2

HAL GLATZER
KATY GREEN SERIES
Too Dead To Swing
ISBN 978-1-880284-53-7

A Fugue in Hell's Kitchen
ISBN 978-1-880284-70-4

The Last Full Measure
ISBN 978-1-880284-84-1

PATRICIA GUIVER
DELILAH DOOLITTLE PET
DETECTIVE SERIES
The Beastly Bloodline
ISBN 978-1-880284-69-8

NANCY BAKER JACOBS
Flash Point
ISBN 978-1-880284-56-8

JANET LAPIERRE
PORT SILVA SERIES
Baby Mine
ISBN 978-1-880284-32-2

Keepers
*Shamus Award nominee,
Best Paperback Original*
ISBN 978-1-880284-44-5

Death Duties
ISBN 978-1-880284-74-2

Family Business
ISBN 978-1-880284-85-8

VALERIE S. MALMONT
TORI MIRACLE SERIES
**Death, Bones, and Stately Homes**
ISBN 978-1-880284-65-0

DENISE OSBORNE
FENG SHUI SERIES
**Evil Intentions**
ISBN 978-1-880284-77-3

LEV RAPHAEL
NICK HOFFMAN SERIES
**Tropic of Murder**
ISBN 978-1-880284-68-1

**Hot Rocks**
ISBN 978-1-880284-83-4

LORA ROBERTS
BRIDGET MONTROSE SERIES
**Another Fine Mess**
ISBN 978-1-880284-54-4

SHERLOCK HOLMES SERIES
**The Affair of the Incognito Tenant**
ISBN 978-1-880284-67-4

REBECCA ROTHENBERG
BOTANICAL SERIES
**The Tumbleweed Murders**
(completed by Taffy Cannon)
ISBN 978-1-880284-43-8

SHELLEY SINGER
JAKE SAMSON & ROSIE VICENTE SERIES
**Royal Flush**
ISBN 978-1-880284-33-9

NANCY TESLER
BIOFEEDBACK SERIES
**Slippery Slopes and Other Deadly Things**
ISBN 978-1-880284-58-2

PENNY WARNER
CONNOR WESTPHAL SERIES
**Blind Side**
ISBN 978-1-880284-42-1

**Silence Is Golden**
ISBN 978-1-880284-66-7

ERIC WRIGHT
JOE BARLEY SERIES
**The Kidnapping of Rosie Dawn**
*Barry Award, Best Paperback Original. Edgar, Ellis, and Anthony Award nominee*
ISBN 978-1-880284-40-7

*REFERENCE/ MYSTERY WRITING*

KATHY LYNN EMERSON
**How To Write Killer Historical Mysteries: The Art and Adventure of Sleuthing Through the Past**
*(forthcoming)*
ISBN 978-1-880284-92-6

CAROLYN WHEAT
**How To Write Killer Fiction: The Funhouse of Mystery & the Roller Coaster of Suspense**
ISBN 978-1-880284-62-9